Watermedia Painting with Stephen Quiller

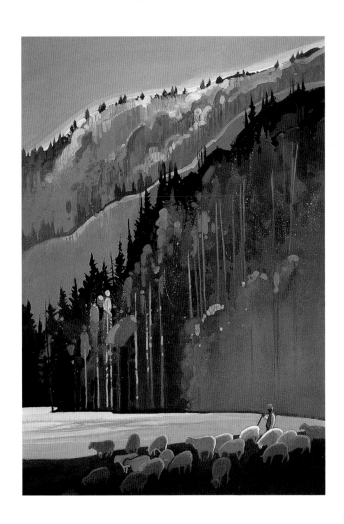

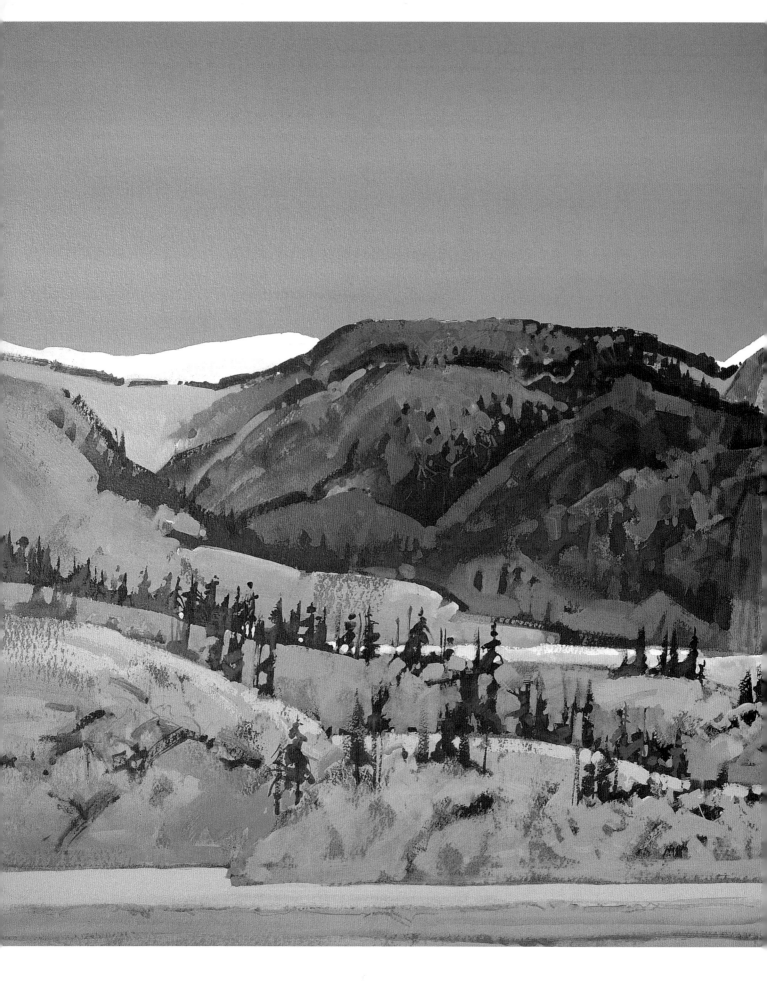

Watermedia Painting with Stephen Quiller

THE COMPLETE GUIDE
TO WORKING WITH WATERCOLOR, ACRYLIC,
GOUACHE & CASEIN

Stephen Quiller

Watson–Guptill Publications

New York

First published in 2008 by
Watson-Guptill Publications,
Nielsen Business Media,
a division of The Nielsen Company,
770 Broadway, New York, NY 10003
www.watsonguptill.com

LCCN 2007936523

Executive Editor: Candace Raney
Editor: Alison Hagge
Designer: Karen Lau
Production Manger: Salvatore Destro

ISBN-13: 978-0-8230-9688-6
ISBN-10: 0-8230-9688-2

Printed in China
First Printing, 2008
1 2 3 4 5 6 7 8 / 15 14 13 12 11 10 09 08

Half-title Page: **Sheep Drive, San Juan Mountains,** 40 x 30 inches (101.6 x 76.2 cm),
acrylic on Aquabord, Collection of Sally and Forest Hogland

Previous spread: **Winter, View of Creede,** 28 x 48 inches (71.1 x 121.9 cm), acrylic on 300-lb. rough
Richeson Premium watercolor paper, Collection of Shelly and Michael Dee

To Marta

I would like to thank my wife, Marta, for her peaceful demeanor, her trust that things do turn out for the best, her encouragement with my painting and writing, her companionship at home and on our painting travels, and her review of this manuscript before submission; Candace Raney, executive editor at Watson-Guptill Publications, for believing in my work over the years; Alison Hagge, editor of this book, for her invaluable suggestions, editorial directives, and creative vision; Karen Lau, designer of this book, for helping to make my vision a reality; Frank Francese, George James, and Carla O'Connor, for contributing their incredible work to this book; Chere Waters, for her research and attention to details, which make it possible for me to do what I do; Jacques Blockx, for his expertise and information about making watercolor paint; Richard Dixon-Wright, former business manager, Artist Papers, at St. Cuthberts Mill in Wells, Somerset, England, for the tour and information about making watercolor paper; Judith and Bob Fields, for the information about mounting watercolor paper; Jack Richeson, for his passion for the art material industry and his trust in my work; Michelle Richeson, for providing me with images and information necessary for the book; the fine people at Jack Richeson and Company, for making top-quality artist materials; Charles Ewing, friend and fellow painter, for developing Aquabord art products; the late Barbara Whipple, for co-authoring my first two books on painting; Grant Heilman and James Schaaf, for sharing their knowledge about photographing art work; David Basler and Eddie Vita, for their technical support; Allison Quiller, for the epilogue poem that means so much to me; and the late Andrew Sheptak, a good friend, whose love and passion for art have been an inspiration.

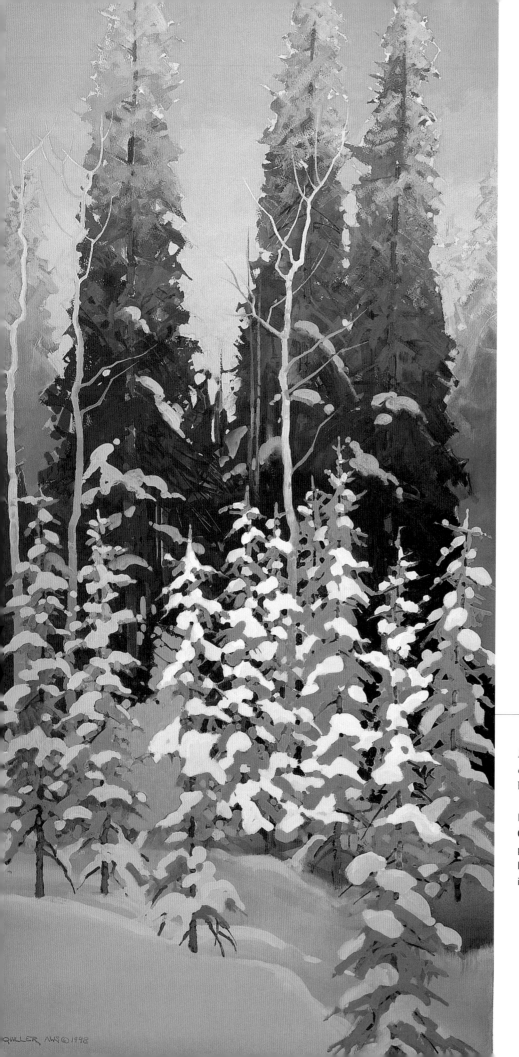

Fresh Snow, 36 x 23 inches (91.4 x 58.4 cm), acrylic on #5114 Crescent watercolor board, Collection of Larry and Sue Jensen

I was cross-country skiing along the Ivy Creek Trail when I noticed the beautiful patterns of fresh snow clumps on a collection of young spruce. This was enough inspiration for a painting.

QUILLER AWS © 1998

CONTENTS

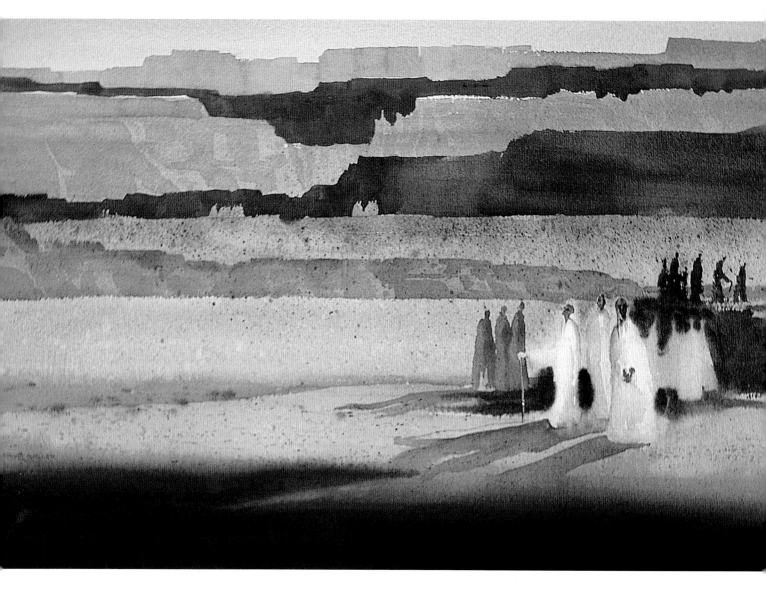

The Pilgrimage, 20 x 29 inches (50.8 x 73.7 cm), watercolor on 300-lb. cold press Arches watercolor paper, Collection of State of Colorado, Governor's Mansion, Denver

Early on in my career I did some spiritual paintings, of which this is one. From time to time, I return to this theme, using these mystical, mirage-like figures.

Introduction

TEACHING IS IN MY BLOOD. MY FIRST FEW years out of college, I taught art in secondary schools during the academic year, making my own paintings at night and starting my own gallery in the summers. In retrospect, this was one of the most important experiences of my early professional life. It taught me how to organize daily and weekly lesson plans; how to speak and present material in front of a group; how to appreciate a student's passion for art—and the joy of sharing my knowledge and talent. This was a great beginning for a somewhat introverted kid.

After three years of teaching high school in Oregon, I took a job as the art department head of an open-campus junior high school on the central California coast. Need I say more? My main reason for accepting this assignment was that I wanted to paint the coast. However, I hardly painted all year, as most of my energies, night and day, were spent corralling these unstructured, pubescent kids. This was the worst year of my life, and yet it was the best thing that ever happened to me. I resigned after a year and have led an independent life of art ever since. To this day I admire a dedicated and passionate junior high instructor as much as or more than any other living soul.

I began painting full time in 1972 and reveled in the uninterrupted work time. I vividly remember a day late that autumn, when I had my first magical painting moment. I felt like an observer and time did not exist. I watched as the paint and water flowed onto the paper. Whatever my brush did seemed right. The painting came together as if by magic. Afterward, still in awe, I returned to view the image many times, to confirm that it really had happened. That painting, *Snow Shadows* (shown on page 175), was selected the following spring for the American Watercolor Society's traveling exhibition.

I kept painting rigorously and each year I occasionally experienced similar moments. Year after year, these instances occurred more frequently. I live for these times. Today, thirty-five years later, I am addicted to painting. I pick up a brush like a conductor takes up a baton. Time is gone, color is intense, and my vision is clear. I am on another journey. It is as good as it gets.

OCTOBER 11, 1997

I do not talk about this often. I want to live by example. I feel we are here to grow spiritually. Life places experiences in our path that we can choose to learn from or not. From my earliest days, it seems I have followed an inner voice. It has led me into an interesting and exciting life.

Early on I learned to meditate. This has made all of the difference for me. It is a special time daily to pause, give thanks, reflect, and be a part of the universal flow. This is what helps keep me centered. Sometimes life gets hectic and complicated, but if I take time to meditate I find an inner peace and enjoy following this life course.

I have devoted my painting career to the watermedia, their visual qualities and handling characteristics. This book contains complete information about all four of the major watermedia. Chapter One is devoted entirely to watercolor paint. I present three different palettes: a twelve-color palette, an expanded palette (which actually contains twenty-seven colors), and a palette that features only transparent colors. I analyze the colors on these three palettes in depth and suggest not only when to use each of these palettes but how each individual color can be used to best advantage. I then delve into the visual properties of the various paints and explain how to maximize the effects of both staining and sedimentary colors.

Chapter Two is devoted to the other three watermedia: gouache, acrylic, and casein. I thoroughly discuss the range of visual effects (from transparent to opaque, matte to juicy, subtle to vibrant) that can be achieved by each of the paints and provide a full working palette for each medium. In the case of acrylic, I also discuss a wide range of water-based products—from interference colors to acrylic gels—that can be used to expand the visual effects. And finally, I end with an invaluable chart that compares, at a glance, the visual characteristics and strengths of all four watermedia featured in the book.

In Chapter Three I examine, in detail, the supplies that are available to watermedia artists today. I discuss a wide range of supports, explaining which is most beneficial when and why. This section includes an intimate look at how watercolor paper is made at the St. Cuthberts Mill in Somerset, England. It also addresses a number of age-old questions, such as what are the benefits of internal and external sizing. And finally, I discuss the other essential supplies, taking a close look at the various brushes and easels that are available.

In Chapter Four I provide an extensive discussion about the many techniques that can be used by watermedia painters, including such

Art's true purpose is to inspire. The whole idea of collecting art for investment defeats the purpose of what art is. Art is pure and honest. It delves into one's soul or unconscious. Art is for everyone and cannot be trapped. It can be detained for a while, but eventually it will be passed on and on.

essential things as controlling the flow of watercolor paint and maximizing the lifting process. I delve into a discussion about how to use the various watermedia in combination, providing a number of distinct pairings, each of which includes copious examples from my own work accompanied by clarification about how I achieved various effects. And finally, I discuss combining watermedia with drawing media.

In Chapter Five I review two aspects of painting that are particularly close to my heart—working with watermedia en plein air and working large in watermedia. The former discussion is filled with tips—both on working in a local region and on traveling overseas. The latter discussion includes a helpful description of how to varnish watermedia paintings.

Composition is seldom addressed in painting books, yet it is essential to the creation of powerful art. Chapter Six is devoted to my thoughts on this subject. I describe the basic and advanced elements that can be used to create a great composition, with plenty of concrete examples. I discuss the importance of developing your eye to see abstractly and provide a number of targeted exercises that can help achieve this goal. I analyze the compositions of paintings created by four historical master artists. And finally, I provide strategies for analyzing the compositions of your own works—both at the conception of an idea and during the painting process.

In the final chapter, Chapter Seven, I provide a number of solid working methods for taking your own paintings to the next level. I explain the importance of working from your own sketches. I show work by three internationally known painters, Frank Francese, George James, and Carla O'Connor, and allow each to divulge his or her unique painting process—from initial inspiration and studies to the final painting. And finally, I discuss how to put it all together, create work with your own signature style, and know when to call a painting "finished."

Layers, 38 x 58 inches (96.5 x 147.3 cm), watercolor and acrylic on 300-lb. cold press Richeson Premium watercolor paper, Collection of the Artist

This is one of the latest paintings in my spiritual theme. It deals with figures moving through different layers of landscape and reality.

Throughout the book I have included exercises that will help you internalize this material. I have also included selections from my own personal journals. These journal entries include a range of ideas I have contemplated and struggled with during my painting career. Keeping a journal has helped me mature as a person and as an artist.

I hope this book will help you to grow as a painter. I have been very fortunate to live my life in art, and I feel it is important to share this knowledge and to pass it on. The more knowledge you gain, the more you immerse yourself in painting, the more opportunities there will be to let go and experience those moments that I mentioned above. We live for those moments!

Lover's Point, Pacific Grove in May, 21 x 29 inches (53.3 x 73.7 cm), watercolor on 300-lb rough Richeson Premium watercolor paper, Collection of Carol Fardal

I created this painting on the Pacific coast on a beautiful May day with the ice plant in full bloom. The color of the blossom is imbued with cobalt violet, so I used this beautifully granulating paint straight out of the tube. The neutral "gray" sky is a mix of viridian and cobalt violet, which visually has the effect of a soft textural shimmer. The streak of blue-green in the water is manganese blue and the neutral blue-violet foreground water is a mix using ultramarine violet.

CHAPTER ONE

Watercolor

EVER SINCE I COULD HOLD A CRAYON, I wanted to be an artist. However, it was chance, or possibly fate, that in the ninth grade I began taking watercolor lessons. At the time I hardly knew the difference between watercolor and oil paint, but the medium grabbed hold of me, and, although I took classes in college in all the various media, my first love has lasted and become the foundation of my life's work.

Painting in watercolor has an immediacy, a beauty and flow, and most of all a spiritual quality that keeps me coming back. When the paper is wet and the paint is moving, I become a part of this beautiful process—listening, watching, responding, and interacting. I am in a higher state of consciousness. Thus I live for these moments.

I vividly remember showing my paintings one time when I was still a college student. A viewer commented on my work and stated that watercolor was indeed the most difficult medium. "You are a very good painter if one out of seven of your watercolors is successful," she said. That made me wonder: *If that is a good ratio for an experienced painter, then what is the ratio for an inexperienced one? And how difficult will it be to turn my passion into the way I make a living?*

Since my college years I have been learning how to make painting with watercolor easier. When I'm painting, I want the medium to help me come as close as possible to the vision in my head. To make this happen I need complete knowledge of every aspect of the watercolor paint, the paper, the brushes, and all of the processes that I use. I must master the materials and techniques in order to let go and express myself. Ultimately this is necessary to ensure that the craft does not get in the way of the flow.

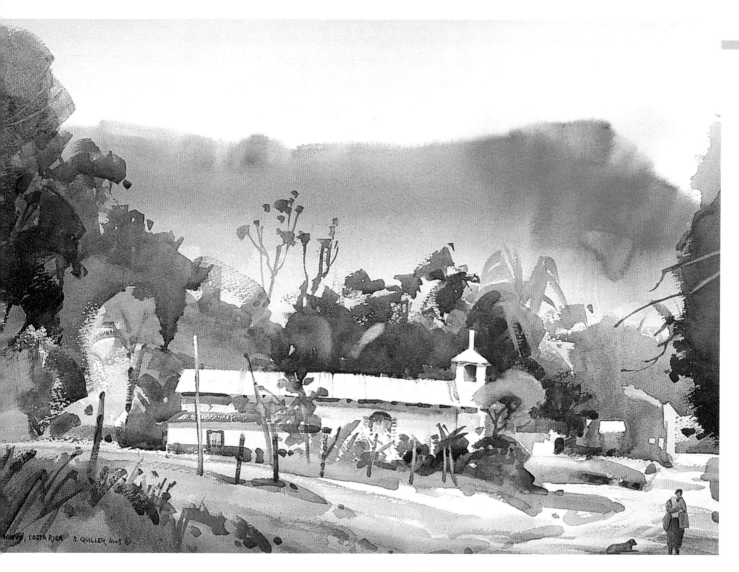

Villa Nuevo, Costa Rica, 20 x 28 inches (50.8 x 71.1 cm), watercolor on 300-lb. rough Saunders Waterford watercolor paper, Collection of Laura and Randy Brown

This small village sits deep in the rain forest beyond the Costa Rican city of Quepos. The mountain in the distance is a sacred site to which the villagers make a pilgrimage once a year. It is so hot there that the beautiful iron windows of the church do not have glass.

OCTOBER 12, 1993

When you have an idea or inspiration, get it down and make notes right away. Experience the moment, because if you go back tomorrow it will not be the same. Live in your painting, feel the wind and the rain on your skin.

Art is not a transcript of nature. Art is the expression of the emotions that those beauties stir in the human soul.

This chapter is about just that. I introduce my twelve-color universal watercolor palette and then expand upon this palette with other colors that are important to capture the complete painting experience. I examine the character of each of these colors and discuss other popular colors, such as the earth colors. I explain the differences between organic and inorganic pigments and detail the unique visual qualities that each kind

of pigment tends to generate—from the sedimentary, granulating colors to the transparent, staining colors. In short, I share the information that has helped me develop my craft. There are no shortcuts. You will learn and grow with both research and mileage on the brush.

The Craft of Painting

The painting process has two parts. First and foremost is the creative, artistic inspiration. This is the raison d'être for the work in process. If the emotion runs strong, the painting can be powerful. The viewer will feel that love and energy radiating from the finished piece. However, to fully realize this expression the painter must be thoroughly versed in the second aspect of the process: the painter's craft. If the artist does not draw well, handle the brushes both knowledgeably and confidently, understand how the watercolor paper or other support works and responds to paint, know how to mix color, and so forth, then the finished painting will look clumsy and indecisive. That is why knowing completely the craft of painting is essential for the finished work to be successful.

Being able to break down the motif and create a strong composition, use expressive and varied brush strokes, and select and apply color that works with the mood of the painting will bring the work to its fullest realization. The craft is essential in the working process. In the 1980s I taught painting, printmaking, color, and design at Adams State College. Unfortunately, technique, materials, color theory, classical drawing, and methods of watercolor and plein air painting are not taught in many colleges and universities today. Students are given materials and told to "express themselves." Many students graduate without a proper foundation.

I truly believe an instructor's goal should be to teach the craft, to give students a firm foundation in methods and materials—drawing techniques, design principles, brush handling, permanency of paint, and so forth. Then they can spend the rest of their lives expanding on these skills and developing their own style and mark, their own unique vision. Personal expression is most effective when it rests on a firm foundation.

The Colors of Watercolor

In September of 2005 I spent a day at the Whitworth Museum in Manchester, England. Not only did I see the works in the numerous rooms of the main gallery, but the curator took me through the vaults and storage areas so I could view beautiful and rare paintings by notable British painters. This museum is unique in that it is devoted almost entirely to watercolor paintings. Most museums have oil and acrylic paintings on permanent display while the works on paper only see the light of day when they are included in a temporary exhibit. While this was necessary at one time, due to the impermanence of the watercolor paints and the fragility of the supports, it no longer needs to be the case. Many people don't realize that the pigments in all of the various media are the same. What makes each medium unique is its binder. Unlike artists of the past, watercolor painters today can select permanent, high-quality paints and archival supports and mats and create works that are extremely durable.

In the sections that follow I show some of the many watercolor colors that are available today, with in-depth and personalized information. Most of these are colors that I use. Each illustrated example features (from left to right) the main color at pure hue, a gradated semi-neutral wash of the color and a neutral color note (both of which are created with the pigment's complementary color), and the pure complementary color. (In addition, the first swatch shows how

I have been interested in color and the pigments used by artists for most of my painting career. In the late 1980s I developed the Quiller Wheel, a color wheel that identifies more than seventy tube colors of artists' paints—locating their position on the color wheel, providing their direct complements, and specifying their color families. The Quiller Wheel is used by painters in all media throughout the world.

In the mid to late 1980s information about the permanency of color was not readily available. However, in the early 1990s two books came out: *The Wilcox Guide to the Best Watercolor Paints* and Hilary Page's *Guide to Watercolor Paints*. It became evident that a few of the colors I had on my color wheel were not permanent and were actually *fugitive*. It infuriated me that well-known paint manufacturers were selling "artist quality" (as opposed to "student quality") paints at high prices while they knew that the color would eventually fade or darken. Thus I re-did my color wheel using only permanent colors.

Shortly after these books came out the major manufacturers "reformulated" their paint and now their lines are lightfast. In fact, each tube of paint now has a label that clarifies its chemical makeup, toxicity, and lightfast rating. Paints with a #1 or #2 lightfast rating can be used for fine-art purposes. I choose to use only the highest permanency rating for colors on my palette. My own brand also lists the complementary color to the color that is purchased.

much color can be lifted with a round synthetic brush.) These swatches are painted on externally sized, 300-lb. watercolor paper. Each diagram is accompanied by a description of the color, which includes the paint's chemical makeup, lightfast rating, properties (such as whether it is transparent and staining or opaque and sedimentary), lifting quality, and how I use it on my palette. In addition, each color is identified by its color index generic name, which is the international standard reference number. In most cases colors have just one index name; for instance, cadmium orange is PO 20. However, in a few instances the color is actually a blend of pigments and thus has more than one index name; for instance phthalocyanine turquoise is listed as PG 7, PB 15 because it is mix of phthalo green and phthalo blue.

Numerous fine brands create watercolor paint. Throughout my career I have used many different paints, including those made by M. Graham, Sennelier, Schmincke, Da Vinci, and Maimeri-Blu. For the last number of years, however, I have settled on a watercolor paint that is manufactured in a small European mill. They use only the finest pigments and add honey to the gum arabic binder to keep the paint moist and to deter mold. The paint is stone-ground, which gives the mineral and earth pigments a more pronounced granulation and all of the paint more character. This paint is now my Stephen Quiller signature brand, imported by Jack Richeson and Company.

Before looking at the colors themselves, however, it is important to understand two terms that characterize and distinguish the pigments—inorganic and organic. Inorganic pigments do not contain carbon. They are usually mineral and can be mined (such as the cadmiums, the cobalts, and cerulean blue), but they can be synthetic (such as the ultramarines and viridian green). Inorganic pigments are often opaque in nature, meaning that light reflects off them. They tend to lift more easily than their organic counterparts. In general, inorganic pigments are more coarsely ground compared to the organic; in addition, because most inorganic pigments weigh much more than organic pigments, they sink quickly in a solution of pigment and water and frequently don't disperse evenly on the paper.

By contrast, organic pigments contain carbon. They are broken down into two categories. First are the natural organics. These pigments (such as genuine rose madder) are directly derived from nature. Second are the synthetic organics, which have been chemically developed and which are

more common today. Most of these paints (such as the phthalocyanine and quinacridone colors) are relatively new. In general, organic pigments are lighter and more finely ground than their inorganic counterparts. This allows them to float longer in a solution of water and evenly disperse on the paper, giving a consistent tone. Organic pigments tend to be transparent, meaning that light filters through the paint to the paper and then reflects back to the eye. In addition, they are usually staining, which means that they seep into the fibers of the paper and do not lift easily.

The Twelve-color Universal Palette

My standard universal palette contains twelve colors: the three primary colors (yellow, red, and blue), the three secondary colors (orange, violet, and green), and the six intermediate colors (yellow-orange, red-orange, red-violet, blue-violet, blue-green, and yellow-green). I call this a painterly palette because it has a lot of mineral inorganic colors and some synthetic organic colors, which allows the artist to lift and stain as well as push the paint around. The palette does include cadmium paints, even though they are toxic if inhaled or ingested. (If you have an aversion to working with these paints, turn to page 24 for a discussion about nontoxic colors that can be used as substitutes.) All of these colors have a #1 lightfast rating, which ensures that with proper care and framing the artwork will last. Every color imaginable can be created by mixing these twelve colors, so if you master this palette, you will be able to interpret subjects as diverse as the high mountains of Colorado, the tropical regions of Hawaii, and the lush and colorful areas of the Mediterranean.

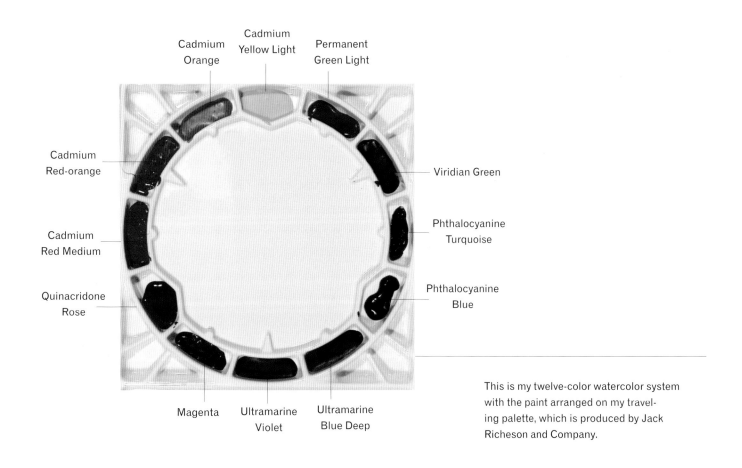

This is my twelve-color watercolor system with the paint arranged on my traveling palette, which is produced by Jack Richeson and Company.

Cadmium Yellow Light (PY 35)

This is the primary yellow and has a #1 lightfast rating. It may appear a bit lemony or to the green side, but it makes rich oranges when mixed with quinacridone rose and rich greens when mixed with phthalo blue. It is an essential color on my palette. Although considered to be opaque, cadmium yellow light thins down nicely to create transparent tones. Contrary to popular belief, I find that all of the cadmiums, this one included, lift fairly well on an externally sized paper. The complementary color is ultramarine violet by Blockx, Schmincke, M. Graham, or Quiller. (Other brands are too red and will not gray out with the yellow.)

Cadmium Orange (PO 20)

I use this magnificent color for the yellow-orange note on my palette. It has a #1 lightfast rating. There is a lot of variation in this color from company to company: Some are more to the orange side and some are more to the yellow. I prefer the brands that are to the yellow, such as Quiller, Winsor & Newton, Blockx, or Sennelier. These colors neutralize well with the complement, ultramarine blue deep. Cadmium orange is considered to be an opaque color, yet it thins nicely and lifts pretty well on externally sized paper.

Cadmium Red-orange (PO 20)

Contrary to its name, this is the true secondary orange on my palette and is made by many manufacturers, including mine. Winsor & Newton's cadmium scarlet is the same color note. It grays out perfectly with its complement, phthalo blue. As a cadmium color, it is considered to be opaque, but cadmium red-orange thins nicely and lifts pretty well on externally sized paper. It has a #1 lightfast rating.

Cadmium Red Medium (PR 108)

This is the red-orange note on my palette. I find that I do not use this color a lot by itself, but rather I mix it with viridian green for earthy evergreen colors and with ultramarine blue deep or ultramarine violet for rich, neutralized violets. Its complement is phthalo turquoise. It is an opaque color that thins beautifully and lifts well on an externally sized paper. It has a #1 lightfast rating.

Quinacridone Rose (PV 19)

This is my primary red. Years ago I used alizarin crimson for this color note but I discovered that it did not have a permanent lightfast rating. Quinacridone rose is a beautiful red, a touch to the blue side, and complements well with viridian green. The synthetic organic quinacridone color family was developed in 1958 and has a #1 lightfast rating. It is a transparent and staining color that does not lift well.

Magenta (PV 19)

This is the red-violet color note on my palette. It is a quinacridone color and is the same color note as many of the quinacridone violets. I mix it a lot with cadmium orange for neutralized earthy warm tones and with phthalo turquoise for neutralized violets. Its complement is permanent green light. However, it is important to use the right brand of yellow-green, as many are too yellow and will not neutralize with magenta. These complements give a beautiful neutral. I use these two colors and their families for tropical or rain forest areas, their vegetation, and grayed fog. This transparent color is a staining synthetic organic paint that does not lift well and has a #1 lightfast rating.

Ultramarine Violet (PV 15)

This is the essential secondary violet color note on my palette and has a #1 lightfast rating. It is one of the few colors for which it is critical to have the right brand. At the present time Quiller, Blockx, and M. Graham are the manufacturers that make the color to the blue side, so that it neutralizes well with cadmium yellow light. I use this color constantly, graying it out with the yellows, mixing it with the oranges for warm earthy semi-neutrals, and mixing it with the greens for cool semi-neutrals. A neutralized blue can be made by mixing ultramarine violet and viridian green. Ultramarine violet is a transparent, inorganic color but granulates well and lifts very well.

Ultramarine Blue Deep (PB 29)

This is the blue-violet color note on my palette. It is a luminous red-blue that simply glows. Ultramarine blue deep and French ultramarine are essentially the same and either can be used. Ultramarine blue light can be somewhat greener, and I would not choose it. I use this color more than any other blue. It neutralizes perfectly with cadmium orange. Ultramarine blue deep is considered to be transparent. It is inorganic, lifts fairly well on externally sized paper, and has a #1 lightfast rating. Most brands of ultramarine blue deep do not granulate well. However, because of the stone-ground milling methods utilized, the Quiller signature paint granulates better than any other paint I have tried.

Phthalocyanine Blue (PB 15.3)

This is my primary blue. Most manufacturers call this color by the company's brand name; thus Richeson blue, Winsor blue, Rembrandt blue, and so forth are simply phthalo blue. Recently some manufacturers have been making a phthalo blue, green shade, and a phthalo blue, red shade. If you have these colors, use the former. Phthalo blue complements with cadmium red-orange. It is a transparent, staining, synthetic organic color that does not lift well but has a #1 lightfast rating.

Phthalocyanine Turquoise (PG 7, PB 15)

I use phthalo turquoise for my blue-green color note. It is simply a mix of phthalo green and phthalo blue, but it is an important transparent, staining, synthetic organic color. It does not lift well but has a #1 lightfast rating. Its complement is cadmium red medium. This color simulates aqua greens of the sea and can make powerful darks when mixed with most colors, including quinacridone rose, magenta, ultramarine violet, ultramarine blue deep, cadmium red-orange, and cadmium orange.

Viridian Green (PG 18)

This is my secondary green color note. Viridian green is somewhat gummy and weak but I really like it and literally go through tubes of it. Far and away my favorite brand for this color is M. Graham. For some reason M. Graham's color has more strength, granulates well, and reconstitutes more easily than others I have used. I see it as a gentle color that works well for mixing the greens of nature. It is a transparent, inorganic color that granulates well and lifts nicely on an externally sized paper. It complements well with quinacridone rose to give a cool neutral. Viridian green has a #1 lightfast rating.

Permanent Green Light (PG7, PY 151)

This is the yellow-green color note on my palette. This is one of the few colors for which is important to get the right brand. Most are too yellow and will not neutralize well with the complement, magenta. Quiller and M. Graham are two brands that will. Permanent green light is a transparent, staining synthetic organic color that will not lift well. There are so many greens in nature, and I find that by mixing this color with each of the other eleven colors on my standard palette, virtually any green can be mixed. It has a #1 lightfast rating.

The Expanded Universal Palette

Although every color imaginable can be mixed using the twelve-color palette, it is sometimes beneficial to use additional pigments, as the granulation, transparency, opacity, or other visual qualities that they offer cannot otherwise be duplicated. The expanded universal palette actually contains twenty-seven colors (the original colors from my twelve-color universal palette, which we discussed on pages 17–19, plus the additional fifteen colors listed on the following three pages). This palette allows me to mix any color I want as well as create any atmospheric effect or feeling for light that I am after.

This expanded universal palette features a variety of organic and inorganic colors, so I can apply beautiful transparent washes as well as granulating textures. The titanium white watercolor in the upper-right corner also allows me to mix translucent and somewhat opaque versions of colors. It works much better than gouache, as the paint has more gum arabic and therefore will not flake. All of these colors have a #1 lightfast rating. This is a truly comprehensive universal palette.

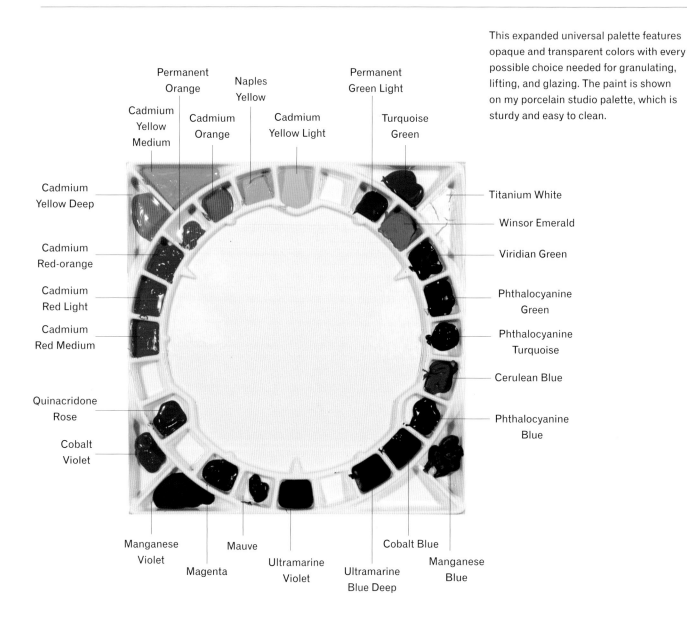

This expanded universal palette features opaque and transparent colors with every possible choice needed for granulating, lifting, and glazing. The paint is shown on my porcelain studio palette, which is sturdy and easy to clean.

Naples Yellow (PW 4, PY 35, PY 42)

This is one of my favorite and most-used colors. I use it to capture the soft, golden sunlight that I see and feel when painting many coastal regions. I also add it to different color mixes to give the paint a bit more body, as it is opaque. With Naples yellow it is important to use a brand that is very yellow. Some brands make this color with more orange, so it cannot be mixed with green to make a fresh color. Brands such as Quiller, Blockx, and Sennelier work well. Its complement is ultramarine violet by Quiller, Blockx, Schmincke, or M. Graham, and the mix gives an exquisite soft gray. The color is a mix of organic and inorganic pigments. It is opaque but lifts nicely and has a #1 lightfast rating.

Cadmium Yellow Medium (PY 35)

This inorganic color is considered to be opaque but lifts pretty well on externally sized paper. I love this color and actually use it more than cadmium yellow light. It is rich and mellow. I use ultramarine violet by Quiller, Schmincke, M. Graham, or Blockx as the complement. I often place this color next to ultramarine blue deep on my paintings, both at pure hue. Cadmium yellow medium has a #1 lightfast rating.

Cadmium Yellow Deep (PY 35)

I keep a number of cadmium yellows on my palette, but in truth, if I only had cadmium yellow light and cadmium orange, I could easily mix the in-between colors. When I am painting something with a predominantly yellow theme, such as sunflowers, however, it is nice to have these straight pigment choices readily available. Cadmium yellow deep is a rich orange-yellow color. Its true complement is somewhere between ultramarine violet and ultramarine blue deep. I usually use ultramarine violet, but the neutral comes out somewhat warm. It is an opaque, inorganic color that lifts nicely on an externally sized paper. It has a #1 lightfast rating.

Permanent Orange (PO 62)

I began using this hue a few years ago, and I really like it. While permanent orange is slightly more orange than cadmium orange (and while I like to keep both colors on my palette), it can be used as a nontoxic substitute for its cadmium counterpart, as the yellow-orange color note. It is a transparent, synthetic organic color that has a pristine purity. It neutralizes perfectly with ultramarine blue deep. It has a #1 lightfast rating.

Cadmium Red Light (PR 108)

This color note varies from brand to brand. Some brands are a bit redder and some a bit more orange. I like the more orange paint made by such brands as MaimeriBlu. It is opaque, lifts fine with an externally sized paper, and has a #1 lightfast rating. Its complement is cerulean blue. This combination mixes to a beautiful soft neutral that is effective for winter scenes.

Cobalt Violet (PV 14)

I go through more tubes of cobalt violet than any other color. It is an inorganic opaque color that granulates very effectively, giving a great textural quality on a rough paper. It lifts very well and has a #1 lightfast rating. Make sure when you purchase this color that its chemical makeup is PV 14; some brands sell artificial cobalt violet, and, although it may simulate the color note, the paint does not granulate. Monet used cobalt violet continually in his later work and declared that he had found the color of the atmosphere—"violet"—by mixing cobalt violet with chromium oxide green. I like to use viridian green or phthalo green to complement this color. The neutral is a bit to the blue side, but it is beautiful. I also mix cobalt violet with Winsor emerald to create a gentle gray. This is the only color that I squeeze out fresh each time it is needed. Otherwise it hardens in the pan and is very hard to reconstitute.

Manganese Violet (PV 16)

I have been using this color recently. In many ways it is similar to cobalt violet but it is deeper, not as "pink," and has a more natural feel. It also reconstitutes easily when dry in the pan. This inorganic color is opaque, has a #1 lightfast rating, and lifts well. It offers a beautiful granulation. I like to mix it with cerulean blue or viridian green. Its complement is permanent green light by Quiller or M. Graham.

Mauve (PV 23)

This color was named after Antoine Mauve, a French painter of the late 1800s who frequently used violet in his work. It is another color that I have recently been using on my palette, as it is powerful, deep, and rich. My manufacturer gives it a #1 lightfast rating. It is an organic, transparent, and staining color. I combine it with phthalo green for blackish-blue to blue-green darks. Its complement is permanent green light.

Cobalt Blue (PB 38)

This color is on my expanded palette, but in truth I use it only occasionally. It is very expensive and is the purest blue available (as it is neither to the red nor to the green side of the primary blue), but somehow I keep gravitating to other blues—ultramarine blue deep, phthalo blue, and cerulean blue. Cobalt blue is considered an inorganic, transparent, and slightly liftable color with a #1 lightfast rating. Its complement is permanent orange.

Manganese Blue (PB 33)

Although this color was recently discontinued I am hopeful that it will be reintroduced. It is inorganic and transparent, has a #1 lightfast rating, and lifts extremely well. Its complement is cadmium red light. Some manufacturers make manganese blue *hue,* which means imitation. True manganese blue is a rich blue-green, but what makes the color unique is its impressive granulation quality; it mixes nicely with cobalt violet, manganese violet, and viridian green.

Cerulean Blue (PB 35)

This is a cloudy, opaque, inorganic blue with a #1 lightfast rating. The paint made by the Quiller brand granulates nicely and lifts very well. I use cerulean blue a lot and find its complement is cadmium red light. This combination gives a soft, beautiful neutral. I use it to represent the gray atmosphere of Colorado winters. I use it with cobalt violet and Naples yellow when painting marble statues and occasionally some of the mountain areas where I live. These three colors mix to a nice gray and lift easily.

Turquoise Green (PB 36)

This color is sometimes called cobalt turquoise and can be substituted for my blue-green color note (phthalo turquoise) if I want an opaque and granular visual quality. (The Quiller brand granulates particularly well.) Turquoise green complements with cadmium red medium. I do not use the color often, but when it is needed nothing is better. I especially like its sedimentary visual quality when it is applied wet with a quinacridone rose (or when mixed with either manganese violet or ultramarine violet) on a rough paper. It has a #1 lightfast rating.

Phthalocyanine Green (PG 7)

This color, like its cousin, phthalo blue, is usually called by the manufacturer's name. Thus Blockx, Grumbacher, Richeson, and Sennelier greens are simply phthalo green. I keep this on my palette next to viridian green. Both serve as my secondary green, but (as I discuss on pages 36–37) I use them very differently. Phthalo green does not lift well and has a #1 lightfast rating. Its complement is quinacridone rose.

Winsor Emerald (PG 7, PY 175, PW 4)

This color is a mix of inorganic and synthetic organic pigments (phthalo green, bismuth yellow, and titanium white). Winsor Emerald has an opaque visual quality, lifts nicely, and has a #1 lightfast rating. I use cobalt violet for its complement and this mix gives a beautiful soft neutral.

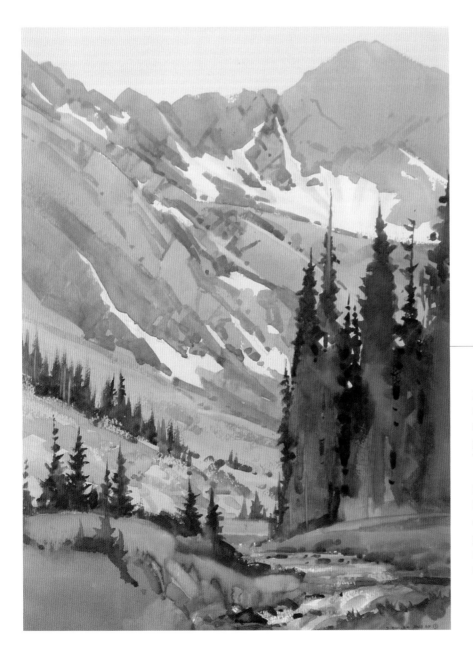

High Valley, Upper Huerfano, 29 x 21 inches (73.7 x 53.3 cm), watercolor on 300-lb. rough Richeson Premium watercolor paper, Collection of Chester and Margaret Wallace

I painted this image of the Sangre de Cristo Mountains in southern Colorado with a mix of cerulean blue, cobalt violet, and Naples yellow. The cooler, distant mountain has more cerulean while warmer, closer passages favor Naples yellow.

Nontoxic Color Alternatives

Cadmium colors are rated as toxic by the American Society for Testing and Materials (ASTM). While I have used, and continue to use, cadmiums in my work, some painters prefer to substitute nontoxic colors. The following colors are alternatives for the cadmium pigments that appear on the expanded universal palette.

While these paints often have the same color note as their cadmium counterparts, they have different visual qualities; in general, they tend to be more transparent. Therefore, you might actually choose to use both the cadmium and cadmium alternative. I do this with permanent orange. While it can serve as a nontoxic alternative to cadmium orange, I find that it serves a unique purpose, so I regularly keep this paint on my palette (which is why I've shown the swatch on page 21 and not here). The only cadmium color for which I have not found a substitute is cadmium yellow deep.

I have included indanthrene blue in this list because it is the natural complement to permanent orange, the substitute for cadmium orange.

Bismuth Yellow (PY 184)

This is a synthetic organic, transparent, and staining yellow. It has a #1 lightfast rating, and it can substitute for the primary yellow on my palette, cadmium yellow light. Its complement is ultramarine violet by Quiller, Blockx, Schmincke, and M. Graham.

Transparent Yellow Medium (PY 154)

This is a synthetic organic, staining, transparent color that can be used instead of cadmium yellow medium. It has a #1 lightfast rating and has some lifting ability on externally sized paper. Its complement is ultramarine violet by Quiller, Blockx, Schmincke, and M. Graham.

Vermilion (PO 73)

This synthetic organic, transparent, and staining pigment is very new to the paint industry. It is reputed to have a #1 lightfast rating, but official results are not yet in. A true vermilion is an organic pigment that is not totally lightfast. This color is strong and powerful and can substitute for cadmium red-orange. Its complement is phthalo blue.

Richeson Red Light (PR 254)

This beautiful synthetic organic color is a member of the pyrrole family. It is transparent, staining, and has a #1 lightfast rating. It has solid coverage power and is a good color substitute for cadmium red light. In fact, I personally use this color more than cadmium red light. Its complement is cerulean blue.

Permanent Red (PR 170, F3 RK-70)

This synthetic organic transparent nonlifting color is a member of the naphthol color family. It is a good substitute for cadmium red medium. It is a powerful red, so a little goes a long way. Its complementary color is phthalo turquoise. It has a #1 lightfast rating and stains well.

Indanthrene Blue (PB 60)

This is a synthetic organic, transparent, and staining red-blue that can substitute for ultramarine blue deep. It has a #1 lightfast rating, and its complement is either cadmium orange or permanent orange. Most painters who use indanthrene blue use permanent orange for the complement because it is also a transparent color.

What is art? It is the expression of your inner being. Today many artists paint pictures instead of expressing their own uniqueness. You need to get to your inner spirit and get that mark down. It is your mark. Choose a subject that you connect with. Any subject. It is important that you have knowledge of the subject so you can let yourself go. When you paint what you do not know, you struggle with the external and cannot get past that.

The Earth Colors and Semi-neutrals

I like mixing the semi-neutral colors rather than having the actual pigments on my palette because this gives me so many more choices. For instance, instead of having the tube color raw sienna, I can premix the color using permanent orange and ultramarine blue deep. But I can also take these same two colors and charge one into the other or glaze one over the other and in essence achieve the same color note but create many more exciting visual qualities.

Nevertheless, many painters use these colors, and so on the following two pages I have provided more complete information on them. Most of the earth colors are actually mineral or inorganic colors and many do come from the earth. The pigments are somewhat heavier than the organics and thus many will granulate; they also tend to lift well.

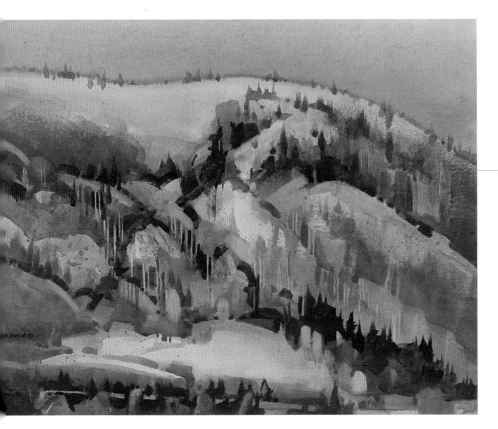

Mountain near Ivy Creek, 18 x 26 inches (45.7 x 66 cm), watercolor on 300-lb. rough Richeson Premium watercolor paper, Courtesy of Quiller Gallery

I began this image with a totally neutral gray sky and lifted back and glazed over many of the greens and red-violets. The painting centered around pattern and rhythm and my personal mark.

Yellow Ocher (PY 42)

This often-used earth color is a slightly neutralized yellow-orange. It can be created by mixing cadmium orange and a touch of ultramarine blue deep. (If you're not using cadmium colors, this color can be created by mixing permanent orange and either indanthrene blue or ultramarine blue deep.) It is an inorganic pigment that does not granulate much, but it does lift well and has a #1 lightfast rating. Its complement is ultramarine blue deep.

Raw Sienna (PBr 7)

This earth color is a bit more neutral than yellow ocher; it is also a slightly heavier pigment and so will granulate some. Like yellow ocher, raw sienna can be made by mixing cadmium orange and ultramarine blue deep; a touch more of the blue is needed. (If you're not using cadmium colors, this color can also be made by mixing permanent orange and either indanthrene blue or ultramarine blue deep.) It is an inorganic pigment that lifts well and has a #1 lightfast rating. Its complement is ultramarine blue deep.

Burnt Sienna (PBr 7)

This is one of the most-often-used earth colors. This inorganic pigment lifts well, granulates, and has a #1 lightfast rating. However, the pigment varies a bit in color, depending on the brand; some are browner and duller, but I prefer the oranger and brighter tone of the Quiller brand. The complement of burnt sienna is ultramarine blue deep; they mix to a beautiful gray, create a good range of values from dark to light, and granulate well. John Singer Sargent used these two colors constantly in his watercolor paintings.

Venetian Red (PR 101)

Some manufacturers name this color light red or English red. It is considered to be opaque yet staining, provides some granulation, and has a #1 lightfast rating. It is a rich and powerful color that complements well with phthalo blue.

Sap Green (PG 7, PY 154)

This mixed color is made differently by many companies. The color note featured here (and listed in the color index generic names above) is the one used for the Quiller brand. Both of the pigments used (Azo yellow light and phthalo green) are synthetic organic, transparent, and staining, and have a #1 lightfast rating. Its complement is mauve.

Hooker's Green (PY 42, PG 7)

This is a slightly more neutralized and deeper color than sap green. There is a lot of variety among manufacturers in terms of how this color is made. Some companies mix viridian green with yellow ocher, in which case the Hooker's green lifts and granulates. The Quiller brand mixes phthalo green and yellow ocher, producing a more transparent and staining color. It has a #1 lightfast rating. The complement is either magenta or manganese violet. I prefer manganese violet because it granulates so well.

Chromium Oxide Green (PG 17)

This inorganic color is opaque, very dull, and neutralized. This green also stains, and the chromium pigment is considered toxic, but it has a #1 lightfast rating. Its complement is quinacridone magenta.

Terra Verte (PG 23, PY 42)

Again, this is a mixed, earthy color and there is a lot of variety among manufacturers in terms of how it is made. The common pigment is a terra verte color that is inorganic, transparent, and granulating, but has a #1 lightfast rating. It is a particularly weak color that complements well with mauve.

Prussian Blue (PB 27)

This synthetic inorganic pigment is a slightly more neutralized version of the phthalo blue color note. This beautiful color has a touch of a metallic sheen if used very heavily. It is staining, transparent, and (with a #2 rating) is not as lightfast as the phthalos. Its complement is cadmium red-orange.

Mixing Your Own Earth Colors and Semi-neutrals

The following four color swatches demonstrate the choices that are available by mixing colors on the expanded universal palette as opposed to using a tube color. It may take some experimentation to get used to this system, but once you understand how to work with your palette in this way, you can mix all of the earth colors and semi-neutrals and create a wonderful range of visual effects.

This is raw sienna from a tube. It is a natural earth color that has some granulating qualities and lifts well.

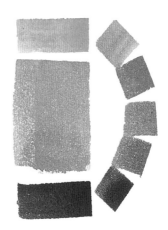

Here I mixed a raw sienna using cadmium orange (on the top) and ultramarine blue deep (on the bottom). As you can see, mixing these two colors created the raw sienna color note as well as warmer, more neutral, and cooler colors.

Here I charged ultramarine blue deep into a wash of cadmium orange. Again, this created a raw sienna color note. However, the interaction of the two charged colors also provided a mingling of pigments and some granulating visual quality.

Here I placed down a flat, even wash of cadmium orange and let it dry. Then I glazed a wash of ultramarine blue deep thinly over the undercolor. Where the colors overlap it created a raw sienna color note, but this color has a completely different visual quality than the tube color.

The Visual Qualities of Watercolor Paint

To best express his or her vision, an artist must understand the character of the paint that is on the brush—namely, whether it is sedimentary and granulating or transparent and staining. Simply put, if these two properties of paints are used well, they can create incredible texture, visual juxtapositions, and luminosity. In this section I discuss what these paints are about and how to utilize them in a composition. Again, we go back to the fundamental distinction between inorganic and organic pigments (as described on pages 16–17); the former tend to be granulating, and the latter tend to be staining.

Sedimentary, Granulating Colors

As a rule of thumb, inorganic paints tend to create rich, textural effects. There are two categories of inorganic paints. The first includes the mineral colors, such as the cobalts, cadmiums, and manganeses. The second includes earth colors such as the ochers, siennas, and umbers. Both mineral and earth pigments are hard to grind.

The paint I use, the Stephen Quiller signature line imported by Jack Richeson and Company, is manufactured by a small European mill that has been making paint since the 1860s. While other manufacturers have mechanized their paint-making process with the use of steel rollers for the milling of the pigment, my paint is made with a triple roller, employing the traditional, stone-ground milling process, which grinds the pigments to between 2 and 8 microns. I feel this adds greatly to the character of the paint.

In general, inorganic pigments are heavier and more coarsely ground than their organic counterparts. In fact, an equal amount of an inorganic color, such as cobalt violet, can weigh twice as much as an organic color, such as phthalo green. This means two things. First, inorganic pigments settle on the surface of the paper rather than seeping into the fibers of the support, which means that the pigments can be lifted more easily after the paint has dried. Second, the pigments sink quickly to the recessed pockets of the paper when applied with a wet wash, which means that they will have a sedimentary visual quality.

The most commonly used granulating colors are featured below. The swatches are designed to demonstrate their granulation. Complete discussions about the colors themselves can be found on pages 18–19, 21–23, and 26–27:

Cobalt Violet

Cerulean Blue

Manganese Violet

Viridian Green

Ultramarine Violet

Ultramarine Blue Deep

Turquoise Green

Burnt Sienna

Manganese Blue

Maximizing Visual Impact with Granulating Watercolors

When working with sedimentary, granulating watercolors, keep in mind the following tips:

For the most pronounced visual quality, use a rough, heavyweight (140-lb. or 300-lb.) watercolor paper. I use the heavier paper for all of my painting, and I particularly like paper that has an organic, rough texture. Richeson Premium watercolor paper is my favorite (particularly the 300-lb., rough variety), but Waterford, Arches, and Fabriano Artistico rough papers can produce exceptional results as well. The roughest textured paper I have found is a very expensive handmade Fabriano paper called Esportazione. It comes in different weights and could be a lot of fun to work with using aggressive and loose paint applications.

Keep the paper flat or at a very slight angle. If the paper is vertical or close to vertical, the pigment cannot sink to the recessed pockets of the paper. Some granulation may still show, as the pigment will catch on the edge of the pockets of the paper, but it will not be very pronounced.

The wetter the paper is, the more the granulation will show. If the paper is very wet, the particles of the pigment will have more time to sink in. Thus a wet-on-wet paint application is particularly effective for this visual quality. However, a wet paint application on a dry paper can work as well. Of course, a dry brush paint application will not show the sedimentary quality.

Agitate the paint and paper while it is wet to create a distinct granulating visual quality. This technique is best performed if the paper is horizontal and the surface is still wet. The shaking movement allows the clear water to wash the pigment from the ridges of the paper and push more of the pigment to the recessed areas.

Apply a wet wash directly on dry paper for a unique effect. To obtain the best results with this technique, keep the paper flat or at a slight angle. Charge your brush with granulating paint. The brush must hold enough water so that when it is applied to the dry paper the stroke will be juicy wet. This will give the granulating pigment time to sink into the recessed pockets of the paper.

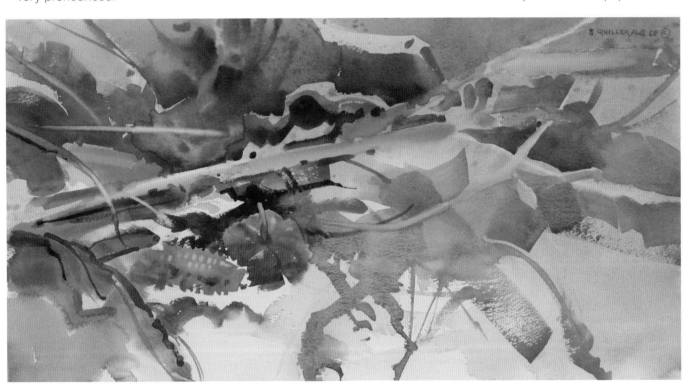

Harvest Still life, Pumpkin and Corn, 14¾ x 29 inches (37.5 x 73.7 cm), watercolor on 300-lb. rough Richeson Premium watercolor paper, Courtesy of Quiller Gallery

I created most of the washes for this still life demonstration with a very wet brush on dry paper using a lot of granulating pigments, including cobalt violet, manganese violet, cerulean blue, and some ultramarine violet.

APRIL 10, 2007

The sedimentary colors can be mixed together to create wonderful effects. Here are three mixes I use frequently, but many other combinations work well.

Cobalt Violet and Cerulean Blue

This combination granulates beautifully and creates a soft, slightly neutralized violet tone. This is because cerulean blue is to the green side, so it slightly neutralizes the red-violet of the cobalt violet.

Viridian Green and Cobalt Violet

I love this combination and use it a lot. Both colors granulate and lift nicely; when mixed together they produce a soft and beautiful neutral that is just a touch to the violet side.

Burnt Sienna and Ultramarine Blue Deep

This color combination is used probably more than any other. In fact, most of John Singer Sargent's "grays" were mixed this way. One is warm and one is cool, and both can give rich color and strong, dark value. Granulation can be achieved with this pair, but again it depends on the brands of paint used.

I just returned from a painting trip and workshop on the main island of Hawaii. On the last day two painting friends took me to a botanical garden on the windward side of the island. We took a walk in the garden. At a twist in the path some foliage patterns and incredible red and green color grabbed me. I could have been at this spot for a week painting close-up and distant views! At times such as this, painting is magic.

Wisdom and Sealing Wax Palm, Hawaii, 29 x 21 inches (73.7 x 53.3 cm), watercolor on 300-lb. rough Richeson Premium watercolor paper, Collection of Yoon and Angela Chang

I started with a neutral wash of cobalt violet and viridian green. These two sedimentary colors became the keynotes. Everything else in the image revolved around these initial notes.

Sedimentary Wash Studies

Select a number of inorganic paints, such as cerulean blue, burnt sienna, cobalt violet, and ultramarine blue deep. Saturate a small sheet of rough 140-lb. or 300-lb. watercolor paper with water. Keep the paper flat or close to flat. Load a 1-inch brush with a generous amount of one of the pigments and charge the wet paper. While the paper is still damp, shake the painting board. Repeat this process with the remaining paints. Allow the watercolor paper to dry and study the difference in granulation.

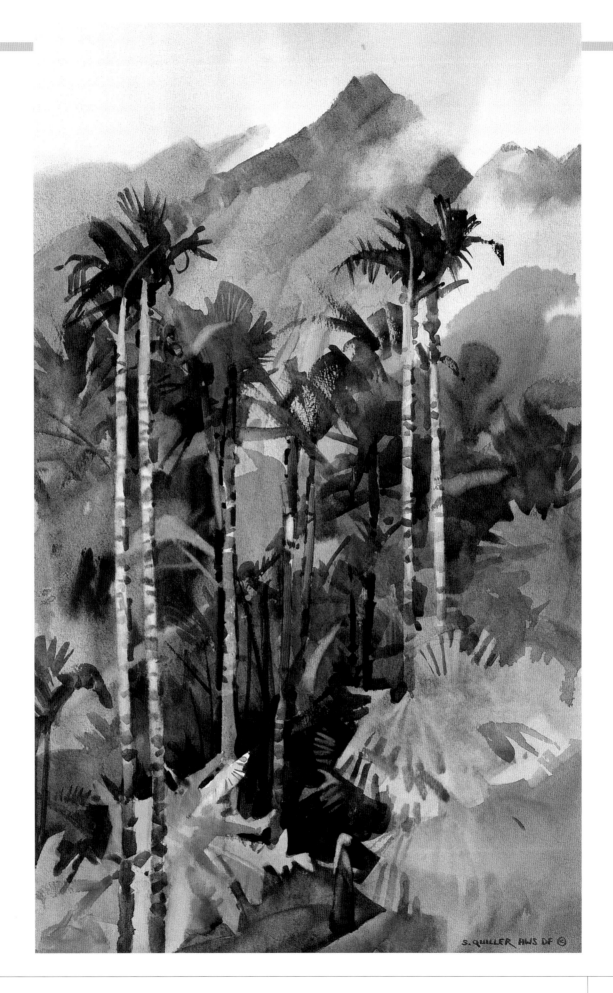

Transparent, Staining Colors

In general, organic paints tend to provide strong, luminous color. This is because the paints are transparent, which allows light to filter through the pigment and reflect off the paper. As mentioned earlier, there are two kinds of organic pigments: natural organic and synthetic organic. Natural organic pigments are made up of either vegetable or animal matter; examples include alizarin crimson, rose madder genuine, and the natural gamboges. Synthetic organic pigments are the largest category of artists' pigments manufactured today, and most of these colors are extremely lightfast. Examples include phthalo blue and green, the quinacridone colors, and permanent orange.

Contrary to popular belief, synthetic organic pigments are not manufactured from dyes but are in fact finely ground particles of pigments that are dispersed and suspended in water. The European mill that manufactures my paint grinds each pigment particle to approximately 0.1 micron. (A micron is one millionth of a meter or one thousandth of a millimeter.) It is hard to imagine how minute this actually is.

In addition to having extremely small particles, all organic pigments are light in weight. (Sometimes organic pigments are twice as light as their inorganic counterparts.) This means two

Staining Wash Studies

Select a variety of synthetic organic watercolors, such as quinacridone rose, phthalo green and blue, and permanent orange. Place the painting board at a slight angle and saturate a small sheet of rough or cold press watercolor paper with water. Using a large, flat brush, wash with an even medium-value tone of one color from top to bottom. Repeat with the other colors. Let the paper dry. Notice that the paper is stained evenly and does not show any sedimentary quality.

things. First, organic pigments remain evenly dispersed and suspended in water; therefore they evenly coat the paper, providing a flat and even tone with no visible sediment. Second, because the pigments are so fine, they stain the paper, both coating the surface and seeping into the paper fibers. Thus these pigments will not lift easily. This means that when the paint is dry a subsequent wash or glaze can be applied over the paint without the color lifting readily.

Below are some of the transparent colors that I use on my palette. Full descriptions of the visual characteristics of these colors can be found on pages 18–19, 21–23, 24, and 26–27.

Bismuth Yellow	Permanent Orange	Richeson Red Light	Magenta
Transparent Yellow Medium	Vermilion	Quinacridone Rose	Mauve

OCTOBER 14, 2005

e color dominance of our area shifts with
seasons. In the spring, when the aspen
es are emerging, it is yellow-green and
-violet. In the summer, with daily showers
deep opaque skies, the palette turns to a
blue-violet, violet, and deep green. In the
umn, the aspen-covered mountains shift
color choice to yellow and violet and their
ilies. And in the winter, with a blanket of
v, the warm light and strong shadows shift
palette to orange and blue.

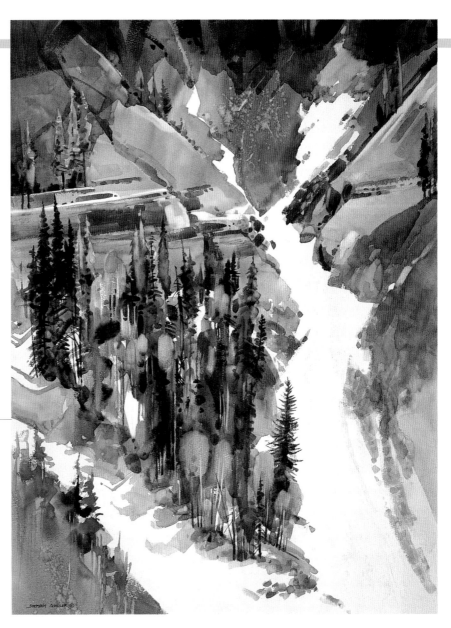

Snow Slide Patterns, Wolf Creek Pass, 29 x
21 inches (73.7 x 53.3 cm), watercolor on
300-lb. rough Lanaquarelle watercolor pa-
per, Collection of Dr. Howard Stringert

I created this work on-site in late May in the
southern San Juan Mountains of Colorado.
Transparent colors helped me capture the
feeling of light.

Indanthrene Blue

Phthalocyanine Turquoise

Permanent Green Light

Phthalocyanine Blue

Phthalocyanine Green

The Twelve-color Transparent Palette

Many artists want a palette with totally transparent colors. These are painters who are staying away from either opaque colors or toxic colors or painters who work with thin glazing layers and therefore do not want to use pigments that lift easily. The twelve-color transparent palette features these kinds of colors; yet it has the same primary, secondary, and intermediate color notes as my more painterly palette and so can be used to mix any color imaginable. Refer to pages 18–19, 21–23, and 24 for the swatches for these twelve colors.

Staining and Sedimentary Wash Studies

Select a staining transparent color such as quinacridone rose and a sedimentary paint such as turquoise green. Generously wet a small sheet of rough watercolor paper and brush in the transparent color. While the paint is still wet, charge in a generous amount of the sedimentary color. Let the paint settle and separate and notice the beautiful visual quality of the interaction of the two colors. Repeat with other color combinations.

Here is my twelve-color transparent palette, shown on my porcelain studio palette. The colors are arranged just like those on my twelve-color painterly palette on page 17.

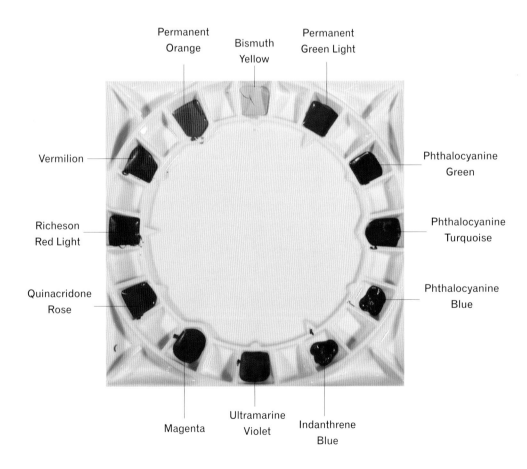

Permanent Orange

Bismuth Yellow

Permanent Green Light

Vermilion

Phthalocyanine Green

Richeson Red Light

Phthalocyanine Turquoise

Quinacridone Rose

Phthalocyanine Blue

Magenta

Ultramarine Violet

Indanthrene Blue

Knowing the unique characteristics of the individual pigments is the key to obtaining exciting visual qualities when combining different paints. Below are three studies that combine the contrasting visual qualities of granulating and transparent colors while using each to its advantage. In all three studies I started by wetting the paper's surface and then covering the paper with the transparent colors while the support was flat on the table. I then charged in the granulating pigments and let them settle while occasionally agitating the support. Notice how the transparent colors evenly coat the surface while the sedimentary colors sink into the pockets of the paper. I used a 300-lb. Arches rough paper for the studies in this exercise, and Quiller signature paint.

Bismuth Yellow, Permanent Orange, Ultramarine Violet, and Ultramarine Blue Deep

First I washed Bismuth yellow and permanent orange onto the surface of the paper. Then, while it was still wet, I applied the granulating colors ultramarine violet and ultramarine blue deep. Notice that the yellow and orange staining colors evenly tone the paper while the ultramarine violet and blue provide the textural, sedimentary pigments.

Vermilion, Richeson Red Light, and Cerulean Blue

After wetting the paper's surface, I coated the paper with the transparent colors vermilion and Richeson red light. While it was still wet I then charged in the sedimentary color cerulean blue. The staining colors provide an even, transparent underwash, and the heavier, more coarsely ground pigment sinks to give the blue-green granular visual effect.

Bismuth Yellow, Permanent Green Light, Cobalt Violet, Manganese Violet, and Ultramarine Violet

I began by coating the wet paper with the transparent colors Bismuth yellow and permanent green light. Then I immediately added the granulating colors cobalt violet, manganese violet, and ultramarine violet and let them settle on the flat surface. The yellow and yellow-green paints are transparent, staining colors and give an even undertone for the sedimentary complementary violet and red-violet colors.

I have both viridian and phthalo greens placed next to each other on my expanded universal palette. At first glance they seem to be the same color. However, these colors have very different properties and are useful for very different reasons.

Viridian green is a natural organic green, sometimes described as a weak and anemic color. It granulates nicely and also lifts well, as is demonstrated in the diagram. The paint made by a few companies dries rock hard and is impossible to reconstitute. Other companies actually add some phthalo green to their viridian green so that it reconstitutes more easily, but that defeats the purpose of using this color. The M. Graham viridian green is my favorite. Although the paint made by this brand reconstitutes fairly easily, I usually squeeze the color out fresh when I need it.

Phthalo green, on the other hand, is a synthetic organic green, and as such is a powerful staining color. When used by itself it can be somewhat acidic, and if not used well it can take over a paint-

ing quickly. However, when phthalo green is mixed with other staining colors, such as magenta, mauve, phthalo blue, or vermilion, it can be an almost-black warm or cool green. Since phthalo green is a transparent, staining color it can easily be used to glaze over previously painted areas.

Edge of the Pond features both viridian and phthalo greens. I did this painting on-site at one of my favorite places off the Shallow Creek Trail. It was during the spring run-off in May, and the area was bursting with greens. For most of the painting I used viridian green. On close inspection the color's granulation is evident in the water, in some of the color mixes in the foliage, and in the shadows in and around the beaver dam. Later I glazed in phthalo green, which I mixed with warm yellows, oranges, and reds to unify and give depth to the water. In the upper right reflection area I mixed the phthalo green with magenta to make an almost-black warm dark and to create the vertical, rhythmic spruce reflections.

Viridian green is a soft, natural green that will granulate and lift nicely.

Phthalo green is an intense green that is both staining and transparent. It mixes well with other colors on the palette for dark, powerful color notes.

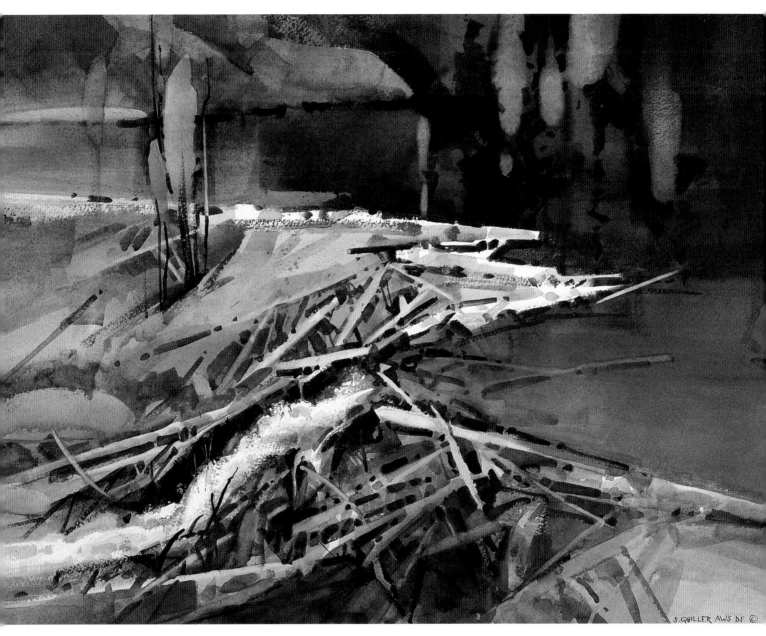

Edge of the Pond, 21 x 29 inches (53.3 x 73.7 cm), watercolor on 300-lb rough Richeson Premium watercolor paper, Courtesy of Mission Gallery

This subject is located off the trail of one of my favorite summer painting haunts. In this image green is a dominant color, allowing me to employ the varying characteristics of viridian green and phthalo green.

Taking a Closer Look: Using Naples Yellow, Cobalt Violet, and Cerulean Blue

I use Naples yellow, cobalt violet, and cerulean blue in many of my watercolor paintings. None of the colors is powerful or intense. This combination should not be used for subjects where strong contrast or intense darks are needed. I use these paints in many cases for aged architecture, stone walls, or marble statues.

Naples yellow is a soft yellow with some white in it. It has a chalky feel and lifts easily. Cobalt violet is a highly sedimentary color that also lifts well. Likewise, cerulean blue granulates nicely and lifts easily. When these colors are mixed, depending on which combination of two is emphasized, they create gentle oranges, violets, or greens. When all three colors are used equally, they create a beautiful neutral gray.

I created *Santa Croce Church, Christmas Market, Florence* on location. I set up at the edge of the square, close to the venders, and began painting. I had previously done a detailed line drawing of the façade and a compositional sketch. I wanted to capture the feeling of low backlight and the activity in the plaza. For the shadowed front of the building I used mainly cerulean blue and cobalt violet with some Naples yellow. I could easily lift highlights on the architecture with these colors. The sky is cerulean blue fading to Naples yellow. I painted the figures, tents, and details on the façade with other colors but returned to these three colors for the wet pavement.

Naples yellow, cobalt violet, and cerulean blue are soft, gentle pigments that lift easily. In addition, because the cerulean and cobalt violet granulate well, together the three colors create a beautiful gray.

Santa Croce Church, Christmas Market, Florence, 29 x 21 inches (73.7 x 53.3 cm), watercolor on 300-lb. rough Richeson Premium watercolor water, Collection of the Artist

I used Naples yellow, cerulean blue, and cobalt violet for much of this composition. These colors helped me capture the light of this late afternoon, the texture of the façade, and the dampness of the plaza on this bustling and festive winter day.

Naples Yellow, Cobalt Violet, and Cerulean Blue Studies

Set up a small still life of fruit or flowers. Squeeze out these three colors fresh on your palette. Use a rough sheet of watercolor paper and work fairly flat. As you paint the subject, use the colors juicy and wet. Let the paint granulate and lift back to create your highlights. Mix all three colors together to make a neutral gray.

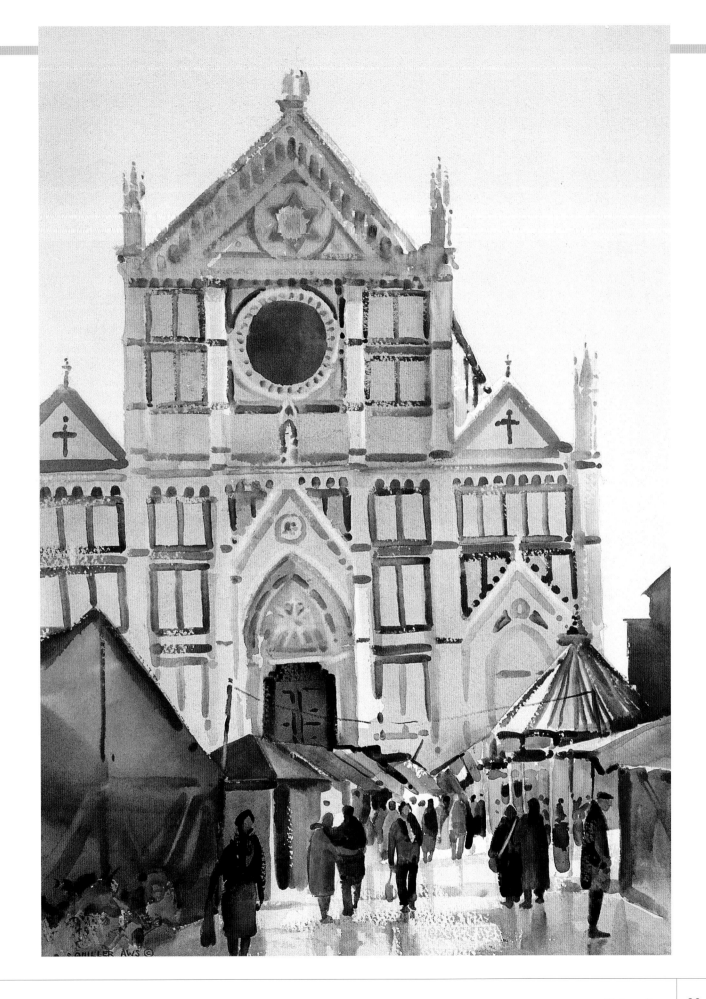

Orange Band, Winter Rhythm, 28 x 34 inches (71.1 x 86.4 cm), acrylic and casein on #5114 Crescent watercolor board, Collection of Bob and Gay Fields

This painting was inspired by the warm spring light along the river next to Cotton Wood Cove. I started with some on-site black-and-white studies. I then worked in the studio to complete the painting. I used a cold press watercolor board so that I would have a good layering flow between the media and also because it could best show the intense color of the painting. I started with a vibrant transparent yellow and orange acrylic underpainting and then worked entirely with casein, allowing some of the undercolor to show through.

$$\boxed{\text{CHAPTER TWO}}$$

Gouache, Acrylic, and Casein

THE ALL-ENCOMPASSING TERM "WATERMEDIA" includes any medium that utilizes water—either as its base or as a means to dilute the paint. Watermedia generally include watercolor, gouache, acrylic, and casein. While these four kinds of paint aren't all of the watermedia available, they certainly are the most known and used—and the media I have worked with since 1972.

My interest in these media began, at least partly, because of the landscape that I paint. In the early 1970s I moved to a small mountain village in southern Colorado. I loved getting out in the winter—both to cross-country ski and to sketch. Before then, like most painters, if I was painting a snow scene I would allow the white of the watercolor paper to represent a snowfield and I would paint the dark spruce trees on the white field. I worked light to dark, from background to fore-ground. However, as I spent more time outside in the brilliant, snow-filled days of winter, I started to see these shapes differently. I started to see the dark mass of spruce trees shaped by a white-yellow field that danced and formed patterns of light around as well as through the trees. I experimented by painting a large, dark transparent acrylic field in the general shape of the tree mass and then shaping the out-lines around the trees and pockets of light through the trees with white opaque gouache or casein.

Those early sensations have guided me on a life-long mission. I have spent the nearly forty years since that time exploring the visual qualities and unique handling characteristics of each of these media —and learning when and why to use each medium or combination of media. Now I simply think of myself as a painter who has chosen these media to express myself.

Watermedia painting has a long history, one that celebrates both its transparent and opaque applications. All of the most renowned

Whether I am using gouache, acrylic, or casein, my method of arranging the palette is the same. I fabricated a 24 x 20–inch palette by securing a white mat board to a double-strength piece of glass with duct tape. On the mat board I used a black felt marker to draw a large circle, around which I positioned my primary, secondary, and intermediate symbols. When I'm ready to paint, I place the tube color where it needs to be and use this palette just like my watercolor palette. I always have an atomizer handy to spray the paint and keep it moist.

If the paint dries out, regardless of whether it is gouache, casein, or acrylic, it cannot be reconstituted to have the body and paintability of the original paint. Thus, it is critical to keep the paint damp and fresh. I have devised a way to do this if I need to leave it for a while—for lunch or for an extended period of three or four days.

On the back of the table where I set my palette I have secured one edge of a large sheet of plastic with tape. When I am through with the painting session, I atomize the paint, set a water container in the middle of the glass palette, lay the plastic sheet over the glass palette, and then tuck the three loose edges under the glass, forming a sealed, airtight bubble. This setup provides a constant,

high-humidity environment that will keep the paint moist for days. When I am ready to begin painting again, I untuck the plastic sheet and let it hang behind the palette.

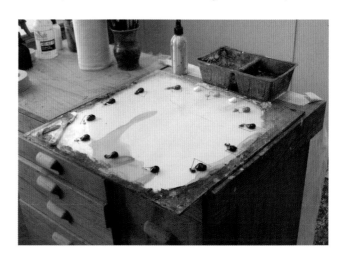

I set up my studio palette in this fashion. I keep this palette serviceable for up to a couple of days by cleaning the center, atomizing the paint with water, placing a water container (shown at the top of the palette) in the center, and covering the entire palette with a plastic sheet.

watercolor painters, including J. W. M. Turner, William Blake, Samuel Palmer, John Ruskin, Arthur Melville, Thomas Moran, James McNeil Whistler, Winslow Homer, John Singer Sargent, Charles Burchfield, and John Marin, applied opaque alongside transparent paint to enhance the visual qualities in their work. Simply stated, to these painters it was a painting first, and they used any method that would help them express their vision, as long as the media were compatible and permanent.

Most watermedia painters have a solid foundation in transparent watercolor painting. We are used to the various technical applications, such as wet paint on wet paper, wet on dry, and dry on dry. When an artist has this foundation, it is fairly easy to learn to paint in the other watermedia. This is because the artist can take more liberties with these media, not only painting light to dark but dark to light, opaque as well as transparent.

At least one-third of my painting is transparent watercolor. The rest of my work experiments with watercolor, gouache, acrylic, casein, and their combinations. In each of the sections that follow I present the palette that I use for that particular medium. As I did with the watercolor palettes in the previous chapter, each color on all three palettes is examined in depth. The accompanying illustrated examples feature (from left to right) the main color at pure hue, a gradated semi-neutral wash of the color and a neutral color note (both of which are created with the pigment's complementary color), and the pure complementary color. The corresponding text describes the characteristics of each medium, clarifying the range of visual effects that can be achieved using it. Learning about and using these watermedia will be fun, exciting, and most importantly will add to your vocabulary as an artist.

The Visual Qualities of All Watermedia

Before examining each of the watermedia, I want to discuss the various visual qualities that they can offer. A cerulean blue is the same pigment in watercolor, acrylic, gouache, or casein. What makes the visual quality different is the *binder.* Thus, the pigment in a milk-based casein will have a different appearance than the same pigment in the polyresin-based acrylic. Further, while each medium uses a different binder, the quality of the pigments can vary from brand to brand. Thus a cadmium orange in one brand of acrylic, for instance, can shift a bit more to the red side or to the yellow side than another brand.

All three of the media to be discussed (gouache, acrylic, and casein) can be used to create a variety of visual qualities—from transparent to translucent to opaque. The following study demonstrates these visual qualities. The play of these different qualities in combination is what bestows stimulating and exciting visual qualities on a painting.

Transparent The transparent visual quality occurs when a thin veil of color is stroked on a support. The color of the support (generally, white) influences how you see the color. Light penetrates through the veil of paint, reflects off the support, and travels back to the eye. In the example shown here, I first wet the paper, applied a thin wash of pyrrole orange, and charged quinacridone magenta acrylic into the orange. The lines point to the areas where the color is transparent. The white of the paper influences transparent layers of color; notice how lively, luminous, and intense the orange and red-violet are. White paint is never added to a transparent application.

Opaque Opaque is the opposite of transparent. The paint is thick enough that the pigment covers the white paper, allowing light to bounce directly off the paint. White paint can be mixed with the opaque application to lighten or tint a color. The lines in the example below point to the opaque blue areas. Notice how the opaque casein cobalt blue paint sets off the transparent paint and makes it even more luminous.

Translucent I describe translucent as a visual quality somewhere between transparent and opaque. It has the look of a cloudy veil. Webster's dictionary describes translucent as "letting light pass but diffusing it so that objects on the other side cannot be distinguished; partially transparent, as frosted glass." In the example below, I mixed a thin, cloudy wash of cobalt blue and white casein and applied it over much of the warm orange and red-violet color. However, I left some of the transparent warm color open. The translucent wash diffuses the undercolor but makes the untouched orange and red-violet even more lively. On the left side I applied the same translucent blue and white wash over a dark blue-violet area. Here the translucent application has a "frosty" visual quality.

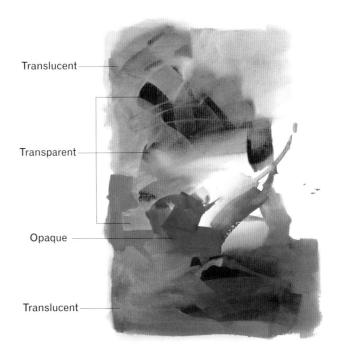

I have spent my painting career working with the visual qualities of the various watermedia—watercolor, gouache, acrylic, and casein. When the media are applied to different painting supports, a range of qualities—from transparent to opaque—can be created.

Gouache

The word gouache is derived from the Italian term *guazzo* (meaning water paint, splash), as it is a type of paint that consists of pigment suspended in water. Gouache uses a gum arabic binder, the same binder used for transparent watercolor. However, with gouache paint the pigment is ground into much smaller particles, and an inert, white pigment, such as chalk, is added. Consequently, the concentration of pigment is very dense, giving the paint body or opacity.

Since the Renaissance, artists working on toned paper with ink wash and line have used gouache for white highlights. William Blake, Samuel Palmer, David Cox, Peter De Wint, and J. M. W. Turner are among the many British painters who used gouache extensively in their painting repertoire. Henry Farny, Thomas Moran, Winslow Homer, John Singer Sargent, Maurice Prendergast, and James McNeill Whistler are some of the American painters who used this medium.

Gouache is the most opaque of the watermedia. Brilliant white or pure-hue colors can be painted over a dark area and they will hold their richness. The opaque paint can be thinned to achieve very fine opaque marks as well. However, when working in gouache you must be careful not to lift the undercolor, because the dried layers of gouache remain soluble.

When gouache dries it has a pleasing chalky-matte quality. Gouache washes can appear softer and more diffused than watercolor washes. When light-value colors are applied opaquely, the colors dry darker; conversely, dark-value colors applied opaquely dry lighter. So, whenever possible, it helps to paint an area "in one go," because it will be difficult to come back and try to match the exact color after it has dried.

Gouache is the logical medium to start with if you have always been a transparent watercolor painter and want to go further. This is because gouache has essentially the same composition as watercolor; therefore it can be handled in a similar manner and will feel much the same on the brush. Likewise, the same brushes can be used, and so there is a comfort zone in the journey of developing an opaque vocabulary with gouache.

Gouache is a brittle medium. Thin layers of gouache may be painted on a lightweight support, such as a 140-lb. watercolor paper. However, if you intend to build up your paint, you should use a rigid support, such as a 300-lb. watercolor paper, watercolor board, or Aquabord, as thick layers tend to crack or chip on a flexible surface.

When purchasing gouache, make sure that you select a true gouache (and not an acrylic gouache, as the paint will not lift once it has dried). Also, some brands offer two different whites—titanium white (which is sometimes called permanent white) and zinc white. Zinc white can be used for tinting colors and for creating translucent washes; however, titanium white is more opaque and I have found that it is all that I need.

Gouache has a stiff but buttery consistency. It is ideal for painting formats up to 22 x 30 inches. For larger sizes that require juicy opaque painting, casein is a better choice. In the dry humidity of Colorado I work with gouache in the studio most of the time, as it dries quickly outside. However, in damper climates the paint stays moist, and long outdoor painting sessions are possible.

OCTOBER 17, 2006

I am a landscape painter, and I am most closely connected with this subject. I have spent my life immersed in nature. It surrounds me. I want to capture my feelings toward different seasons, atmospheric moods, and times of day and night.

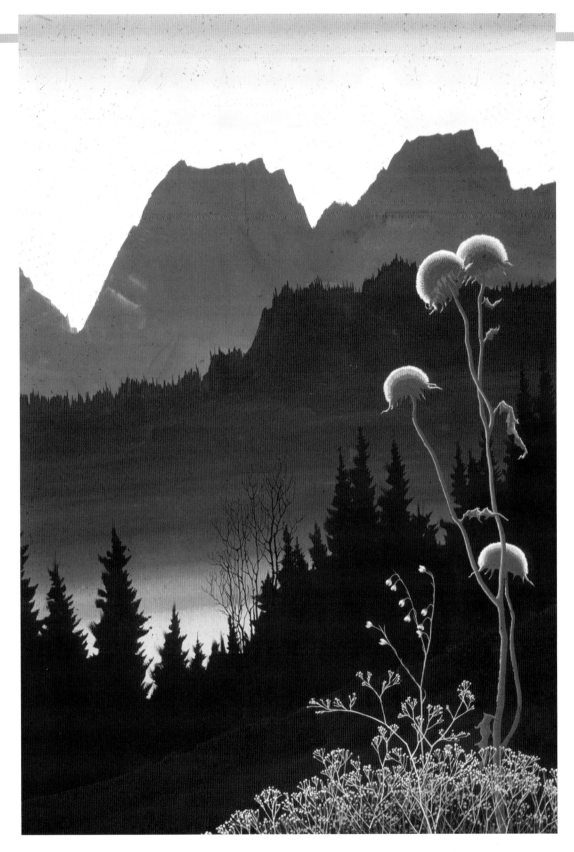

Night Moon, 29 x 21 inches (73.7 x 53.3 cm), gouache on #114 Crescent watercolor board, Collection of the Estate of Ruby and Carl Kujak

I painted this image in 1976 when I was doing a series of gouache paintings of this theme. This medium is ideal for capturing the feeling of night and light detail over dark.

The Gouache Palette

Over the years I have used a lot of different brands of gouache. I highly recommend the gouache manufactured by M. Graham. This is a fine-art gouache based on French formulas. Many other companies make gouache for advertising and commercial art purposes and some of their colors are not permanent. A general rule to follow is that if the paint has a pigment name (such as cerulean blue) it will be permanent; however, always check the paint's lightfast rating on the back of the tube to be sure. Also, avoid paints whose name includes the term "hue" (such as cobalt blue hue), as true pigments have not been used.

I use a thirteen-color palette that is based on my color system. Titanium white is the thirteenth color. I place this white on both sides of the yellow. The white to the left is for mixing with the warm hues, while the one to the right is for the cool colors. The paint will not contaminate as easily this way. Although I squeeze out my paint fresh with each painting session, the color can be placed in the palette and stored, as described on page 42. When using gouache I mist the palette with an atomizer bottle from time to time. All of these paints have a #1 lightfast rating.

Cadmium Yellow Light (PY 35)
This is my primary yellow—a true pure yellow, not too green or orange. Its complement is dioxazine violet mixed with some ultramarine blue.

Cadmium Orange (PO 20)
This is my intermediate yellow-orange, and its complement is ultramarine blue.

Cadmium Red Light (PR 108)
While its name is somewhat misleading, this is my secondary orange. Its complement is phthalo blue.

Cadmium Red (PR 108)
This is my intermediate red-orange. Some brands refer to this same color as cadmium red medium. I use cerulean blue for its complement, as there is no true blue-green in the M. Graham brand.

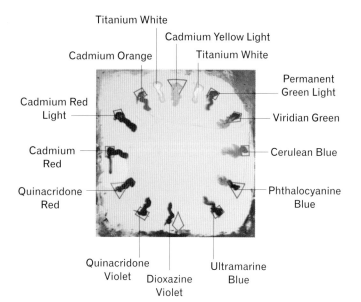

Titanium White
Cadmium Yellow Light
Cadmium Orange
Titanium White
Permanent Green Light
Cadmium Red Light
Viridian Green
Cadmium Red
Cerulean Blue
Quinacridone Red
Phthalocyanine Blue
Quinacridone Violet
Dioxazine Violet
Ultramarine Blue

This is how I set up my gouache palette. I place titanium white on either side of the yellow, which allows me to mix one with the warm pigments and one with the cool pigments.

Quinacridone Rose (PV 19)

This is my primary red. Its complement is viridian green.

Phthalocyanine Blue (PB 15.3)

This is my primary blue. Its complement is cadmium red light.

Quinacridone Violet (PV 19)

This is my intermediate red-violet, and its complement is permanent green light.

Cerulean Blue (PB 36)

Because there is no true blue-green in this brand of gouache, I use cerulean blue for my intermediate blue-green. Its complement is cadmium red.

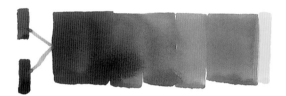

Dioxazine Violet (PV 37)

This is my secondary violet, although it is a bit to the red side to be a true secondary. I add a bit of ultramarine blue to cool it so that it grays beautifully with its complement, cadmium yellow light.

Viridian Green (PG 18)

This is my secondary green. You could use phthalo green in its place, if desired. Its complement is quinacridone rose.

Ultramarine Blue (PB 29)

This is my intermediate blue-violet. It is a rich blue-violet note that complements with cadmium orange.

Permanent Green Light (PG7, PY 151)

This is my intermediate yellow-green and its complement is quinacridone magenta.

The Visual Qualities of Gouache

Now that the palette is established, let's take an in-depth look at the visual qualities and handling characteristics of this medium. I have selected a few paintings to demonstrate the many possibilities that gouache offers.

Transparent Gouache

Gouache is primarily made for opaque painting. However, it can be used transparently in much the same manner as transparent watercolor but with different visual qualities. Most of *Early December, View from My Studio* was painted with transparent gouache. Notice the warm and cool frosty transparent visual quality in the small trees to the right. Finely ground white pigments are added to the gouache, so when the paint is thinned the visual quality is softened, creating a certain gentleness. Even the golden yellow of the back hill formation and reflected water has a softness that is unique to gouache.

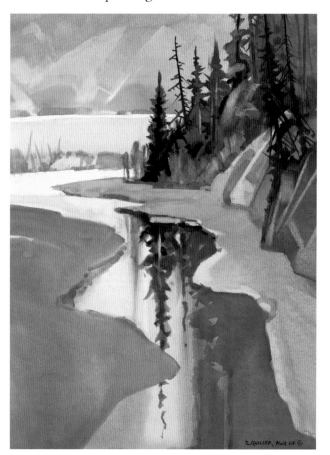

Like watercolor, gouache is pigment combined with a gum arabic binder. However, white pigment is added to the mix to give the medium its opacity. As a result the two media handle in much the same way. In particular, because both paints remain soluble indefinitely, transparent, translucent, and opaque passages of a painting can be softened or lifted with a damp brush or sponge at any time.

This characteristic is evident in this detail of the tree forms near the top of *Early December, View from My Studio.* After the dark blue paint was dry, I used a clean, damp #10 round synthetic brush and a paper towel to soften and blot out the rounded, diagonal shapes that indicate light frosted foliage forms. I also used a clean, damp ¾-inch flat synthetic brush to lift the vertical thin light shapes that indicate trunks of the spruce. This approach can be used to obtain soft and hard edges throughout a gouache painting, which can be a great way to help move the eye throughout a composition.

I lifted these trunk forms using a clean damp, flat brush.

Early December, View from My Studio, 19 x 14 inches (48.3 x 35.6 cm), gouache on #5114 Crescent watercolor board, Collection of Jim and Ginny Neece

I used gouache to capture the frosty nature of an early morning in December. Compare this painting to *March, View from My Studio* (shown on page 169), which is of the same subject but was done in transparent watercolor.

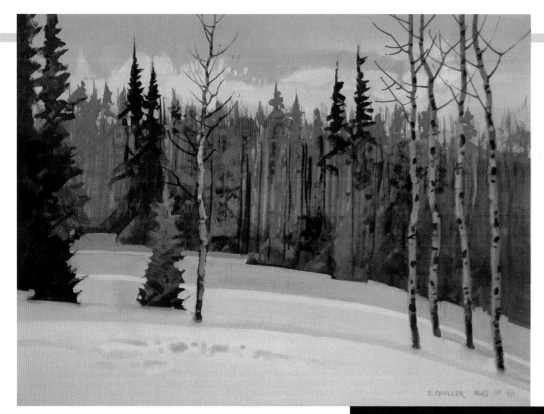

Late Light, Telemark Hill, 14 x 19 inches (35.6 x 48.3 cm), gouache on #5114 Crescent watercolor board, Collection of Bob and Gwyn Pirnie

I savor the end of the day during the winter, when I can do some cross-country skiing on a favorite mountain. To capture this scene I played with the juicy, wet-on-wet paints and built up the opaque color, especially the rich orange against the cobalt blue.

Opaque Gouache

Gouache is a dense and heavy-bodied paint that can be built up very thick. I have seen masters such as John Singer Sargent use gouache in places where it is at least ⅛-inch thick. However, if the paint is to be used in an impasto manner, the paint should be built in layers rather than applied as one glob. Gouache is a brittle medium, and when it is applied with thick and juicy strokes, it can crack. Never use a hair drier to dry gouache, as this can cause it to dry unevenly and crack. The central area of *Late Light, Telemark Hill* that captures the glow of the setting sun demonstrates the beauty of the dry, chalky thickness of the orange, yellows, and blues, which I built up in layers.

By contrast, one of the outstanding features of gouache is its capability to make extremely fine

Applying Gouache Wet on Wet

A wet-on-wet application of gouache creates one of the most beautiful visual qualities possible with this medium. This method is best achieved using a cold press paper surface such as #5114 Cresent watercolor board. This elongated horizontal detail of *Late Light, Telemark Hill* is a good example of this paint application. Notice how the soft yellow and violet paints meet, mingle, and bleed into one another. Fine, fan-like fibers melt to create a beautiful visual quality.

To make this happen, the surface must be very wet. First, I applied a juicy layer of white gouache as an underpaint. While the paint was still very wet, I charged a mix of whitish yellow paint on the paper, followed by the violet. I kept the support at a 45-degree angle, which allowed the paint to move downward. It is great fun to play with this method, provided that you understand that complete control is not possible and that you are at the mercy of the interaction of the paint.

I wet the sky and then applied juicy portions of opaque yellow and then violet gouache in a wet-on-wet manner.

opaque detail. *Night Moon,* which apears on page 45, shows how incredibly opaque and fine a line can be with gouache. I created the wild thistle to the right of the painting on a very dark gouache undertone. Keep in mind that dark undertones will lift. To avoid this, I let the undertone thoroughly dry and then created a mixture for the lighter tones of the weeds, using burnt sienna, raw sienna, yellow ocher, titanium white, and just enough water to get a good creamy opaque mix of gouache and still have some paint flow on the brush. I applied this paint with a small round #7 brush. I then added more white to the mixture for the lighter weeds. Even though these are very thin brush strokes over a dark area, the opaque light color shows brilliantly. I used a paper towel to remove any excess moisture from the brush before applying the paint.

Translucent Gouache

Yosemite Valley, November shows the beauty of a translucent blue gradated wash made with gouache, which is set off by the opaque gold-colored sky. To create the simplified mountain forms I added some white to the blue mix and gradated the color, darker at the top and lighter as the wash moved down. The wash is thin enough that the eye sees through to the paper but is dense enough that there is a cloudy, or in this case smoky, visual quality. When the color was dry I lifted a few lighter shapes with a clean damp brush.

Yosemite Valley, November, 18 x 20 inches (45 7 x 50.8 cm), gouache on #114 Crescent watercolor board, Private Collection

The morning I did this painting there was a controlled burn in the park. The gray-blue smoke put forth a diffused haze that simplified the mountain forms and neutralized the color.

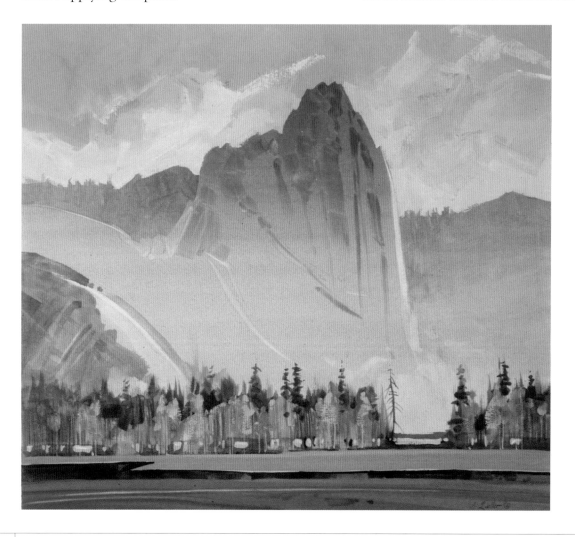

Taking a Closer Look: Incorporating Transparent, Translucent, and Opaque Passages in Gouache

I painted *Lovers, Zocalo, Puebla, Mexico* on-site at the downtown square in the city of Puebla. I had spent a few days milling around this zocalo in the late afternoons and evenings and was inspired by the young lovers on the park benches. This particular location interested me because of the shadows that cast from the trees and the light that bounced off the buildings and archways through the tree foliage and trunks. This vision called for an opaque medium and—because the architecture was stone and stucco and because strong color filtered through the trees—gouache seemed like the right choice.

I first did a few line drawings of lovers on the park benches. I then set up my easel, laid out my composition, and began painting transparently with the neutral gray undertone as well as the yellow-green and cool darker green foliage. I next worked entirely with translucent and opaque gouache, painting negatively through the tree shapes to get the impression of the warm and cool building forms. Ultimately gouache served as the ideal medium for this painting because the chalky visual quality captured the dryness of the atmosphere and the heat of the day.

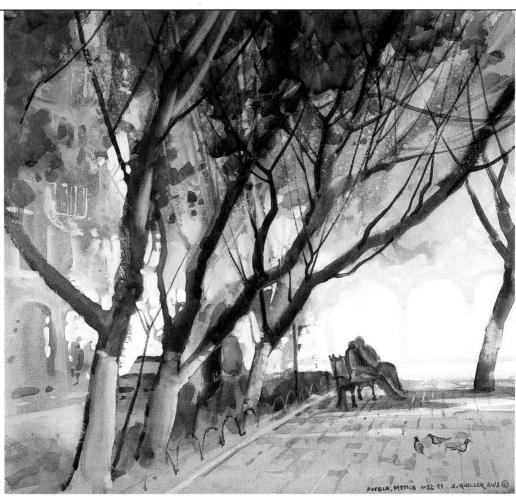

Lovers, Zocalo, Puebla, Mexico, 18 x 24 inches (45.7 x 61 cm), gouache on 300-lb. rough Saunders Waterford watercolor paper, Collection of Marta Quiller

After teaching a workshop each day in Puebla, I would sit in the town square and enjoy the colors, music, and young lovers on the park benches. They were oblivious to their surroundings and I had to capture this experience.

Acrylic

Acrylic is the medium of our age. It uses a polymer resin binder. These particles are suspended in water; when the water evaporates, a clear, strong, flexible paint film that is both waterproof and highly adhesive remains. Acrylic was first developed as a house paint, but because it is water-based, easy to use, and durable, it quite naturally was formulated as an artist's painting medium in the late 1940s.

Acrylic can be used transparent, translucent, and opaque. It is water soluble until it dries and is fast drying, nontoxic, and binds to nearly any non-oily surface. It is extremely flexible and will not crack or harden with age, even if the support expands or contracts. Thick impastos can be built, layer over layer, and they will still bind well. Acrylic is also believed to be the most permanent of all the painting media.

One of the greatest features of acrylic is that the paint is totally insoluble when it is dry. This means that layer upon layer of transparent color can be applied without each layer disturbing the underlayer. Thus a depth of transparency can be obtained with acrylic that cannot be matched in any other medium. Caution should be taken when soft edges are desired, however. These edges are best addressed while the paint is still wet. Otherwise soft, translucent layers of paint can be applied to diffuse an edge.

Compared to gouache or casein, acrylic is not highly opaque. It may take two or three applications of paint to get a rich, bright color field over a dark underlayer of paint. When working translucent and opaque the paint has a tendency to glob on the brush and streak. This can be avoided, however, by working the paint into the brush more thoroughly on the palette and adding a touch more water.

When first working with acrylic, the artist may notice a plastic feel. This is normal, as acrylic has a polyresin binder. The feel of the brush is very different than it is with watercolor, and this takes time to get used to. It is extremely important to clean brushes well with soap and water after a session of painting with acrylic. Otherwise the paint dries in the fibers of the brush and is impossible to get out. I actually use an older set of brushes when working with acrylic and casein.

When acrylic is used transparently, the color will dry with the same intensity and value as when it was painted, creating a visual quality of great brilliance. However, when acrylic is used opaquely, the paint dries darker than when first applied. In fact, acrylic is by far the most luminous and intense medium available. In a sense, this medium needs to be tamed. The color is so strong that if it is not used well, it can get out of control and have an unpleasant, garish quality.

The surface of a painting that has been made with opaque acrylic will have a distinctive plastic sheen. In fact, the clarity of the dried acrylic film is unparalleled in paint media—in its richness and in that it will not degrade, yellow, or become brittle over the course of several decades. This surface can be saved or altered with the application of matte, satin, or gloss acrylic varnish. And finally, acrylic paint is compatible with a number of products, including iridescent, metallic, pearlescent, and interference colors and acrylic pastes and gels.

SEPTEMBER 6, 1996

I believe that the subject finds the artist rather than that the artist discovers the subject. It comes when you do not expect it— and most often when your mind is free and not searching. When the artist searches, the paintings become contrived. The exciting subjects leap out and grab you, and you have no choice but to render them.

A Scottish Dream, 34 x 24 inches (86.4 x 61 cm), acrylic on #5114 Crescent watercolor board, Collection of George and Ruth Gilfillan

It is a rare occasion that an artist dreams about an image and then is so taken by the event that he makes a painting, long before he sees the actual subject. It was indeed the case with this work.

The Acrylic Palette

Many brands of acrylic are available. They differ in price, quality of materials (both the pigments and polymer resin binders), and whether additives and fillers are in the mix. Since 1970 I have tried many different company's paints, with varying degrees of success. Recently I have been using a superior acrylic that is from my own signature line; the Jack Richeson Company imports and distributes this product. The paint has a new and superior polyresin binder, contains only the highest-quality color pigments, and does not contain fillers or extender. Each color in the line has been formulated to achieve maximum pigment concentration and lightfastness in conjunction with good handling properties. The paint has a smooth buttery texture that retains brush and knife marks, yet is not stiff or difficult to manipulate.

I use a thirteen-color palette that is based on my color system. (Once again, titanium white is the thirteenth color.) Every color is placed in position opposite its true complement. Each complementary set will give you beautiful semi-neutral colors and an absolute neutral. In fact, I worked with the color chemist to make Quiller violet, which is discussed further on page 59. This color will gray out beautifully with cadmium yellow light and cadmium yellow medium, which was never before possible in acrylic.

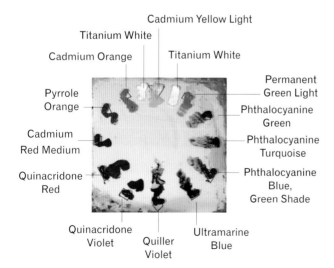

Cadmium Yellow Light (PY 35)

This is my primary yellow. It neutralizes perfectly with its complement, Quiller violet.

Cadmium Orange (PO 20)

This is my intermediate yellow-orange. Its complement is ultramarine blue.

Pyrrole Orange (PO 73)

This is my secondary orange. Its complement is phthalo blue, green shade.

Cadmium Red Medium (PR 108)

This is my intermediate red-orange. Its complementary color is phthalo turquoise.

This is how I set up my acrylic palette. I place titanium white on either side of the primary yellow and use one white for warm and one for cool colors.

Quinacridone Red (PV 19)

This is my primary red. Its complement is phthalo green.

Phthalocyanine Blue, Green Shade (PB 15.3)

This is my primary blue. Its complementary color is pyrrole orange.

Quinacridone Violet (PR 122)

This is my intermediate red-violet. Its complement is permanent green light.

Phthalocyanine Turquoise (PB 15.3, PG 7)

This is my intermediate blue-green. Its complement is cadmium red medium.

Quiller Violet (PB 15.1, PV 23)

This is my secondary violet. Its complementary color is cadmium yellow light.

Phthalocyanine Green (PG 7)

This is my secondary green. Its complementary color is quinacridone red.

Ultramarine Blue (PB 29)

This is my intermediate blue-violet. Its complement is cadmium orange.

Permanent Green Light (PY 3, PB 7)

This is my intermediate yellow-green. Its complement is quinacridone violet.

The Visual Qualities of Acrylic

Now that the palette is established, let's take an in-depth look at the visual qualities and handling characteristics of this beautiful medium. This discussion includes a few paintings that demonstrate the many possibilities that acrylic offers.

Transparent Acrylic

I contend that acrylic is the most transparent of all painting media if it is used like watercolor. It is also the most luminous and intense. When used transparently, the colors dry with the same value as when they are first applied. When the color is dry, it is insoluble and cannot be lifted. Thus it is the ideal medium to use for a tone of transparent undercolor. In addition, as long as each application dries completely before the next is put down, layer upon layer upon layer of color can be applied to get an incredible depth of transparency.

I got the idea for *View from the Air* while flying west over the Sangre de Cristo Mountains at 5 pm in February. The sunset sky glowed rich against the cool tones of the mountains. Acrylic was the ideal medium to capture this image. In this painting I was most interested in achieving a brilliant transparent color vibration between the pyrrole orange of the sky and the phthalo blue of the mountain range. The majority of this painting is transparent and, as you can see, it glows.

The intense luminosity of transparent acrylic is particularly notable in the warm tones of the sunset. The yellow gradates to transparent, full-intensity pure orange. This color touches the transparent phthalo blue and ultramarine blue mountain forms. Where these two complementary colors meet they create a stimulating optical shimmer of simultaneous contrast.

Translucent Acrylic

When the translucent visual quality of acrylic is used successfully it can diffuse underlying forms and create a transition between transparent and

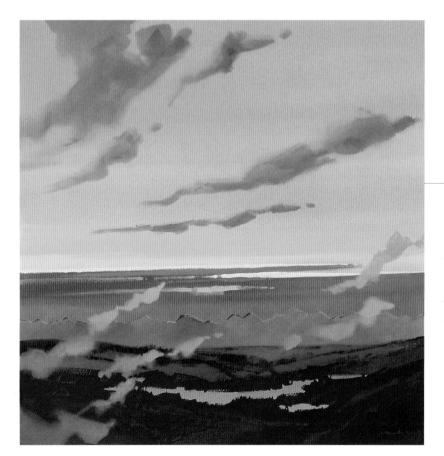

View from the Air, 32 x 28 inches (81.3 x 71.1 cm), acrylic on 300-lb. cold press Richeson Premium watercolor paper, Collection of Jean and Phillip Bethke

Flying over the Sangre de Cristo Mountains, I was inspired by the rich, warm color of the sunset and the cool blue and violet shade of the mountains. I used the back of an airline ticket to put down a few lines and notes.

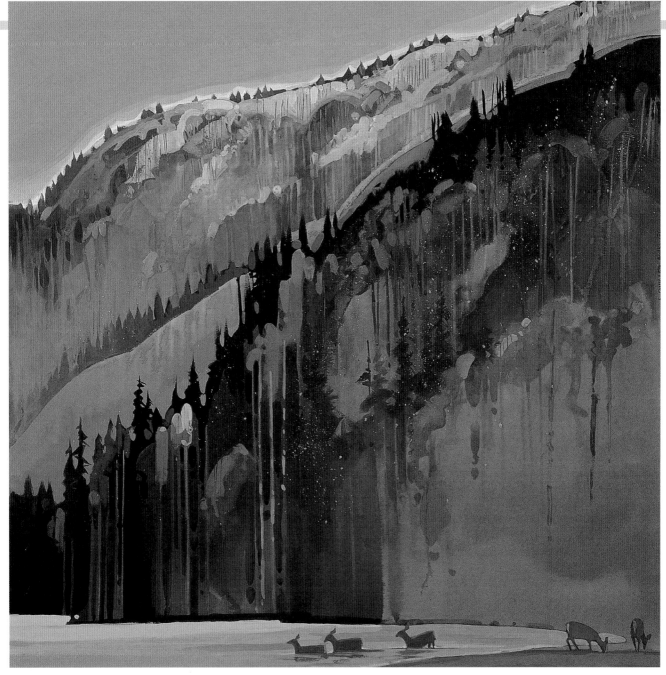

Deer Crossing #3, 34 x 28 inches (86.4 x 71.1 cm), acrylic on #5114 Crescent watercolor board, Collection of the Artist

During the summer to late autumn I watch the deer cross the river below our home. They gather along the bank and then proceed single file. During the late autumn the mountain across from our home blazes with color. I integrated these two seasons and views to make this composition.

opaque areas of a painting. Care should be taken to thoroughly blend the water, white, and the color of choice, however. Otherwise acrylic can streak. Work the paint well with the brush on the palette before applying it to your painting.

Deer Crossing #3 is a composite painting that merges a view of a mountain across from my stu-dio with a view along the river below my studio. I often see the deer congregating and then crossing the river single file. The rich autumn colors, deep violet shadows, and cloudy translucent mist in the canyon needed to be expressed in acrylic.

The translucent quality of acrylic is particu-larly noticeable to the left of the image, where

the cloudy, velvety blue-violet passages give the appearance of low-hanging mist. It simplifies and diffuses the underlying forms, creating a quiet area that brings out the strong color and contrast of the foreground trees. This translucent blue-violet tone was made with a thin mix of white and ultramarine blue and a touch of its complement, cadmium orange.

Opaque Acrylic

Acrylic has tremendous advantages when used opaquely. The binder is flexible and extremely adhesive. Also, acrylics are formulated to a heavy body that will hold juicy, thick strokes and peaks, yet they have a high concentration of pure pigment for solid, rich color. The surface of dried opaque acrylic has a plastic sheen that is very distinctive. In fact, the clarity of dried acrylic film is unparalleled in paint media.

One year in mid-September on the mountain by my studio we had a significant snowstorm while the aspen trees were in full autumn color. I spent a few days doing some studies of the brilliant warm white snow and cool violet-blue shadows contrasting with the yellow-green, yellow, and yellow-orange of the foliage. I used these studies to work up some large studio acrylic paintings. In *An Autumn Snow,* which is shown in full on pages 122–123, I explored the versatility of using acrylic from transparent to juicy opaque. The buildup of this painting includes many layers.

This detail shows three different ways that I used opaque acrylic paint. On the lower right I applied the warm white opaque acrylic fairly thin, and while it was still damp I used the tip of the handle of the brush and scraped back to the underlayer of transparent red-violet. In the upper center I painted a flat, even coat of neutralized violet and blue-violet over underlayers of color. To the left I put down warm white in a juicy, opaque manner. The buildup of paint is very thick, forming ridges and peaks and creating interesting visual qualities that contrast with the thinner adjacent paint and underlayers of colors.

This detail of *An Autumn Snow,* which is shown in full on pages 122–123, features opaque snow highlights that cut between and around the tree forms.

Floating Acrylic on a Wet Watercolor Board

This study shows how acrylic floats on a watercolor paper or board surface. I first saturated the watercolor board with water. I then used a single-edge razor blade, scraping it into pure acrylic pigment and incising it heavily across the board. The pigment disperses beautifully and seems to float on the surface much differently than it does with the other watermedia. I use this technique occasionally when I am beginning to create an elongated horizontal landscape.

Acrylic can be painted with tools other than brushes. I use my fingers, atomizers, pocket knives, and, in this study, a razor blade.

In acrylic paint, the color that traditionally has been missing from the twelve-color spectral palette system has been a true violet. Every brand makes a dioxazine violet (which is a red-violet), and a few companies make an ultramarine violet that is either reddish or a very "gummy" color in acrylic. I have worked with a chemist to make a new violet that is rich, deep, and the perfect complement to cadmium yellow light and cadmium yellow medium. The result is Quiller violet. It grays out perfectly with these yellows and makes beautiful semi-neutrals.

This is important for many reasons. In my opinion, violet is the most spiritual of colors. It is the color to which I gravitate when I want to elevate the color relationships in a composition. I equate the red-violet, violet, and blue-violet color notes of a painting to the bass notes of a musical composition. These notes are the foundation upon which everything else is built. Likewise, I believe that the violets resonate and hold together many of my compositions; they are felt but rarely observed by the average viewer.

I painted *Crows in Flight near Nikolaevsk* on-location near a small Russian village close to Homer, Alaska, in September. At this time of year the sky and sea are charged with a gray-silver light that I captured by mixing white, cadmium yellow light, and Quiller violet. I wanted to evoke the feeling of birds in flight, the starkness of the landscape, and the silver-yellow light that bounces off the sea in this cool northern climate.

This chart shows some of the possibilities created by Quiller violet and its complement, cadmium yellow light. The vertical columns show a range from a pale, transparent gradation (on the left) to a juicy, opaque application (on the right).

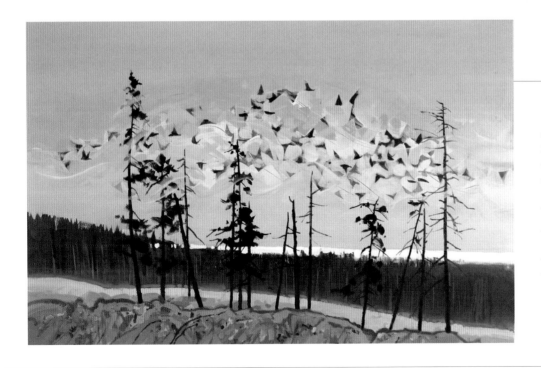

Crows in Flight near Niko-laevsk, 19 x 29 inches (48.3 x 73.7 cm), acrylic on #5114 Crescent watercolor board, Collection of the Artist

This painting of an area near a Russian village close to Homer, Alaska predominantly features a limited palette of white, cadmium yellow light, and Quiller violet, which is distributed by Jack Richeson and Company.

Additional Acrylic Products

Acrylic is the most recently introduced of all the major artists' paint products, and manufacturers continue to discover new ways to create exciting visual effects with the polyresin-based medium. Below are a few products that can heighten the visual qualities of acrylic paint.

Iridescent, Metallic, and Pearlescent Acrylics

Acrylic paint is available in a variety of iridescent, metallic, and pearlescent colors. These colors can be mixed with traditional acrylic colors, washed over transparently to give a glint and sparkle to an area, or painted opaquely to indicate a solid metallic field, such as a gold foil.

Some metallic colors available in acrylic paints include (from left to right) pale gold, deep gold, copper, silver, and pearl.

Acrylic Interference Colors

The interference colors are composed of acrylic polymer medium and mica particles. When the paint is squeezed from the tube it appears to be a translucent pasty clear color with an iridescent feel. The paint is available in the primary and secondary colors. A color such as a green will have a green sheen, but it will shift to its complement, red, depending on the angle of the reflected light. Interference colors can be glazed over an area of acrylic underpainting, mixed with tube colors directly in a thick, heavy stroke, and thinned and mixed with a color to give a translucent and iridescent visual quality.

This swatch of paint is a thin, diluted mix of interference green and phthalo turquoise. It can be glazed over an area to create a mood and unify the color harmony.

Acrylic Gels and Paste

Various surface textures can be created with acrylic mediums, gels, and paste. Here are a few products that you might play with:

Modeling Paste This high-viscosity paste allows artists to build up the surfaces of their paintings. Stiff peaks can be created as well as crisp, rigid textures. The paste dries to a white matte opaque finish and can be sanded and lightly carved.

Nepheline Gel This semitransparent medium (available in both coarse and extra coarse) is used to create flexible, granular texture. It can be mixed with acrylic color or put down directly on the painting support and then painted over.

Gel Medium In essence, this medium (available in both gloss and semigloss) is a high-viscosity paint without the pigment. Gel medium is made from 100 percent pure acrylic polymer emulsion. It is white when wet but will dry to a clear, glossy, and flexible film. It has a creamy, buttery consistency and is capable of holding every texture and detail—from high peaks to fingerprints. It has a superior adhesive quality, making it the perfect medium for collage and mixed media work.

Here I applied gel medium with a palette knife and my fingers and let it dry overnight. I then mixed some Quiller violet with a touch of white and painted it opaquely at the top of the study and transparently at the bottom.

I tend to use acrylic collage when I want to work in a more experimental direction. I look forward to these occasions, when I tap into what I call my "inner vision" and allow myself to listen and respond to what is happening within. Generally, when I paint in the studio, I work from sketches and studies; with my inner-vision work, however, I do not preplan my paintings but let them develop as they go.

I work on a variety of supports, including watercolor board, watercolor paper, and Aquabord. I begin by wetting the surface and charging it with gel medium. I then tear various smooth and textured rice papers (such as Kozo, Kasuiri, Unryu, and Ogura Natural) and laminate them to the support with a thinned-down gel medium. While the collage papers are wet I charge transparent acrylic onto the painting, using large flat brushes. I want the fibers of the rice papers to be an important part of this process, so I do not use the paint too heavily. I let the painting dry before going too far.

I turn the support in different directions, listening to the shapes and textures and colors. When the painting tells me which way to go I respond with transparent, translucent, and opaque paint, pulling the work together. At this stage I use interference and metallic colors, modeling paste, and nepheline gel to push the painting as far as it can go.

Sheep Collage in Orange and Blue is a good example of my inner-vision approach to acrylic collage painting. I began by laminating the rice papers to the watercolor board and washing on a limited palette of transparent orange and blues. I then built the composition with opaque paint and integrated the metallic and interference paints. I kept some large, simple shapes and let the fibers of the rice paper be an important part of the statement.

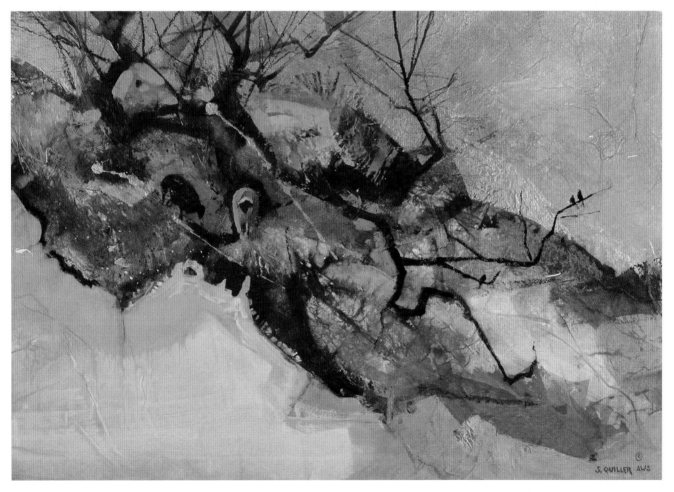

Sheep Collage in Orange and Blue, 16 x 24 inches (40.6 x 61 cm), acrylic on #5114 Crescent watercolor board, Private Collection

Occasionally, I revisit a sheep theme that I have developed over thirty years. Most often, as in this case, the sheep become symbols of a higher spiritual element in nature.

Colored undertones have been used by painters for hundreds of years. There are many advantages to using transparent acrylic as the underlayer. First, transparent acrylic will generate a luminous glow. Second, when acrylic is used transparently it stains (and does not seal) the paper. Third, acrylic is compatible with other watermedia, so the overpainting can be watercolor, gouache, casein, or acrylic. Finally, when the acrylic paint is dry it will not lift, so overpainting applications of paint will not contaminate the underlayer.

Before choosing what color to use for your underlayer, consider the following:

The color can be used to enhance the mood of the painting. For instance, you might select a yellow undertone if the painting needs a warm golden light.

The color can establish the major tone of a color family for a painting. For instance, you might select a warm orange undertone before overpainting yellow ocher, raw sienna, and burnt sienna.

The color can be the complementary opposite of the major tone of a color family for the painting. For instance, an orange undertone can be used before overpainting with a dominant color theme of blue-green, blue, and blue-violet. Letting some of the warm undertone show through will enhance the visual quality of the painting.

The color can be a true neutral or gray color. The lifeless gray will take on the complementary tone of the color next to it. For instance, a neutral gray next to a warm white-yellow snowfield will appear to be violet.

The sequence below demonstrates the beauty of using a transparent acrylic underpainting and then building up layers of translucent and opaque paint. I knew that my final painting would have a dominant color family theme of yellow-green, green, and blue-green. Therefore, I selected a rich transparent underlayer of red-violet, red, and red-orange.

In the first image I wet the Crescent watercolor board and washed in quinacridone violet, quinac-

First, I applied a transparent wash of acrylic to the watercolor board and lifted a few vertical strokes.

Next, I painted negatively around some of the red trunk shapes, adding lighter internal details for the tree forms.

ridone red, and pyrrole orange transparently. While the paint was still wet I lifted a few vertical strokes and scraped a few marks.

With yellow-green and blue-green opaque acrylic I built some of the tree foliage, as shown in the second image. I mixed phthalo green and Quiller violet and painted above the foliage and also painted negatively around the central trunk forms. I then mixed a translucent color using white, phthalo green, and Quiller violet and painted a negative passage, which formed the dark spruce trees.

In the third image, I mixed a transparent deep color using quinacridone violet and Quiller violet and painted more negative shapes. I mixed more light opaque blue-green to add more foliage to the tree on the central right side. Finally, I mixed an opaque light neutral, using the Quiller violet and phthalo green, and painted more negative shapes and formed more tree patterns in the upper background area.

In the final stage I worked primarily with opaque acrylic. I first placed in the light trunk pat-

terns on the central aspen and then the dark trunks on the trees at the left. I painted in the dark spruce to the right of and behind the central aspen. I added the foreground yellow-green bank and more foliage to the aspen trees. Finally, I painted a dark transparent veil of water.

Acrylic Underpainting Studies

Choose any subject—a still life, figure study, landscape, or an abstract composition. Stain the underlayer of a sheet of watercolor paper with a solid transparent tone of acrylic paint. This can be a warm golden, red-violet, or cool green tone. Using the complementary color family to the undercolor, create your image. Leave some of the acrylic underpainting open, but cover about two-thirds of the painting with translucent and opaque acrylic. Try lifting back to the underpainting. Note how the undercolor ties the painting together.

Then I painted more negative shapes in the internal areas and formed more tree patterns in the upper background areas.

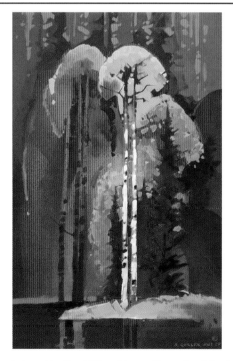

In the final stage I built additional forms throughout the image, working primarily with opaque acrylic.

Casein

Casein is a quick-drying, aqueous medium that uses a milk-based binding agent. It is one of the oldest and most durable media known to man. Nine-thousand-year-old casein cave paintings have been discovered in Asia. In more modern times, Edvard Munch, Gustav Klimt, Thomas Hart Benton, John Sloan, Ben Stahl, Hans Hoffman, Ben Shahn, and Stuart Davis worked with this medium.

In 1933, casein pigments in tubes were developed by the Spanish American painter Ramon Shiva. During the 1940s and 1950s Shiva led the world in reviving an interest in casein. It was widely used until the 1960s, when acrylics began to dominate the market. Today another revival of this medium has occurred in the watermedia world. Casein has beautiful and unique visual qualities and handling characteristics. Personally I love this medium, and have been using it by itself or in combination with the other watermedia since 1972.

Known for their versatility, casein paints share many characteristics with other media, making it possible to create a wide variety of effects using many different techniques and surfaces. Casein may be used to create the thin washes of watercolor, the smooth opacity associated with tempera and gouache, and the richer textures of acrylic. It can be reworked or layered repeatedly. Layering is much easier with casein than with gouache or watercolor because it does not lift as easily once it dries. In fact, the solubility of casein is unlike that of the other media. When the paint is first dry it still does lift, but not as easily as gouache. Edges can still be softened. However, an underlayer of casein will not come up without some effort, and thus it will not contaminate the overpainting. While there is some variation from color to color, in general, casein becomes impervious to water after a two-week period.

Casein can be applied to any non-oily support but, like gouache, a fairly rigid support should be used if the paint is going to be applied thickly. Aquabord, watercolor board, and 300-lb. watercolor paper are supports that will work. Like gouache, casein is a fairly brittle medium, and a flexible support, such as a thin watercolor paper, will expand and contract, causing the medium to crack.

Casein is very juicy and has great coverage power. By this I mean that paint can be mixed to a creamy consistency and will flow beautifully when the brush meets the support. Since the paint is opaque, it can cover a large area in one go. Whenever I am working full sheet (22 x 30 inches) or larger and need to choose between casein or gouache for the opaque medium, I will always choose casein.

Almost any kind of brush can be used with casein, depending on the desired effect; everything from stiff synthetic brushes to soft sable brushes. The quick-drying semi-soluble medium can be hard on brushes, however, so it is important to thoroughly clean them with liquid soap and water at the end of each painting session. In fact, I always use an older set of watermedia brushes when working with casein and acrylic. Casein has an exceptional integrity of color and always dries to a perfect velvety-matte finish. This stunning visual quality is exceptionally beautiful.

DECEMBER 8, 2007

Painting is about energy and the mark. There are great marks, good marks, and bad marks. No matter what the subject matter or lack of subject matter, we are always working on a two-dimensional surface with paint of some kind, creating at the most an elution of the image or idea with various kinds of marks.

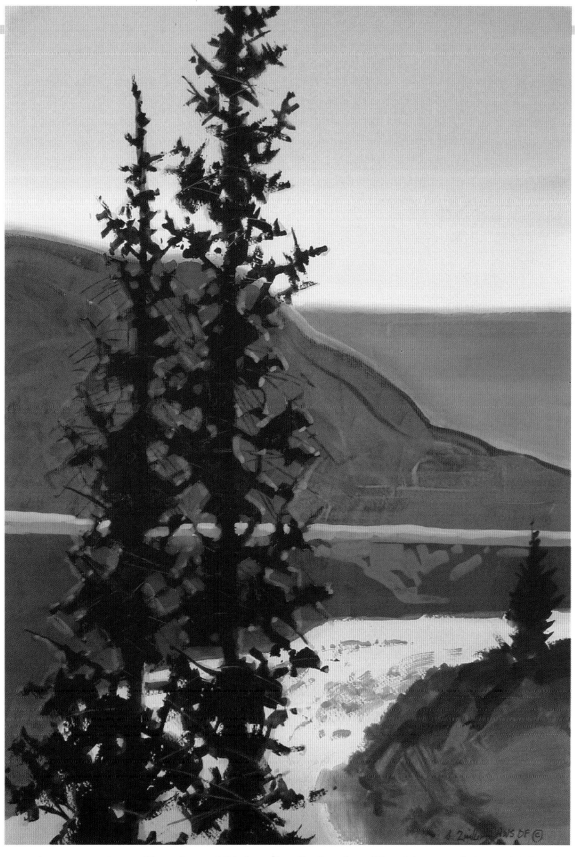

Dusk, View from My Studio, 19 x 13 inches (48.3 x 33 cm), casein on #5114 Crescent watercolor board, Collection of Jim and Sherry Lanvender

The softness of this hour, the afterglow of the light, and the cool, gray-violet shimmer of the twilight shapes called for casein.

After doing a preliminary sketch and a color study, I set up my casein palette to create this painting.

The Casein Palette

Casein uses a milk-based binding agent, which is what gives it its unique velvety quality. Shiva is the only brand available in this medium. While there are thirty-two colors in the Shiva casein line, I generally place only eleven colors on my palette and I use these to create every color that I need. The colors magenta and permanent green light are not made in casein, but those colors can easily be mixed. To the left of the primary yellow I place cadmium yellow medium. It is not one of the primary, secondary, or intermediate colors, but it is a beautiful color that I use all the time. As with my gouache and acrylic palettes, I place titanium white both to the left and right of the primary yellow. And, as with the gouache palette, the Shiva (dioxazine) violet is redder than the true violet, so some ultramarine blue needs to be added to bring the violet to its proper position.

These are the colors that I frequently use on my palette. All of these colors have a #1 lightfast rating. When working in casein, I sometimes also use ivory black, Venetian red, terra verte, burnt sienna, raw sienna, and golden ocher. One bonus about working with casein is that a deodorizer is added to the paint, so whenever you use it a pleasant scent will permeate the air.

Cadmium Yellow Light (PY 35)
This is my primary yellow. In casein cadmium yellow light does not have a direct complement, but it can be mixed with Shiva violet and ultramarine blue to create beautiful grays and semi-neutrals.

Cadmium Orange (PO 20)
This color goes in the intermediate yellow-orange position and complements with ultramarine blue.

Cadmium Red Pale (PR 108)
This is my secondary orange. Its complement is cobalt blue.

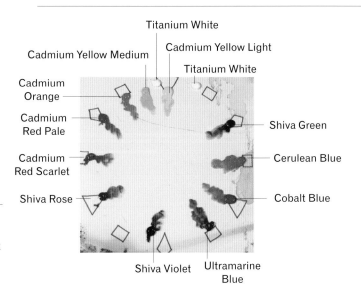

This is how I set up my casein palette. Notice that there is no yellow-green or red-violet. I leave these two spaces open and mix these colors from adjacent pigments.

Cadmium Red Scarlet (PR 108)

This is the red-orange color note on my palette. Its complement is cerulean blue.

Shiva Rose (PV 19)

This is my primary red. Its complement is Shiva green.

Shiva Violet (PV 23)

I place this color to the left of the secondary violet position. This is because it is not the true complement of the primary yellow. It is redder, and although it is a great color, it needs to be mixed with ultramarine blue to bring the color note to the secondary position.

Ultramarine Blue (PB 29)

This is my blue-violet color note. It is my favorite color in casein, as it is rich, deep, and very beautiful. Its complement is cadmium orange.

Cobalt Blue (PB 28)

I use this color in the primary blue position. Shiva (phthalo) blue is actually the best pure primary, but I stay away from it because it can be very hard to get out of the brush and it needs to be cleaned well with soap and water. The complement of cobalt blue is cadmium red pale.

Cerulean Blue (PB 35)

This is my blue-green color note. It is a rich and velvety color that complements well with cadmium red scarlet.

Shiva Green (PG 7)

This is actually a phthalo green, and I place this color in the secondary green position. It is a beautiful, staining color. The brush needs to be cleaned well after using this color. Its complement is Shiva rose.

The Visual Qualities of Casein

Now that we've established the palette, let's take an in-depth look at the visual qualities and handling characteristics of this medium. I have selected a few paintings to demonstrate the many possibilities that casein offers.

Transparent Casein

Casein is a versatile medium. When used transparently casein has a soft and velvety look that is consistent with the visual qualities of the paint when it is used translucently and opaquely. A complete painting can be done using this medium transparently. The key is to choose a subject, mood, or atmospheric condition that will be enhanced with this approach. Normally, however, casein is used transparently in combination with opaque paint applications. *High Meadow by the Equity* is a good example of using multiple applications, particularly the area near the ghosted spruce in the foreground on the right. The violet and red-violet tones of the transparent casein juxtapose with the translucent and opaque overpainted strokes. Notice how the transparent red-violet color glows as it is offset by the opposite color family of yellow-greens and greens.

High Meadow by the Equity, 15 x 10 inches (38.1 x 25.4 cm), casein on #5114 Crescent watercolor board, Collection of Cynthia Mooris

I did this study entirely in casein on an early summer morning in a high meadow in a remote part of the San Juan Mountains close to the Continental Divide. I was interested in capturing the strong diagonal shadows that move down the steep mountainside.

Visual Qualties Studies

Select a limited palette of casein. Choose two warms (such as cadmium orange and cadmium red light or their equivalents), two cools (such as ultramarine blue deep and a phthalo green), and titanium white. On a small sheet of cold press watercolor paper or watercolor board, play with the paint's visual qualities: transparent, translucent, and opaque. See if it lifts. Observe how opaque or translucent an overlay of color is. Write your observations on the edge or the back of the sheet. Repeat this exercise with a similar palette of acrylic and then a palette of gouache, using a different sheet for each study. Note the differences in the handling qualities of each of the media.

Translucent Casein

Casein is the ideal medium to use for achieving a cloudy translucent veil. The paint flows and covers large areas easily and provides that unique velvety-matte look that is so beautiful. If casein is painted over a dry transparent underlayer of casein, the underpainting will hold well and will not contaminate the application. (In other words, the underlayer does not lift easily and the color that is applied on top will not pick up the underlayer easily.) Remember that a translucent mix of casein usually contains some white, but it is diluted somewhat to give a cloudy, diffused look.

The undercolor can still be seen, but not as clearly as if it were a transparent application.

The distant mountains in *Morning Light, La Garitas* show this visual quality well. The warm transparent orange underpainting can be felt through the translucent, gradated violet veil of paint. I put down the bluish violet paint in an opaque manner at the top of the mountain form and then diluted the paint with water as I moved down the mountain. This bestows a soft, airy quality to the composition, creating depth and helping to unify the composition.

Morning Light, La Garitas, 19 x 29 inches (48.3 x 73.7 cm), casein on #5114 Crescent watercolor board, Collection of Jim and Ginny Neece

"La Garitas" is Spanish for "the Guardians" and is an appropriate name for the distant rhythmic mountain range in this painting. Casein seemed the perfect medium for the soft airiness of this subject.

Opaque Casein

The true beauty of casein is when it is used opaquely. This is when the velvety visual quality is most evident. This look is unique to casein, and of course it is because of the milk-based binder. The medium also has great coverage power when used opaquely. This is evident in the fairly large painting *Summer Mountain Patterns,* where large flat opaque shapes dance throughout the composition. The surface quality has a solid but soft look. Layers can be built up, as is evident in the sky in the upper right corner. It is also seen in the foreground in the bright yellow-green patterns of the young aspen tree; I painted this sapling over the top of the other shapes near the end of the painting.

In addition to working in opaque layers, casein can be used in a thick, juicy opaque manner. These luscious strokes can be built up to give a milky, sensuous visual quality. When working this way, it is important to let the paint air-dry. Do not use a hair drier to aid the drying time, as doing so can cause the paint to crack.

High Meadow by the Equity, which appears on page 68, demonstrates how casein can be built up

page 68

in layers. The first layer was a transparent underpainting of red-violet, followed by translucent violet and green. Then I added darker opaque spruce tree patterns, followed by middle-value yellow-greens around the dark spruce. Finally I introduced juicy strokes of creamy light yellow-green to represent the feeling of sunlight on the mountainside along with thick orange strokes to add the colorful energy that I felt during the painting experience.

Summer Mountain Patterns, 26 x 36 inches (66 x 91.4 cm), casein on #5114 Crescent watercolor board, Collection of David and Berna Lester

Sometimes paintings need time to incubate. I started this image in the summer of 2000. I was interested in the rhythmic patterns of the trees, but somehow I never completed the work. Six year later, when the colors of summer appeared again, I pulled out the painting and completed it.

Capturing Aged Textures with Casein

Subjects such as aged stucco, adobe, rock forms, and petroglyphs can be captured beautifully with casein. This is because the paint can be layered from transparent to opaque, because it can be spattered or scraped through to underlayers while it is damp, and because the milk-based medium has a soft, aged visual quality.

Chioggia, often called the "working man's Venice," is a coastal Italian village on the Adriatic Sea. It is a beautiful place filled with narrow streets and canals, colorful boats, and hanging laundry. *Blue Boat, Old Walls, Chioggia* is a particularly good example of creating the texture of old stucco walls. I placed a thin transparent underwash down and then added subsequent overlays of casein. While the creamy white-yellow paint was wet I used my fingernail to scrape back to some underpaint. I also lightly spattered some of this creamy mixture. Later I painted in the brick color.

Blue Boat, Old Walls, Chioggia, 21 x 29 inches (53.3 x 73.7 cm), casein on 300-lb. rough Richeson Premium watercolor paper, Collection of Jackie and Charles Railsback

I did this painting while instructing a workshop in Chioggia, Italy. I was inspired by the various aged textures and the beautiful patterns of the reflections in the canal.

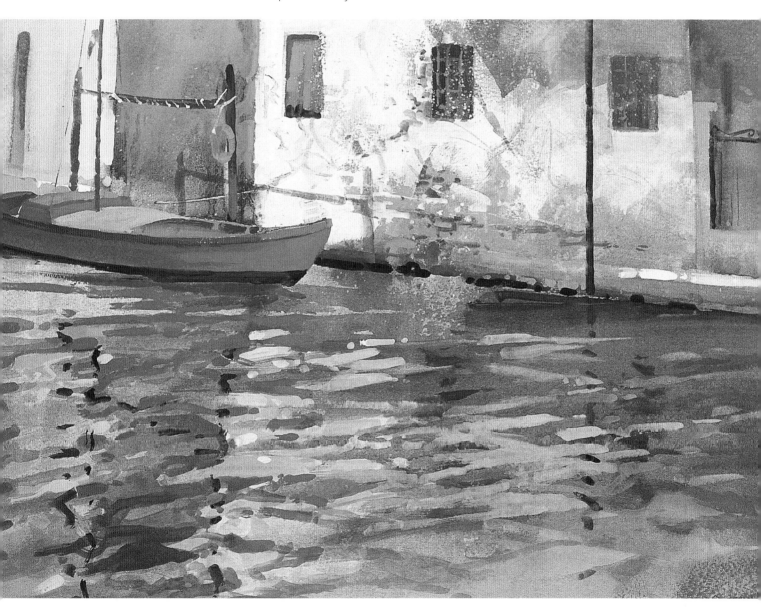

Comparing All Four of the Watermedia

The chart on these two pages places the unique visual qualities and handling characteristics of each of the four watermedia into categories. This is a reference tool to help you determine which medium or combination of media will best present each painting.

	Watercolor	Gouache
Transparent Visual Quality	Beautiful, vibrant, soft, luminous glow; the color dries twice as light as when first put down	Soft and chalky-matte
Translucent Visual Quality	N/A	Rich, cloudy veil with good flow
Opaque Visual Quality	N/A	Highly concentrated pigment with excellent opacity, even when used light over dark
Overall Visual Quality	Vibrant, soft, luminous glow	Soft and chalky-matte
Binder	Gum arabic, a vegetable gum made from the acacia tree family	Gum arabic
Solubility When Paint Is Dry	Completely soluble; paint can be lifted and removed at any time; some colors will stain the surface	Completely soluble
Paint Used for Transparent Undercolor	Has a soft undercolor glow and can be lifted when it is overpainted	Undercolor will lift easily and can contaminate the overpainted application
Coverage Power	Has great flow and can cover very large areas	Best used for smaller work (up to 22 x 30 inches)
Painting over Undercolor	N/A	Underlayers will lift very easily and can mix with the overcolor
Softening Edges	Edges can be softened easily, even after the paint is dry	Extremely fine detail can be created; also light paint can be applied over dark areas
Detail	Extremely fine detail can be created	Easily done because paint remains soluble; can paint extremely fine detail, even light over dark
Brush Handling for Opaque Detail	N/A	Can paint extremely fine detail, even light over dark
Brushes	Any watermedia brushes can be used (from pure sable to synthetic), and no special cleaning is required	Any watermedia brushes can be used (from pure sable to synthetic), and no special cleaning is required
Support	Any support can be used for watercolor applications (from thin watercolor papers to 300-lb. watercolor paper, watercolor board, or Aquabord)	Any support can be used for thin watermedia applications; rigid support (such as watercolor board, Aquabord, or 300-lb. watercolor paper) should be used if working in juicy opaque

Acrylic	Casein
High, intense, and brilliant; the color dries the same value and intensity as when first applied	Soft, velvety-matte finish
Cloudy and somewhat plastic appearance; it can be streaky if the paint is not worked well into the brush	Soft, cloudy, milky, and velvety
High intensity with a plastic sheen	Velvety-matte with a sensuous sheen
Rich, intense, vibrant color with a plastic sheen	Velvety-matte with a sensuous sheen
Polyresin	Milk protein base (curd) and oils (oils in water emulsion)
Completely insoluble; paint can be applied without disturbing the underlayer	Partially soluble; paint can be lifted, but not easily; the longer it sets, the harder the film will be; with time it becomes impervious to water
The ideal painting medium for underpainting	Has a soft undercolor glow and will not lift easily
Excellent for supports of all sizes	Excellent coverage power for supports of any size
Overlayers are easily achieved if each layer dries in between	An overlayer can be applied without the undercolor lifting if the underlayer has dried completely and the paint is not worked too hard
Cannot soften edges after the paint is dry	When first dry, the edges can be softened with effort; after the paint cures, it is insoluble
Difficult to achieve detail	Fine detail can be created, even light over dark
Difficult to achieve fine detail; paint tends to thicken on the brush	Fine detail can be achieved; good brush flow
Use older set synthetic watermedia brushes and clean well with liquid soap and water after each painting session; if paint dries on the brush, it is impossible to get out completely	Use older set of synthetic watermedia brushes and clean well with liquid soap and water after each painting session; if paint dries on the brush, it is impossible to get out completely
Paint binds well to any non-oily support (including thin watermedia papers, watercolor board, Aquabord, and 300-lb. watercolor paper)	Any support can be used for thin applications; rigid support (such as watercolor board, Aquabord, or 300-lb. watercolor paper) should be used if working juicy opaque

Defining the Differences between Gouache and Casein

When I am instructing watermedia workshops, one of the most frequently asked questions is, "What is the difference between gouache and casein?" This is an excellent question because these media appear to be very similar. I describe gouache as having a "chalky-matte" finish when used transparent to opaque. This makes sense because white participated chalk pigment is added to the colorant to give gouache opacity or body. I describe casein as having a "velvety-matte" finish, which, to most eyes, looks like gouache. Casein is a milk-based paint, and that is what determines its visual quality. Both media are very opaque, even when painted light over dark.

The main differences between these two paints then are their handling qualities.

Coverage Power By coverage power I mean how large an area can be covered with a juicy brushload of paint. Casein comes in 37-ml tubes, and the paint has a soft, buttery consistency. It is easy to load the brush and charge the mix on a dry or wet sheet of paper. The paint flows easily, and large brushes can be used to cover the support. Gouache, on the other hand, comes in 15-ml tubes. The paint is a bit stiffer and more concentrated than casein when squeezed from the tube, so it is harder to mix a large amount of paint and get a consistent and even paint application on the support. Basically, I use either gouache or casein when working smaller but always use casein when working larger.

Detail Gouache is the most opaque of the watermedia and can be thinned to achieve fine detail. Extremely fine, thin strokes can be made with light-colored paint over a dark area. Although very opaque, casein is not as opaque as gouache. Fine detail can be made with casein, even when painting light over dark; however, it cannot achieve the same razor-sharp edge as gouache.

Painting over Undercolor When painting in layers of color, casein has a decided advantage over gouache. Although casein remains soluble for a time after it dries, it does not lift as easily as gouache. Therefore, overlays of paint and buildup of color can be made with casein with little fear of lifting the undercolor. Gouache, on the other hand, remains water soluble forever. Many years after the work is painted, the paint can be softened or lifted with water. Therefore, any overpainting must be done carefully in order not to disturb the underlayer. Consequently, when I am painting in layers and building up the paint surface, I use casein.

Brushes The best sable or synthetic brushes can be used with gouache, and the brushes can be cleaned easily with liquid soap and water, even after the paint has dried on the brush. Casein, on the other hand, requires more care. I always use a separate set of older brushes when using either casein or acrylic. I always clean my brushes thoroughly with liquid soap and water after each painting session. Even more attention and care should be given if synthetic organic pigments, such as the phthalocyanine (Shiva) blue and green, are used. If casein dries on the brush, it can harm the performance of the brush.

FEBRUARY 14, 1995

I want my art to get closer to painting the light, sounds, and smells of the various seasons—not unlike Charles Burchfield, although in an entirely different way. I want to create the sound of crickets, the vibration of an evening star, and the silence of gentle snow.

Winter Night Sky, Bachelor, 38 x 30 inches (96.5 x 76.2 cm), watercolor and casein on 300-lb. rough Richeson Premium watercolor paper, Collection of Cary Bush and Randy Nicholson

The energy of a winter night sky in our mountains is incredible. The color of the stars ranges from blue-green to orange and the night air has a pulsating quality.

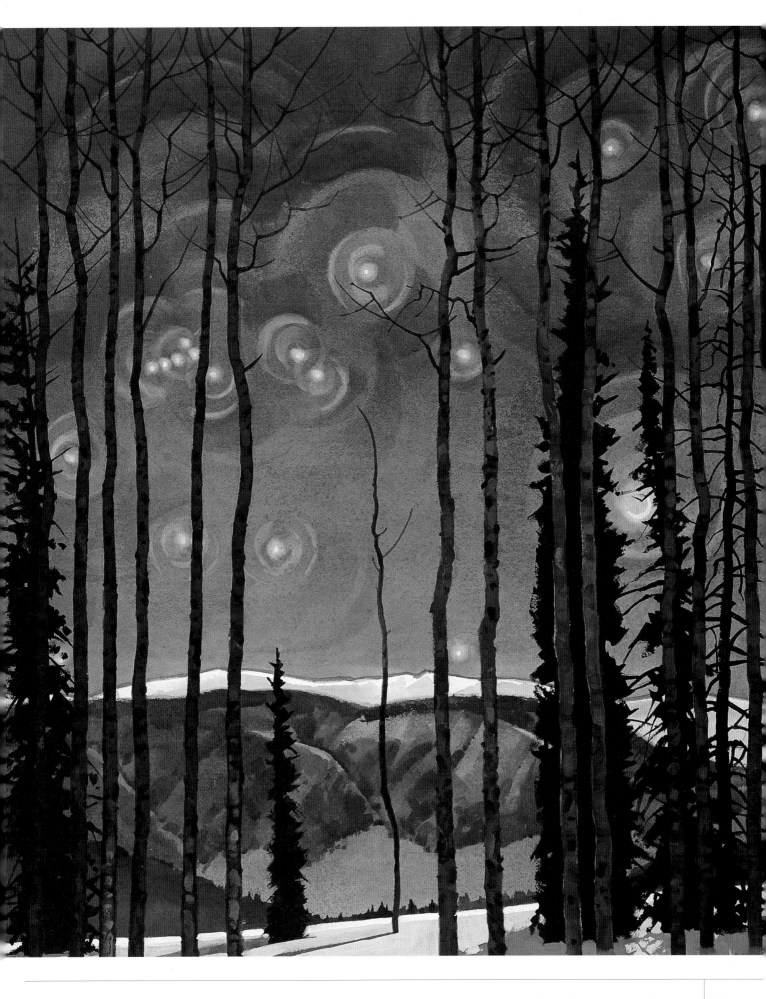

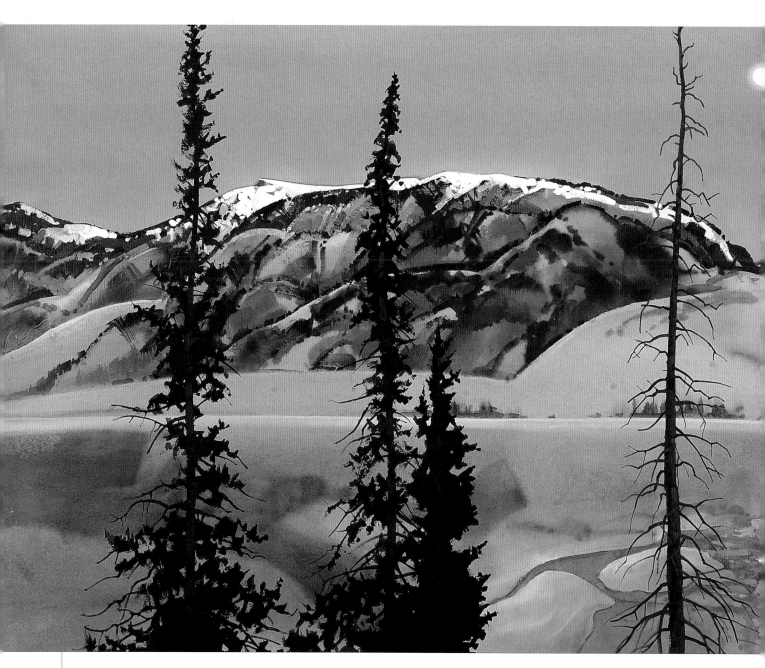

Trace of Dawn, November 16, 2005, 38 x 56 inches (96.5 x 142.2 cm), acrylic on 300-lb. rough Richeson Premium watercolor paper, Collection of Bryce and Johanna Milam

I woke up one mid-November morning to this view from our living room window. The early light turned the upper ridge of the mountain range orange, the sky was gray-violet, and the full moon reflected in the open water on the river below. I loved the vertical tree shapes, which overlapped the horizontal band to form rectangular shapes. The limited palette of orange and blue emphasize the isolated, solitary mood. I chose to work in a very large format to capture the expanse and drama of this landscape.

<div style="text-align: center;">

CHAPTER THREE

Essential Watermedia Supplies

</div>

I ONCE HEARD A STORY ABOUT THE MASTER watercolor painter John Pike. He was sitting by a tree with his art supplies. A student asked him what materials he would recommend for painting. He reached down, grabbed a branch, and promptly sliced one end to create some fibers. He then dipped the branch into a mud puddle and began a painting on his watercolor paper.

This story is meant to show that it takes more than quality materials to make a painting. Years of working daily with paint and paper is by far the most important thing. Nevertheless, materials *can* make a difference in the quality and character of a finished work. For instance, a rough watercolor paper responds differently than a hot press smooth paper; a flat, synthetic brush makes different marks than a round, #12 Kolinski sable brush. Not only that, but in many cases materials can make the process of painting easier for the painter. And, certainly, if the artist is interested in the permanency of his or her work, then the paint and support that is used is of utmost concern.

In this chapter I discuss the different watermedia supports that are available today, such as watercolor papers, watercolor board, and Aquabord. I provide an intimate, behind-the-scenes view of how a great archival watercolor paper is made. I describe different watermedia brushes, their character, and the ones that I choose for various watermedia applications. And finally, I detail the easels that are essential for all kinds of watermedia painting, including studio and plein air work.

Supports

One of the main tools we have as watermedia painters is the support—either traditional watercolor paper or an alternative support such as Aquabord. Many weights, surfaces, and brands of paper are available; all have unique characteristics, and these days most are archival. It is important to know your support well—especially what medium it is best suited for and what it can and cannot do.

The first key decision pertains to the weight of the support. If you're going to use gouache or casein and if you plan to apply the paint heavily, it is important to use a fairly rigid support. This is because these media are fairly brittle and can chip or crack during the expansion and contraction that occurs with a thin and flexible paper. I suggest using a 300-lb. watercolor paper, watercolor board, or Aquabord. If, however, you're planning to apply gouache or casein with more traditional watermedia techniques, you can safely choose a lighter paper. Acrylic can be applied to any support because it is a very flexible medium and adheres well to any non-oily surface. Of course, watercolor paint can be applied to practically any support, including all weights of paper, watercolor board, and Aquabord.

The second main consideration is the reflective quality of the surface of the support. With traditional watercolor paper, three surfaces are available: hot press, cold press, and rough. Again, which surface you select depends on which medium or media and which techniques you intend to use. When working with watercolor by itself or watercolor in conjunction with any other watermedia, I tend to select rough paper because this surface more fully shows the granulation of the pigment as well as the sparkle of the paper when a dry brush scumbles across the paper surface. When utilizing layering watermedia applications, I usually choose a smoother surface, such as a cold press watercolor paper. This is because the light reflects more directly off the paper and the paint, giving a rich visual quality. Cold press watercolor board or Aquabord also works well for this situation. (Since rough paper has deeper pockets, which allow the light to reflect at various angles, it does not have as rich a visual quality.) Hot press paper has a very smooth and slick surface. Paint can be pushed around easily on this paper and the paint can be lifted most easily from this paper. Brush marks and painted textures can also be created easily.

In this section I delve into the paper-making process, review various watercolor papers, focus on some unique properties of papers I use and how I go about maximizing them, and discuss both watercolor board and Aquabord.

Traditional Watercolor Paper

Perhaps one of the best ways to become familiar with watercolor paper is to examine how it is made. There are four major watermedia paper-making mills in the world: the Fabriano Mill in Italy (established in 1283), the Arches Mill in France (1492), the Lana Mill in France (1590), and the St. Cuthberts Mill in England (1736). They make most of the mold-made papers that painters use today. I had the opportunity to tour the St. Cuthberts Mill and observe the Richeson Premium watercolor paper in production. This is the paper I use most of the time. With minor variations, watercolor papers at all mills are produced this way.

St. Cuthberts Mill is located in the countryside of Somerset, England, just outside the cathedral city of Wells. The mill was originally built in the 1700s and to this day is a thriving commercial paper mill. Initially the mill created paper made by hand; today, the mill utilizes the mold-made paper process.

In the first step of the papermaking process, sheets of pure cotton (imported from the United

States) are placed in a large vat, or pulper. This cotton is mixed with water channeled from the nearby River Axe, which provides an uncontaminated flow of water that is naturally filtered by limestone rock formations. A rotor then begins churning the cotton and water together at the bottom of the vat. During this stage, calcium carbonate powder is added to the mixture to help combat acid attack, which the paper may endure from pollution. The resulting mixture is pumped out of the pulper and stored in a large bin.

Next, the mixture is sent to the refiner, a machine with blades that shorten the length of the cotton fiber; this step ensures the best possible weaving strength. This liquid is then sent to the stuff bin (pulp bin), where it waits to enter the mold machine. In this container, the fiber and water are constantly stirred, and inter-

Night Air, 20 x 34 inches (50.8 x 86.4 cm), watercolor and casein on 300-lb. rough Richeson Premium watercolor paper, Collection of Beth Davis and Mark Richter

I see this view when I walk home from my studio during the winter months. I used watercolor for the sky because of the granulation and because it lifts easily from this externally sized paper.

nal gelatin sizing is added to the solution. The amount of internal sizing added at this stage determines how much moisture can soak into the sheet. Without this sizing the paper would act like blotting paper, instantly sucking up the paint and leaving no time for manipulation.

This fibrous liquid, which contains 99 percent water and 1 percent fiber, is then fed into a cylinder mold, a large cylindrical drum covered with a fine, bronze mesh. This drum is half immersed in the pulp and, through the use of a vacuum, it sucks the pulp against the wire screen to form a

NOVEMBER 30, 2007

Being in the present and not allowing the racing mind to introduce past or future clutter is like tuning in to a radio station at a certain frequency. If the dial slips up or down in the slightest, the words become garbled, but if it is in exactly the right place the sound is loud and clear. It is difficult to find that frequency and harder still to hold it, but that is where the "channel" or pure consciousness comes in, and this is where the guidance and bliss occurs.

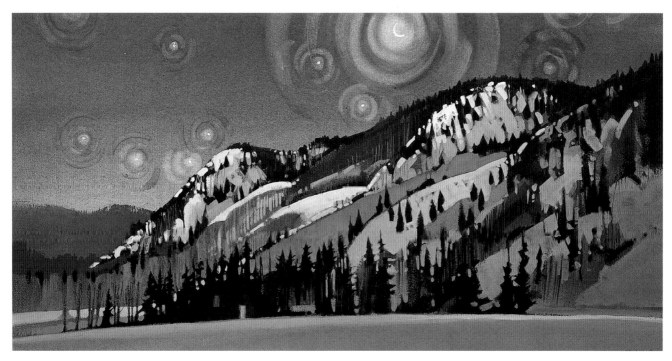

layer of paper. The faster the cylinder turns, the less pulp will attach to the screen, and the lighter the paper will be. (For instance, a rapidly turning cylinder will create a 140-lb. paper, while a slower cylinder will make a 300-lb. sheet.)

This screen has a slightly raised ridge, called a tear strip, that runs horizontally across it at one place on the drum. On a finished, dry sheet, the tear strip creates a thin line in the paper that can be easily torn to give the paper its deckle. The drum also features a raised metal watermark that imprints the paper with the mill's trademark seal. At the end of this process the paper is 85 percent water and 15 percent fiber.

The damp paper is then sandwiched between two revolving woolen blankets. These blankets determine the texture of the paper; the rougher the blankets are, the rougher the paper will be. Once the paper is pressed it is 65 percent water and 35 percent fiber.

After being pressed, the paper is passed through steam-heated cylinders, which remove excess water. The continuous sheet is then immersed in a solution of gelatin sizing. This external sizing actually coats and penetrates both sides of the outer layer of the cotton fibers. This step regulates how easily paint can be lifted from the sheet.

If it is to become hot press paper, the mixture moves through a vertical system of rollers that press the sheet, creating a smooth surface. (Cold press and rough watercolor sheets skip this stage.) The continuous sheet is then wound onto a large paper roll that contains about 2,000 pounds of paper. From start to finish, one ton of mold-made paper takes nearly five hours to make. At this stage, computers monitor the weight and the moisture content of the paper.

A single sheet from the finished roll of paper is then sent to the lab, where tests are performed to ensure that each batch is uniform and meets the same high standards. Some of these tests relate to the following:

Paper Strength The paper must withstand scrubbing, scraping, scarring, and the removal of masking fluids. Both external and internal paper strengths are tested.

Water Absorbency This test determines how slowly and evenly water soaks into the watercolor paper. It also determines whether there is too little sizing (soft sizing), which would allow the paint to bleed or "feather," or whether there is too much sizing (hard sizing), which would allow the paint to bead, slide, and skip on the surface.

Surface Quality An even tone of watercolor (ultramarine blue deep) is washed onto the sheet to see if there are any imperfections.

Surface Texture As discussed above, woolen felts create the texture on the paper. Over time these felts can wear and the pattern that they make on the paper can break down. To check for quality, extreme long-raking light is shone on a sheet from a previous batch and a sheet from the present batch; the two sheets are then compared.

Color A color-reading machine that simulates sunlight is used to check the shade of the paper. The sheet is also inspected under different light sources to ensure that the shade doesn't change when it is placed under artificial light.

Weight The sheet of paper is weighed on extremely sensitive scales to make sure that it is the correct weight.

After all of these tests have taken place, the roll of paper is inspected by hand for imperfections and then hand-torn into 22 x 30–inch sheets with deckle edges. Any rejected sheets are sent back to the pulper to undergo the papermaking process once again. Five sheets are removed from each roll of finished paper, documented, and preserved in a vault. If, in the future, an artist has a problem with a sheet of paper, the company can determine which batch the problem paper came from. The remaining sheets are sorted and packed.

JUNE 15, 1994
So many times we walk through mountain meadows and take the wildflowers for granted. Maybe we see them as a part of the whole, but rarely do we take the time to sit down and look at them—their shapes, textures, patterns, and colors.

Wild Iris off Phoenix Park Trail, 29 x 19 inches (73.7 x 48.3 cm), watercolor on 300-lb. rough Richeson Premium watercolor paper, Private Collection

I take a few days each year to spend time with these beautiful flowers. Their color and sensuous physical nature are unique to our terrain and offer a feast for the eye.

Evaluating the Benefits of External Sizing

Since the late 1980s I have been using watercolor papers that have an external sizing. This gelatin sizing is added during the final stage of the paper-making process and coats both the front and back of the paper. Having this sizing on the surface allows me to be more painterly with my various painting applications. Not only can I work from light to dark with transparent paint, but I can also lift paint off a dark layer by massaging it with clear water and a flat or round monofilament brush and then blotting the sheet with a paper towel. I can then glaze over that area with other, transparent watercolor. In short, I can work back and forth.

Keep in mind, however, that using externally sized paper is not a cure-all method. If the paper is presoaked or continually brushed with color and water, the sizing will come off. In addition, painters who favor transparent glazing techniques generally select papers without external sizing, as the surface sizing can disturb the overlays of paint.

Here are some papers that I have used over the years with very good results. All have external sizing.

Richeson Premium This slightly off-white cotton-fibered watercolor paper has an organic rough texture.

It is archival, takes abuse, and is a tough paper. It comes in a variety of weights and in both cold press and rough. I do most of my work with this paper, and in fact the watercolor blocks have my painting on the packaging. This paper can be ordered in 40 x 60–inch sheets (available in 300-lb. weight, both cold press and rough), which are shipped in packages of ten sheets. I use these sheets all the time and cut them into various shapes for my large watermedia paintings.

Saunders Bockingford This wood-pulp-fibered watercolor paper is available in white as well as in a variety of tints, such as blue and tan. It lifts probably the best of all of the papers and comes in 140-lb. cold press.

Lanaquarelle This bright white, 100 percent cotton, acid-free watercolor paper is softer and more uniform in texture than the others, but it lifts extremely well. It comes in a variety of weights and in cold press, rough, and hot press.

Saunders Waterford Endorsed by the Royal Watercolour Society of England, this off-white and tough watercolor paper has a nice texture and lifts very well. It comes in cold press and rough and a variety of weights.

Watercolor Board

Watercolor board is simply a sheet of watercolor paper, usually 140-lb. or lighter, that is mounted either on rigid cardboard or on heavy-duty, ⅛-inch-thick white core acid-free board. This board prevents the paper from buckling. I use #5114 Crescent watercolor board for some of my watermedia painting, particularly when I am layering the paint. This support features a cold press paper; however, hot press paper is also available (#5115). In addition, both kinds of paper are available on acid-free boards.

Aquabord Watercolor Studies

Obtain a small piece of Aquabord. (A piece 12 x 16 inches would work just fine.) Set up a twelve-color transparent watercolor palette. Work wet-on-wet and with flat washes. Lift the color back to the white board. Play with the paint and explore what effects you can achieve.

Aquabord

One of my favorite traveling companions and friends is the artist Charlie Ewing. We have painted together in Mexico, Canada, and the western United States. He is an incredible painter who used to be an outfitter and a guide. He is one of those people who can do just about anything. Many years ago he invented a painting support by laminating a thin, even surface of kaolin clay to hardboard. He used this material for his scratchboard and much of his painting work. Today this invention is commercially available as Claybord, a product at the heart of the internationally known company Ampersand.

Aquabord (which used to be called Claybord Textured, as it is similar to Claybord but has a rough surface) is made for watermedia, especially watercolor. It will take wet-on-wet washes and can be used with all of the various watercolor techniques. It takes the paint beautifully but differently than any paper or other support I know. The paint seems to melt into and become a part of the clay, much like paint is absorbed into a lime fresco surface. Watercolor paint lifts readily even after it is dry and thus Aquabord can be used to achieve very painterly effects.

I use Aquabord occasionally for watercolor paintings but primarily I use it for acrylic and casein paintings. The paint layers absorb beneath the surface, and layers of paint can be built one over the other easily, making it an ideal support for acrylic transparent to opaque applications. In addition, because the support is rigid, thick applications of casein or gouache can be applied to Aquabord without the fear that the paint will crack.

When using Aquabord, keep in mind that it is not paper and it accepts the paint very differently than paper does. It may take a few attempts to get the feel of the surface. However, it is well worth the effort. When the watermedia painting is finished, acrylic varnish can be applied to the surface of Aquabord and the painting can be shown without glass.

Aquabord Acrylic Studies

Obtain a small piece of Aquabord. (Again, a piece 12 x 16 inches would work just fine.) Set up a thirteen-color acrylic palette. Begin by washing transparent, rich, and vibrant undercolor washes of warm colors, such as pyrrole orange and quinacridone magenta. When the paint is dry, build a translucent, cloudy layer of complementary cool green and blue-green (phthalo green and phthalo blue) mixed with white. Leave some of the transparent underlayer open. Finally, with the same cool colors, build solid, juicy opaque areas with the acrylic, leaving some of the previous layers exposed.

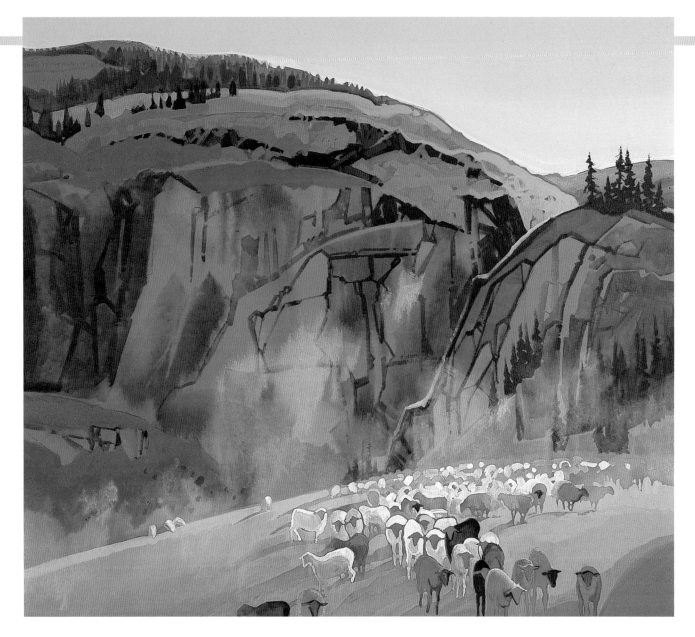

High Country Dust, 32 x 34 inches (81.3 x 86.4 cm), acrylic on Aquabord, Collection of Russ and Bonnie Weathers

I did a couple of quick small watercolor studies on-site and then worked up this painting on Aquabord in the studio. The paint seemed to melt into the clay of the support and the interaction between the fluid acrylic wash and the porous surface helped generate a dusty quality.

April 25, 2007

The key to a good life is finding the balance: time for painting, time for friends and family; time for teaching and giving back; time for contributing to the community. I find that this balance is always changing; it is not the same from year to year.

Brushes

The brushes that an artist uses affect the look of his or her paintings. This is especially true with watermedia painting, so brushes need to be selected carefully. When painting with watermedia I look for the flow of the paint on the paper or other support. I look for brushes that hold a lot of color, have a good snap, come to a sharp edge or point, and hold up well. These brushes can be a synthetic bristle or a natural hair. For complete watermedia painting, a synthetic brush is definitely the best, while for transparent watercolor a good synthetic brush can be great, but for delicate or sensitive marks or glazing over watercolor layers, a good Kolinsky sable brush may be the best.

Keep in mind that these brushes all come in flat and round fiber shapes. These two styles generate different kinds of marks. The flat brush makes a more chiseled mark, holds a lot of water, and lifts paint with a more "blocky" mark or wide to thin shapes. Large flats, such as 2- to 4-inch brushes, are excellent for large wet-on-wet applications. A round brush is great for more rounded marks, such as floral shapes, or for thin, linear marks or detail. Similarly, a round brush used for lifting paint will make a more rounded light shape. I personally use flat brushes for 80 percent of my painting. This is because I live in angular country, filled with cliffs, mountains, evergreens, and waterfalls.

Since 1991 I have been using the Watercolor 7000 Series synthetic brushes made by Jack Richeson, brushes that now have my signature. To shape this brush, eleven different lengths and thicknesses of monofilament are used. Its unique composition features a razor-sharp edge or point to make crisp marks for my landscape shapes, a good belly to hold a lot of paint, and durability to withstand scrubbing and general abuse. This series is by far the best overall watermedia brush that is made. The round brushes come in a wide range—from a very tiny #000 to a giant wash brush #24. Personally I use #7, #10, #12, and #24. The flats are available in a range of sizes, including a ⅛-inch, ¼-inch, ½-inch, ¾-inch, 1-inch, 1½-inch, 2-inch, 3-inch, and 4-inch. I use the ¾-inch through the 4-inch. A good starter set would be a #7 and a #10 round and a ¾-inch and 1½-inch flat. I use the 3-inch and 4-inch flats for the beginning stages of large paintings and the 2-inch, 1½-inch, and 1-inch flats and the #24, #12, #10, and #7 rounds for 95 percent of my painting.

Summer Aspen on Upper Huerfano, 29 x 19 inches (73.7 x 48.3 cm), watercolor and casein on 300-lb. rough Richeson Premium watercolor paper, Collection of Jackie and Charles Railsback

For this plein air painting I started wet and washed in the granulating red-violet and viridian neutrals. Then I lifted back the foliage areas and aspen trunks (with a 1-inch flat and a #12 round brush respectively) before adding the opaque casein.

Occasionally, however, I need a soft-haired sable brush to gently wash and glaze over under-layers of color. Sables are much more expensive than synthetics. The hair is extremely sensitive and can give beautiful marks when needed. However, they will break down and lose their shape, edge, or point with scrubbing and abuse. Generally, I use these brushes at the end of the painting when I need to add finishing glazes and unify the color. There is less chance of lifting the undercolor when an overwash is applied with a large, sensitive and soft-haired sable brush. I use the flat 1½-inch brush in the Richeson Kolinsky Sable #6229 Series for this work.

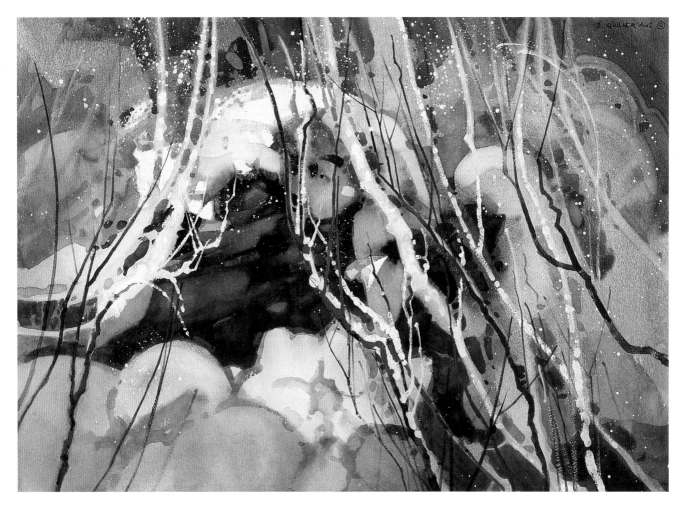

Warm Spring and Fresh Snow, Shallow Creek, 21 x 30 inches (53.3 x 76.2 cm), watercolor and casein on 300-lb. rough Richeson Premium watercolor paper, Collection of John and Carol Simmons

Angular shapes in many of my paintings require flat brushes. However, because of the curvilinear shapes in this painting, I used mostly round brushes, from a large #24 to a medium #10.

MAY 2, 1993

Painting is a combination of setting up strategies and then making decisions throughout the process. There is an open communication among the materials (the paint, brushes, and paper), the universe, and the artist—a three-way situation. We are simply a medium through which the expression can work.

Easel

Many different kinds of studio easels are available today, and they come in a wide range of sizes and prices. I work at least five months of the year in my studio because it is too cold to work outside. During the studio time of the year I usually work in more experimental watermedia, and many times I work very large. So I look for an easel that can accommodate large paintings, that raises or lowers the painting easily, and that holds up over time. I have had the Abiquiu Easel by Best Easel for many years with great results.

The choice of easel is especially important for the watermedia painter who wants to work on-site. Over the years I have used many kinds of easels and have observed artists using all kinds of setups. There are many things to consider when choosing an easel. Below is a list of questions to help you in the selection process:

How large do you want to work, and do you stand or sit while painting? You may need an easel that adjusts to various levels. I like to work large, and I paint standing up (often in rugged locations), so I need an easel that holds a large painting board, is very sturdy, and allows me to stand back to take a look.

How far will you be carrying the easel? The weight of the easel is an important consideration. You need to determine what you can comfortably carry. It makes a difference if you will be driving to the painting site or hiking a good ways before you begin your painting. Regardless of your travel plans, never reject a solid, sturdy product in favor of a light but weak one.

Does the easel have a tray or drawer where you can place your palette? I have seen many artists try to hold their palette, brushes, water, and paper towels while painting. This is impossible and will get in the way of a good painting flow. My easel has a pull-out tray, on which I rest my palette. To make sure it is stable, I secure it with a small bungee cord.

Is there a place to set or attach the water container? I use a heavy-duty binder clip to hang my water container from my palette.

Can the arm of the easel that holds the painting be adjusted easily to different levels and angles? Most of the time I work with the painting in a vertical position, but sometimes (such as when I want to apply a very wet wash or when I want to create pronounced granulation) I need to quickly move the painting to a flat position.

How well does the easel pack in a suitcase, fit in a backpack, or otherwise suit your travel needs? Some artists strongly prefer small easels that meet FAA requirements and that can be carried on an airplane.

With these factors in mind, I will give my recommendations for three easels with their advantages and disadvantages. No matter what easel you choose, it is important to occasionally go through all of the fittings and tighten them. I carry an all-purpose screwdriver, pliers, and knife tool inside the drawer of the easel.

Julian Original French Easel

Many French-style easels are on the market, but this is the original from which all others have derived. The legs can be adjusted to whatever height and angle are needed. The half (backpacker) easel is best when hiking to a remote location, while the full easel is best when painting close to your mode of transportation. When traveling by plane, the full easel is bulky and heavy, so I opt for the half easel, which packs well. I remove the neck

JUNE 19, 2005

Nothing is better than having a good painting going and needing to continually take a peek from time to time. Objects are living things. Go beneath the surface to find the energy and the life force.

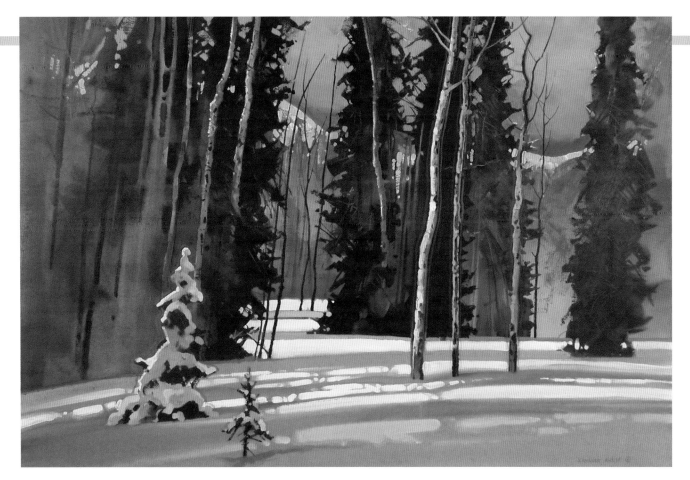

and adjustable base that the painting rests on and pack them beside the easel in my suitcase.

Soltek Easel

I have used this easel for many years with good results. While it is a little tricky to set up, once you understand how to arrange the easel for use or to put it back down, it can be done very quickly. I use this easel when I travel overseas because it packs so I can actually carry it on the plane. The carrying bag also houses my palette and brushes.

The one disadvantage to this easel is that the arm that changes the angle of the painting cannot be adjusted easily, especially when the palette is secured on the tray (as the legs need to be rearranged). So when using this easel I usually work vertical or totally flat, understanding that I will not do anything that requires quick change.

Eric Michael Easel

This 20-ounce easel mounts to a lightweight metal tripod. This easel assembles quickly, has a

Golden Light by the Cross-country Trail, 30 x 44 inches (76.2 x 111.8 cm), acrylic on 300-lb. rough Richeson Premium watercolor paper, Collection of Richard and Cathy Ormsby

I painted this image on my Abiquiu Easel in the warmth of my studio. A transparent yellow acrylic undertone helped me capture the golden light that permeates the forest in the late afternoon in January and February.

retractable brush holder sized to hold the most popular watercolor brushes, and fits in a small backpack or laptop-sized case, making it easy to transport and store.

If you work primary with one-quarter sheets (11 x 15 inch) or smaller, this easel will suit your needs. It packs easily, is easy to set up, and has a base on which to place your palette. It is also easy to rotate the painting from vertical to horizontal. The drawbacks of this easel are that it doesn't accommodate larger sheets and it doesn't stay in position in strong winds. However, for small sketches and paintings on a long trip or for hiking to the high country, this easel works magnificently.

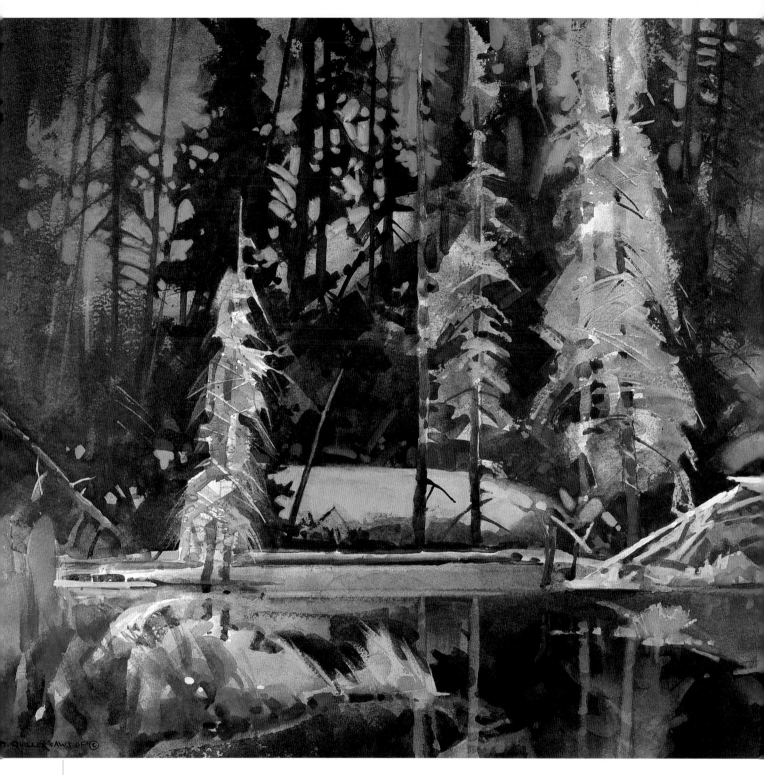

Beaver Pond off the Deep Creek Trail, 21 x 29 inches (53.3 x 73.7 cm), watercolor and gouache on 300-lb. rough Richeson Premium watercolor paper, Collection of John and Corina Deaver

I hiked three miles into the mountains along one of my favorite trails to do this painting. I carried all of my supplies in my canvas backpack. This is farther than I normally go with all of this weight. After doing a line sketch of the subject, I started with transparent watercolor and finished with some opaque gouache. When I completed my painting session it started to rain. I pulled out my plastic garbage bag, slipped my painting inside, and taped it shut. Then I proceeded on my long walk home.

Essential Watermedia Techniques and Combinations

MANY YEARS AGO I HAD THE OPPORTUNITY to visit the Musée Marmottan in Paris. This museum has the largest collection of Claude Monet paintings in the world. I began by viewing some of his early Impressionist paintings. I then went to the last room, where I viewed the water lily paintings that he made at the end of his life. In these later works each powerful stroke of paint conveyed the culmination of his life experiences. Monet's early dabs of paint led to that final level of mastery—pure genius on canvas.

All artists start with basically the same tools. However, these raw materials produce very different results, depending on who is using them. As we begin our painting journey, we fumble with the craft, but as we learn how to use our materials, we begin to express our vision. Each medium has its own energy and personality. Likewise, each artist has different facets and each one, at certain times, should be expressed. This can be done with the choice of materials and with the way the painting is executed, which is why it is so important to know your materials well.

Most readers will have a solid foundation in transparent watercolor painting, and therefore I do not cover such basic techniques as working with wet paint on wet paper, wet on dry, and dry on dry in this chapter. Rather, I outline essential, but slightly more nuanced, techniques for the watermedia painter. I also discuss numerous ways to use the various watermedia in unique and exciting combinations. And finally, I explore ways to combine watermedia with an array of drawing media.

Maximizing the Lifting Process

Lifting has become an integral part of my painting process. Most of the time, when I am using this technique, I am working in watercolor. However, there are certainly occasions where I am lifting when working with the other watermedia, including acrylic and gouache.

I have painted this way for so long that it now influences how I see the landscape—things like highlights on the ridges of a mountain, bright foliage in front of a dark forest, light aspen trunks in front of a dark background. I visualize these elements as I lift the shape to the white of the paper and then glaze back over the area with my color of choice.

When working with acrylic, the paint must still be damp in order to lift the color; once the paint has dried, it will not lift. When using the other media, follow these steps: To lift an area, first clean your brush in clear water and remove most of the water with a paper towel. Then stroke and lift, stroke and lift, stroke and lift the shape, cleaning the brush in between each stroke. If the color is lifted while the paper is damp, the lifted stroke will have a soft edge. If the color is lifted when the paper is dry, the edge of the shape will be somewhat harder or sharper.

Working in this way expands my repertoire of ways that I can put paint down on paper and thus creates a variety of visual qualities for the viewer to experience. Once you master the technique, lifting can become second nature. Here is a list of items that must be considered when using this technique:

Choose a paper that is externally sized. This is crucial; without this paper you will not be able to lift well.

Evaluate the color and value of the watercolor surface that is to be lifted. The tone of the paper where the lift will occur must be dark enough that the lift will show. If the area is pale, then no matter how well the color is lifted, it will be hard to see.

While learning this process, work in the studio whenever possible. Working indoors provides the ideal environment for lifting: some humidity, a mild temperature, and no direct sunlight.

When working en plein air, be aware of the humidity. If you are working in a damp climate, the paint will dry slowly. In these situations you can take your time, as you seemingly have all day to work the paint. However, if you are in a dry climate, such as the high desert of New Mexico or the mountains of Colorado, you must work very quickly. The paint will seem to dry as fast as you put down, so you must visualize the strokes and react quickly and intuitively.

Face the paper away from the sun whenever possible. This will protect your eyes from the white glare of the paper and will allow the paint to dry more slowly. In hot, dry climates with the sun shining on the paper surface, the color seems to bake on. It becomes next to impossible to remove the paint, even if the paper has the best external sizing.

Work in the morning. The light tends to be cooler and the air tends to be more humid in the morning than in the afternoon, which makes it easier to lift the paint.

Know the properties of the colors you are using for the undercolor. Are they sedimentary, mineral pigments or staining, transparent pigments? In general, the inorganic pigments are easily lifted, either wet or dry, while the staining colors are more difficult.

Determine the wetness of the paint on the paper. Is it wet, damp, or dry? The best time to lift is when there is just a dull sheen reflecting from the underwash.

Choose the right brush. A good synthetic brush, such as the flats and rounds in the Watercolor 7000 Series made by Jack Richeson, is the best. The monofilament is tough and will hold up to abuse, scrubs into the pigment and

paper well, and comes to a good point or razor-sharp edge. As for how to decide the size and shape of the brush, simply visualize the stroke to be lifted. Is it angular or rounded? Is it a large or small? Is it long, even, and cylindrical or is it tapered at both ends? Once you see the shape to be lifted, it is easy to decide on the brush to use.

I created these various marks using (from top to bottom) #24, #12, and #7 round brushes, then 1-inch and ½-inch flat brushes.

View off Slumgullion Pass, 29 x 21 inches (73.7 x 53.3 cm), watercolor on 300-lb. rough Richeson Premium watercolor paper, Courtesy of Quiller Gallery

This painting shows my approach to lifting. Although I painted around the bright aspens in the center, I lifted a number of shapes from a neutral wash base, including the larger trees to the right, the distant aspens on the mountain, and the sticks on the edge of the beaver dam.

Lifting Studies

Select a sheet of an externally sized watercolor paper and a variety of organic and inorganic paints. Wash a medium-value tone of each color on the paper and let the swatches dry completely. Take a clean, damp brush and remove the paint; experiment with both round and flat brushes. Notice the difference in how much paint can be removed—between the two types of colors and with the two kinds of brushes. Now try the same exercise but remove the paint while the paper is still damp. Notice how much more paint can be lifted.

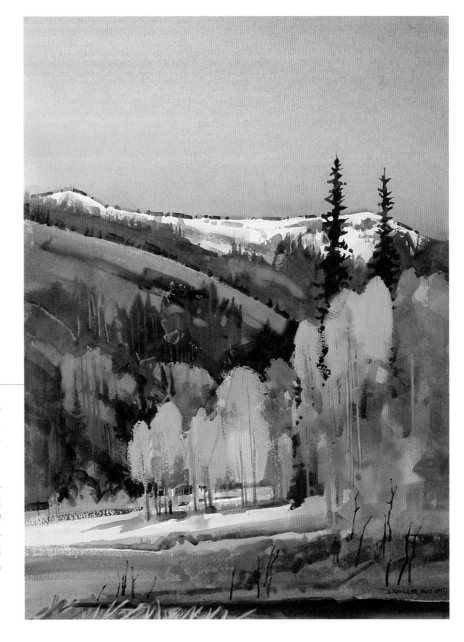

Using Various Watermedia in Combination

I have been experimenting and painting with all four of the watermedia featured in this book and their combinations since the early 1970s. To play with the different combinations of these watermedia, it is important to learn the visual qualities and handling characteristics of each paint and know when and why each can be used. Studying the chart on pages 72–73 will help you understand the watermedia; however, the best way to truly know each one is to dive in and get some "mileage on the brush." Soon each medium's characteristics will be evident. I must say that even though working with these watermedia has been my mission and way of life as a painter, I am just scratching the surface. I encourage each painter to push on and take this exploration further. Many possibilities have not yet been considered.

Watercolor and Gouache

Morning Light, View by Dolcote, England and *View by San Gimignano, Italy* are two examples of how I use watercolor and gouache in combination. The first was done in England, the second in Italy. Both are plein air paintings. I use gouache a lot with watercolor when working outside; in fact, most times when I am using these two media, I am working on-location and I am using a rough, externally sized watercolor paper. This surface is important because I am pushing distinct granulation to get texture into the landscape and atmosphere. I am also lifting and glazing, so the gelatin in the externally sized paper comes in handy.

In Somerset, England, in mid-September, the morning light is dense and heavy. Distant shapes are diffused, soft, and a bit cloudy. Closer shapes are crisper and clearer. Gouache and watercolor help me capture this feeling in *Morning Light, View by Dolcote, England*. I mixed

Choosing between Watercolor and Acrylic as Transparent Underpainting

When I work in a combination of watermedia, I begin with a transparent underpainting. And in this process I use either watercolor or acrylic, depending on the painting. (A step-by-step demonstration of an acrylic underpainting appears on pages 62–63.)

Here are the reasons I use for choosing one medium over the other:

Watercolor If I am working with transparent and opaque paint while working on location, I almost always use watercolor as the underlayer, because it is much easier to transport and to work with outside than acrylic. Also, when I work outside, I normally develop the transparent part of the painting much more, using the transparent medium for most of the work and adding the opaque medium toward the end. When working en plein air I lift the paint, show the granulation, soften edges, glaze over, scrape and scar the paint, and so on. In fact, many times paintings that I begin on location become mostly a transparent watercolor with some translucent and opaque watermedia applications, which I add at the end. When I use watercolor as the underpainting in a studio work it is for many of the same reasons—in short, it allows me to develop the underpainting to its fullest.

Acrylic Occasionally I have toned my watercolor paper with a transparent acrylic the night before and then worked with watercolor and gouache the next day on-site. However, most often I am working in the studio when I use acrylic as the transparent underpainting in a watermedia work. I use acrylic when I want a brilliant, intense transparent underpainting that will not lift when it is dry. There is nothing like acrylic for generating luminous color. It radiates beautifully through translucent overlays of gouache or acrylic. And the gemlike transparent color dances and shimmers when it is left uncovered and positioned adjacent to areas with opaque and translucent color applications.

white gouache into the watercolor to soften and diffuse the distant forms. The sky is actually an opaque soft yellow gouache. However, the closer architecture, tree, cows, and foreground meadow are pure transparent watercolor. I emphasized some granulation using cobalt violet and viridian green watercolor in the area from the middleground to the foreground.

The second example, *View by San Gimignano, Italy,* which appears on pages 102–103, reverses the approach used in the previous painting. I painted it in Tuscany, Italy, in October. As the image features both distant hill-and-field patterns and close grapevine forms, I wanted to create depth. I decided to work with a soft, diffused, and neutralized transparent watercolor for the distant forms. In the middleground I lifted the watercolor and added a glaze of yellow-green. To emphasize the depth, I wanted to have stronger value and color and some solid opaque paint in the foreground grapevine forms. At this time of year the vines change color from green to yellow and orange. I painted these vines in pure-hue transparent watercolor and then painted cool opaque ultramarine blue gouache around the shapes to set off the color.

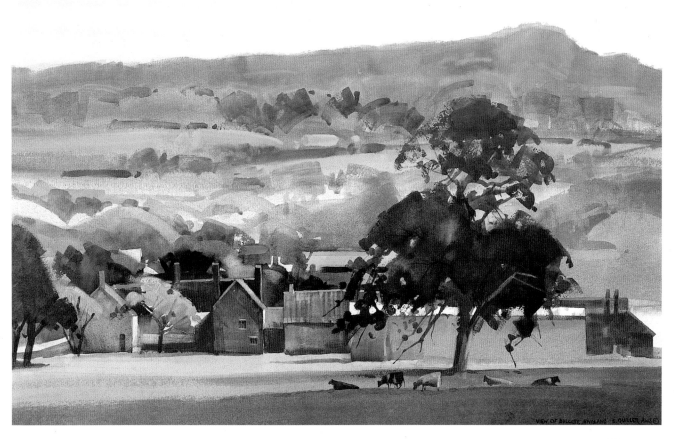

Morning Light, View by Dolcote, England, 21 x 29 inches (53.3 x 73.7 cm), watercolor and gouache on 300-lb. rough Richeson Premium watercolor paper, Collection of Ann and Alan Robson

I have returned to this region of Somerset, England at three different times in my painting career. I used white gouache mixed with watercolor to capture the heavy atmosphere in the background, then returned to pure watercolor for the foreground elements.

Watercolor and Casein

Lately, when I am working in watercolor and want to have translucent and opaque overlays, I find myself using casein (rather than gouache). The painting on page 127, although small, was painted with these two media. Mostly, though, I use casein with watercolor when working 20 x 30 inches or larger, and I do these works in the comfort of my studio. Many times I stretch the watercolor paper on stretcher bars, as described on pages 116–117. In most instances I choose a rough, externally sized watercolor paper because it shows the distinct granulation and has lifting capabilities. Using large flat and round bushes, I start with watercolor and play with granulation and lifting. Then I introduce casein; I find it has exquisite translucent and opaque visual qualities and works beautifully with the watercolor. The following are two paintings that use these two media.

I painted *Color of Winter, Dawn* on a 60 x 40–inch, 300-lb. watercolor paper that I soaked and stretched around 58 x 38–inch heavy-duty stretcher bars. I began with very wet transparent watercolor, using many granulating colors. I then lifted the aspen trunks and continued to develop the watercolor further. At a certain point I set up a casein palette next to my watercolor palette and started working back and forth. I created the halation of the background mountain in casein; it represents the dawn light creeping up behind the mountain ridge. I applied the casein translucently and opaquely, just listening to the painting and going where it needed to go. Finally I painted the two black spruce trees and the landform with ivory black casein. This rich, velvety opaque black sets off the transparent aspen in the center and the dead spruce on the left.

San Juan Mountain Still life, 34 x 26 inches (86.4 x 66 cm), watercolor and casein on 300-lb. rough Richeson Premium watercolor paper, Courtesy of Mission Gallery

The transparent yellow and orange watercolor poppies have more impact because they are set off by opaque casein, which is used in the distant mountain.

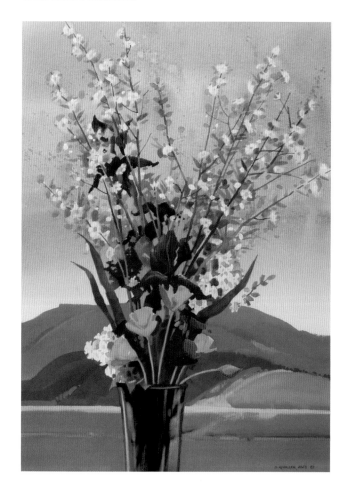

Wet and Juicy Studies

Tape a small sheet of externally sized rough watercolor paper, such as Richeson Premium or Lanaquarelle, to a thin plywood or Masonite board. Select a subject, such as an abstract floral design, that could be presented well with a wet and juicy application of paint. Wet the paper and then quickly apply cool, granulating watercolor paints, such as ultramarine violet, manganese violet, and turquoise green. Work flat, and while the paper and paint are still wet, shake the board. When the paint is dry, place a selection of warm-tone casein or gouache paints plus white on your glass palette. This could be a cadmium yellow light, cadmium orange, and a quinacridone rose. Mix these colors with white and paint translucently and opaquely around some of the granulated shapes to form the flowers.

June 8, 1993

People think that to have a style one needs to stay with the same medium and paint the same or a similar subject. That could not be farther from the truth. In fact, this inhibits growth and creativity.

The style is in the mark. It is like your signature. Throughout life your signature continues to develop until it is unmistakably your own. That is how it is with painting. The more one paints, the more one's style is refined.

Color of Winter, Dawn, 58 x 38 inches (147.3 x 96.5 cm), watercolor and casein on 300-lb. rough Richeson Premium watercolor paper, Collection of the Artist

I chose to use a vertical format and to work very large in order to play with the lifting, granulating, and mixed media applications in this painting.

The inspiration for *San Juan Mountain Still life* came from a floral arrangement that was in our home. I placed it in front of our living room window and created a few line drawings and compositional sketches. I then took the still life to my studio and began painting. I started with transparent watercolor and a 3-inch flat brush, applying a wet background wash of warm tones. I then charged in some manganese violet, placed the paper almost flat, and let the granulating pigment settle into the crevices of the paper. While the paint was still damp I lifted the white flowers that are in the sky area and completed the vase and flower forms in transparent watercolor. Next, I painted the solid blue mountain form and valley in casein. While the paint was damp I lifted the lower horizontal bands and then glazed the yellow-green over with watercolor. The opaque blue of the mountain sets off the transparent, brightly colored flowers. Finally, I painted some opaque light emerald green casein to set off the large red-violet iris in the center of the still life.

Acrylic and Casein

I must admit that I love working with these two media and have been doing so since the early 1970s. As I mentioned earlier, acrylic is by far the most vibrant and intense of the watermedia when used transparently. I love the rich glow and color that it offers when it is left open or glazed translucently with casein. I also love the play of the luminous acrylic and the velvety-matte casein. The transparent acrylic does not "seal" the paper with a plastic film but rather just stains the paper. This allows the overlay of casein to bind to the fibers of the paper.

Many times when I work with these two media I use a cold press watercolor board, rather than a rough watercolor paper. Color is paramount to the interaction of these two media, and the reflected light bounces more directly to the eye from this flat surface than it would from a rough surface. This smooth surface also makes it easy to layer the combination of the two media. Let's look at two paintings executed with acrylic and casein. One is a summer scene that I did as a demonstration in my Creede Studio Workshop; the other is a winter scene that I made from black-and-white studies of the view from my studio window. I should mention that this approach can also be done using gouache instead of casein. The visual qualities are similar, and actually it is very easy to lift a gouache overlay back to the acrylic underlayer.

I think *Aspen Patterns and La Garitas, August* truly demonstrates the visual qualities that can be created by juxtaposing the vibrant transparent acrylic and the velvety translucent and opaque casein. I created this painting from a watercolor and gouache study I had done earlier on-site. I wanted to capture the genuine rich feeling I have about summer in the Colorado high country. I began with intense transparent washes of yellow, yellow-orange, orange, and burnt red acrylic and let the paint dry. I then worked entirely with casein, starting very loosely with the paint and on occasion scraping and spattering. I intentionally left some of the transparent acrylic open and in some cases washed the casein translucently to form a cloudy veil on top of the acrylic. I then built up the aspen foliage patterns with opaque casein and popped in the dark spruce. Finally, I introduced the translucent and opaque cool violet and ultramarine blue casein to give the painting substance and a foundation.

Aspen Patterns and La Garitas, August, 19 x 26 inches (48.3 x 66 cm), acrylic and casein on #5114 Crescent watercolor board, Collection of the Artist

Using an on-location color study as reference, I worked in the studio to capture this expressive image with transparent acrylic and translucent and opaque casein.

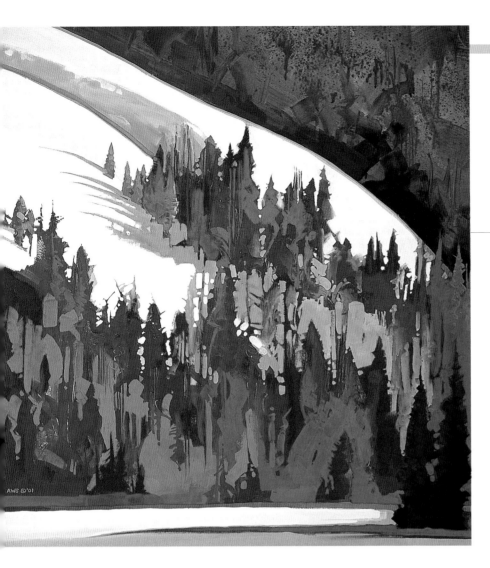

February Light, 28 x 29 inches (71.1 x 73.7 cm), acrylic and casein on #5114 Crescent watercolor board, Collection of the Artist, Recipient of the Philadelphia Watercolor Society Award from the National Watercolor Society

I paint the mountain across the road from my studio at all times of the year, but something special happens when the February light is on the mountain.

I love early spring light, especially in the late afternoon when the light is long. I observe the extended shadows as they move across the snow. The subject featured in *February Light* is found on the mountain next to my studio. I began with transparent acrylic, working in the upper right triangular wedge that represents the distant mountain forms that are in deep shadow. I used violet, green, and blue acrylic in a loose and painterly approach. When that area was dry I wet the rest of the painting and washed in warm, rich yellow-orange, orange, red, and red–violet transparent acrylic. When the paint was dry I painted large dark violet general shapes in a mass where the spruce shapes were and let the paint dry. I then began building around and forming the evergreen forms by negatively painting with opaque casein. This negative painting creates the illusion of the spruce and mountain patterns. I used rich blue-violet in the lower area, lighter cerulean in the central area, and warm white (representing the snow) in the upper area. Finally, I used ivory black casein to form the two spruce trees at the lower right and as a glaze in the shadow next to the sunlit ridge.

Dark-to-light Studies

Choose any subject—a still life, figure study, landscape, or an abstract composition. Wet the surface of a small sheet of watercolor paper or watercolor board. Then paint a dark field of acrylic on the support. When the paint is dry use casein or gouache and build translucent layers in medium-value and then lighter-value colors. Finish with some opaque notes of the lightest, near-white paint.

Combining Watermedia with Drawing Media

My basic philosophy on watermedia painting is simply that anything can work as long as the media are permanent and compatible with one another. In the late 1800s, when Edgar Degas worked with pastel it was generally thought that pastel was just a sketching medium and would not last. However, Degas's pastels are as fresh today as they were when he painted them. So my feeling is that if a medium or combination of media is needed to best represent the image, go ahead and use it.

I have found that many drawing media can be used beautifully in combination with watermedia. Ink, graphite, colored pencil, and oil pastel can be helpful. However, I most often use charcoal and pastel with my watermedia, for two main reasons. First, both charcoal and pastel dissolve and melt when water is added. (Many pastels are made with a gum arabic binder, which is probably why they dissolve so well and hold so beautifully.) The pastel mark can be left dry on top of the watermedia, it can be melted in to blend and create transitions with the watermedia, and it can be drawn into a wet passage, which allows the medium to dissolve somewhat and give a rich mark of color. Second, the dry pastel mark has a visual quality that is similar to both gouache and casein. Therefore, these drawing media are not only compatible, but they feel right when interacting with gouache or casein.

The studies on the bottom of the facing page show the drawing media I use the most with watermedia. The study on the left features a compressed charcoal stick by Yarka. At the top are dry marks of the charcoal. In the center I took a flat brush dipped in water and dissolved the charcoal; the resulting effect looks like a watercolor wash. At the bottom I wet the surface with clear water and then drew into the area; the mark melted into the water, creating a rich and velvety appearance.

The study on the right uses yellow and orange Unison pastel. At the top I made some dry marks with the pastel. In the center I took a flat brush dipped in water and washed into the pastel; it dissolved to look like a watercolor wash. At the bottom I wet the surface and drew directly into it; the pastel mark melted to form a solid, sensuous line. These drawing applications can be very beautiful in combination with the watermedia. Here are a few paintings that utilize this approach.

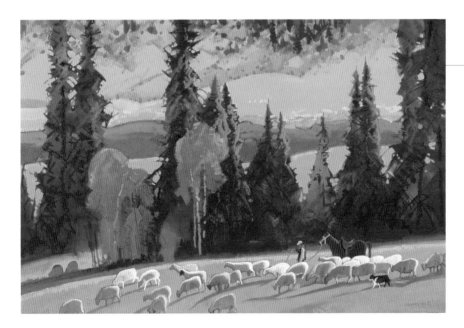

Sheep Drive, San Juan Mountains, 26 x 34 inches (66 x 86.4 cm), acrylic, casein, and charcoal on 300-lb. rough Richeson Premium watercolor paper, Collection of the Artist, Recipient of the Winsor & Newton Award from the American Watercolor Society

This image began with an ultramarine blue acrylic undertone. I then worked with charcoal and casein to complete the painting.

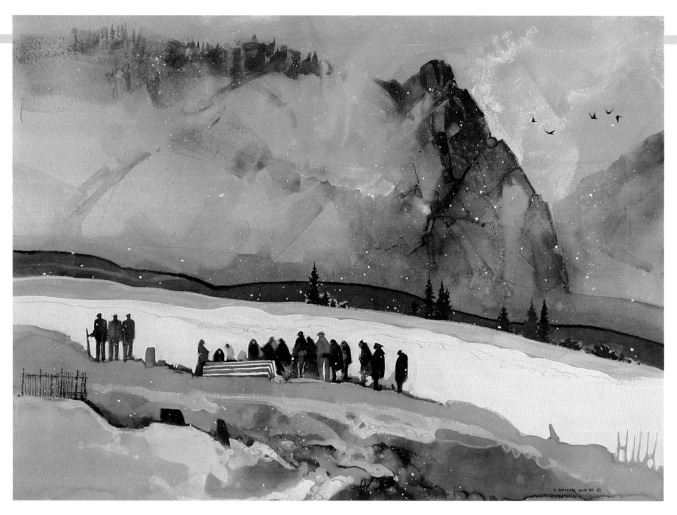

The Flag, 28 x 44 inches (71.1 x 111.8 cm), watercolor, casein, and charcoal on 300-lb. rough Richeson Premium watercolor paper, Collection of the Artist

In contrast to most of my work, this painting uses predominantly neutralized color. Crows swirl by the cliffs and snow-filled sky and the stark, silhouetted figures are set off against the snow. I employed charcoal for this painting because it is burnt and comes from the earth.

Charcoal pigments dissolve easily with water and can work very well with all watermedia.

Dry pastel has a visual quality similar to casein and gouache; like charcoal, it dissolves easily with water, creating wonderful effects.

I had been a pallbearer for a military funeral on a stormy winter day in Creede. It got me thinking about the lives that have been sacrificed for political conflicts, and about the families and communities throughout the world that have been powerfully affected by these losses. I decided that I needed to do a painting that would show a squally stormy day and a humble community gathered around a flag-wrapped coffin. The result is *The Flag,* which appears on the previous page.

The soldiers, in uniform and with their guns in place, stand at attention to honor this life. I chose to use watercolor for the initial medium, letting its granulation and neutral, earthy colors capture the day. I then used a combination of charcoal and casein. I melted the charcoal into wet areas to give a black mark that is from the earth. A lot of the figures in the painting were made from charcoal with some casein. I also used charcoal dry in the foreground and in the background cliffs for the same reason. I used the casein because it would appear translucent and opaque and because of its earthy-matte visual quality.

I used pastel in this next image, creating an entirely different emotonal impact. *Autumn in Blue and Gold #2* was the culmination of a number of small, on-location watercolor studies. I spent a number of days sketching outside at the peak of our autumn color. Back in the studio I stretched a large sheet of watercolor paper on stretcher bars, let the paper dry, and began the painting process.

I first used transparent watercolor and developed the overall composition, including a lot of the mountain and tree patterns and the river. I then set up my casein palette and spread out my set of pastels. I used these two media in combination, working back and forth between them. I left some of the pastel marks as they were and blended others into the other media. In the end, I applied many coats of an acrylic varnish to the painting and framed it without glass.

OCTOBER 27, 1995

It is important not to become too good or facile at any one medium. That is why I choose to work in a variety of media. The process can become too easy and slick if I do not challenge myself. Part of my interest in the painting process is the probing and searching and listening to the painting. Each painting should take its own direction.

Autumn in Blue and Gold #2, 28 x 44 inches (71.1 x 111.8 cm), watercolor, casein, and pastel on 300-lb. rough Richeson Premium watercolor paper, Collection of John and Carol Simmons

This painting is about the soft diagonal rhythmic movement of the mountain and tree patterns flowing to the water's edge. I incorporated soft pastel to get some expressive linear marks.

Drawing Media Studies

Experiment with various drawing media. Start with charcoal or pastel. Put some marks down on any watermedia support. Then take a large flat brush and water and go over some of these marks. While the paper is still wet, draw back into the surface with the charcoal or pastel. Allow yourself to play with these drawing tools. When the surface is dry, paint over and/or around your marks, using gouache or casein. Leave the exciting marks exposed. Paint translucently over some areas, so the drawing is still visible. Paint opaquely over other areas. While the opaque paint is wet, use your fingernail or a knife and scratch in a linear way back through to the underdrawing.

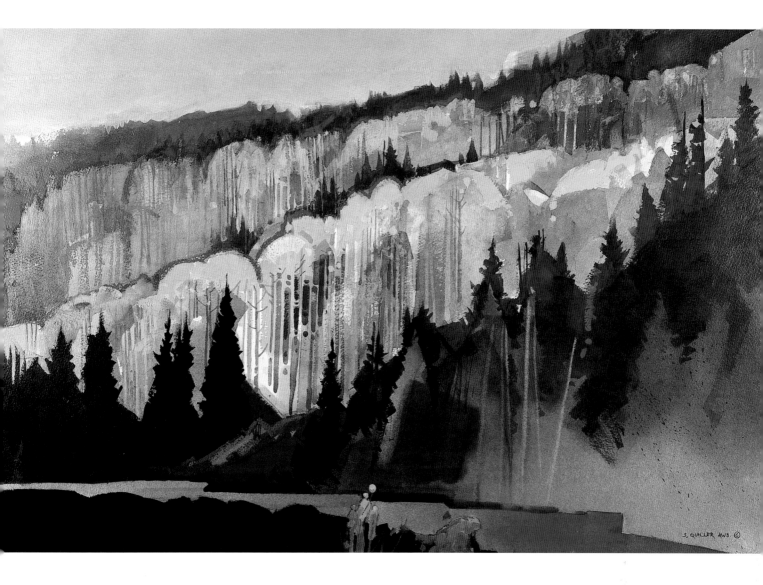

Controlling the Flow of Paint

I am often asked how I maintain control of the paint on a wet sheet of watercolor paper, especially when working with the paper almost vertical on an easel. Here are some techniques that will help you gain control during the wet painting process:

Always keep the paint on the brush drier than the paper. This means have more paint and less water on the brush. I check the paper to see how wet or dry the surface is. A very wet sheet will have a brilliant reflected shine while a slightly damp sheet will have a dull sheen.

Remove excess moisture from your brush with a folded paper towel. While painting, I always have a sheet of Viva's Job Squad in my right (nonpainting) hand. I can tell how much moisture and paint must be removed to make the brush and paint less moist than the paper. Sucking out most of the moisture from the brush leaves damp pigment that will hold when placed on the semi-moist to wet paper.

If you're having trouble maintaining control, keep the paper flat. In a wet stage it is easier to control the water and paint if the paper is flat or at a slight angle rather than vertical. However, with practice you will be able to control the paint on an almost vertical sheet of paper on an easel.

Know the painting characteristics of the watercolors on your palette. A heavily pigmented mineral or earth color, such as manganese violet, burnt sienna, or ultramarine blue deep, will sink into the paper and hold better than a lighter transparent pigment such as vermilion or phthalo green. The lighter pigments float and seep out of the painted areas much more easily than the heavier paints.

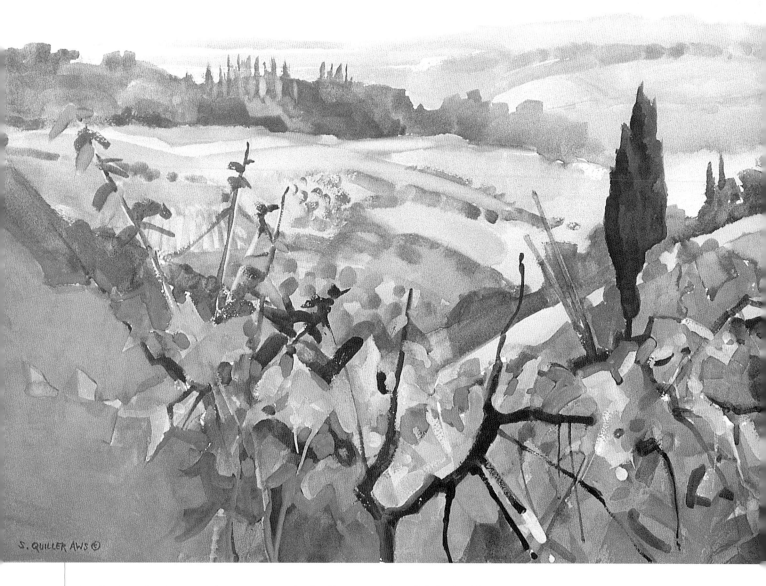

S. QUILLER AWS ©

View by San Gimignano, Italy, 21 x 29 inches (53.3 x 73.7 cm), watercolor and gouache on 300-lb. rough Richeson Premium watercolor paper, Collection of Esther and Deane Wymer

In the Tuscany region of Italy the blue-violet gray haze seems to hang constantly from October through November. I wanted to emphasize that quality in this painting as well as the strong color of the grapevines in the foreground. I spent the day painting this work while my friends explored the village of San Gimignano.

En Plein Air Painting and Working Large

IN THIS CHAPTER I WANT TO SHARE TWO aspects of my painting that are close to my heart and that I have learned a lot about throughout this painting journey: The first is painting in all of the various watermedia en plein air, and the second is working large with watermedia. Each process tests different skills and knowledge of the materials—but each is tremendously satisfying.

In 1983 I began teaching an annual watercolor workshop, sponsored by Adams State College, in Taos, New Mexico. It is always held during the second week of June so the weather is warm, the air is clear, the days are long, and the Southwest color is everywhere. Before this workshop, I was almost entirely a studio painter. I was outside a lot, but only sketching and taking notes and then returning to my studio to do the finished painting.

While walking around and making suggestions to the many workshop participants, I got the bug. I wanted to try working on-site myself. That summer I religiously went to the field, making small studies and attempting larger finished works. The first paintings were clumsy, and I struggled. The light kept changing; sometimes it rained; wind would gust and occasionally blow over my easel; bugs were sometimes a distraction; every once in a while someone would look over my shoulder and comment on paintings that their grandmother used to make. These were challenges that I did not have when working in the haven of my studio.

However, the more I worked in the field, the more I enjoyed it. There were things that I could get in my paintings on-site that I could not get when painting in my studio. Nature sounds and smells

and the energy of the landscape crept into my paintings. I realized that working en plein air helped my sense of observation. The more I worked outdoors the less I struggled in the studio.

Most days from May to October I am painting at a mountain site. Many times in the autumn or winter I travel for two weeks to four months to foreign countries and capture my experiences outside on paper each day. When working en plein air locally or in some exotic place, there is a point when I am lost in the painting process. The light, energy, and sounds; the flow of water, paint, and paper; the hand, mind, and eye become one in the process and time does not exist.

Although I consider myself to be a seasonal plein air painter now, I have always done a lot of studio works and consequently throughout the course of my professional development I have utilized numerous watermedia techniques. In this chapter, I provide tips that I have learned about painting on-location—both when going out locally for a day trip and when traveling to foreign countries for many months. I discuss a few essen-

tial techniques for working large in watermedia. And finally, I outline the steps for varnishing watermedia paintings, which is essential if you are going to work large. Hopefully these techniques and methods will help you to grow as a watermedia painter.

JUNE 6, 1993

Painting in such a dry climate as the one in southwestern Colorado has helped me become more intuitive and spontaneous in my painting process. I must make decisions as quickly as I apply the watermedia, because the drying time is so rapid. I do not have time to be methodical with my work. In this way, it helps me get in contact with a higher self, to be conveyed by senses rather than be analytical or contemplative.

View of Creede, July 24 x 34 inches (61 x 86.4 cm), acrylic and casein on #5114 Crescent watercolor board, Collection of Marne and Dan Wine

I have painted a number of views of my village at different times of year and in different atmospheric conditions. I made this painting during the warmth of midsummer.

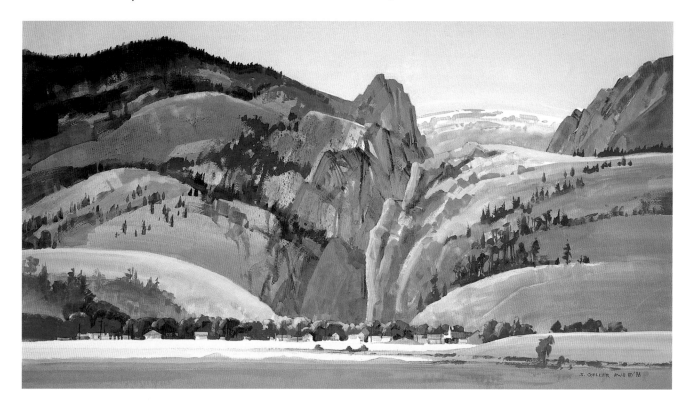

Painting with Watermedia En Plein Air

John Singer Sargent, a famous on-location water-color painter, would often excuse himself from social gatherings and dinners to get outside and paint. He referred to these times as his "emergencies." He loved these experiences in water-color so much that during his lifetime he would not sell the paintings. He felt that that would commercialize the process and these experiences would become a job rather than his passion. Because he did not sell these works, major museums such as the Brooklyn, Metropolitan, and Worcester purchased large blocks of the paintings toward the latter part of his life. Today, by appointment, you can go to the drawing and print study room of these museums and view a large collection of Sargent's paintings.

In this section I want to prepare you for having this experience of an "emergency." I will show you what I do: how I prepare myself at the beginning of a typical day of painting in my region; how I set up once I get to my desired location and my painting strategies once I begin; and finally how I plan for and maximize my time during foreign travels. Hopefully these tips will help you when you get the urge and will make your plein air painting experiences at home or abroad as meaningful as mine have been.

Painting in Twilight

Trying to capture twilight and night subjects is a fun challenge. As seen in the images on pages 45, 75, and 79, I have done a number of night paintings in my region. I have also found that in late May, June, and July the light hangs on in countries that areto the north, such as Great Britain, France, and Italy. I can start a twilight painting at 8:30 or 9:00 when the sun goes down and the light will shift very slowly to night. At times I can still be putting strokes on at 10:30.

If possible, I set up close to a streetlight or harbor light, but at times I am on a beach with no artificial light. The painting must be done quickly, and it can be hard to see the paint and paper well, so often I am painting by feel. This is when it is important to know the palette and the mix of colors. The next day, under normal daylight, I can adjust the painting. The work is usually much more spontaneous, the composition more abstract, and the color and value more pronounced than the paintings I create during the day.

Cassis, June Night, 22 x 15 inches (55.9 x 38.1 cm), watercolor and gouache on 300-lb. rough Lanaquarelle watercolor paper, Collection of Kay and Robert Carrel

This painting was inspired by the hues of dusk and the brilliant village lights, which reflected on the water.

Planning for Your Excursion

There is nothing worse than hiking in an area, discovering an inspiring vista, starting to set up your materials, and then realizing that you forgot a crucial item. When working en plein air, planning is critical. Below is a checklist of the items I take for a typical day trip in the high country:

French Easel Backpack This heavy-duty pack, made of 100 percent cotton duck canvas, is designed to carry a full easel and everything listed below. It is not meant to be used for major excursions, but I have carried it for three miles or more without too much discomfort. It also packs nicely in a suitcase.

Easel If I am going to hike a good ways, I will take my backpacker's easel (the half French easel). If I can drive to the site, I will bring the full French easel.

Watercolor Paper I like to use Richeson Premium watercolor paper (either rough or cold press), which is 22 x 30 inches. Occasionally, however, I will bring a quarter-sheet (11 x 15 inches) watercolor block.

Light Plywood Board (Optional: If you have a watercolor block, you do not need a board.) You can tape your watercolor paper to this board to stabilize it. My standard board is 23 x 33 inches because that is the size of the paper I use most. If you work smaller, take a smaller board. I tape a thin sheet of cardboard the size of the board to the back of the board on three sides to form a pocket. I store extra paper in this pocket in case I need it during the day.

Palette I bring the Standard Quiller Palette with the expanded selection of twenty-seven watercolor paints already arranged in it. The paint is dry so it will not leak when the palette is turned vertically while hiking. In addition, the Quiller watercolor paints contain honey, so they remain a bit moist and are easily reconstituted by massaging them with a wet brush or by pre-wetting the paint with an atomizer before beginning to paint.

French Companion (Optional) When I am not hiking but am painting close to my vehicle and planning to work in acrylic, casein, or gouache, I include this item.

Watercolor Paint In addition to having a tube of each of the watercolor paints on my palette, I also carry a few extra tubes of the colors I use most often or that I like to squeeze out fresh each painting session. These are Naples yellow, cobalt violet, viridian, cerulean blue, ultramarine blue deep, ultramarine violet, and manganese violet.

Gouache or Casein Paint I usually also bring a set of gouache or casein paints in case I need to add some opaque passages to a painting. Gouache tubes are small and light, but lately I have been gravitating more and more to casein.

Watermedia Brushes I carry a fairly large selection of brushes, all of which fit into a cloth container with a covered flap (the American Journey Brush Holder, which is 8 x 15½ inches folded). I bring ½-inch, 1-inch, 1½-inch, 2-inch, and 3-inch flat brushes; #7, #10, #12, and #24 round brushes (all Richeson Watercolor 7000 Series synthetics); a 1½-inch Richeson #6229 sable; and #7 and #10 sables.

Freezer Paper I fold a large sheet of freezer paper and keep it in the pocket of the backpack in case I decide to use other watermedia besides watercolor during the day.

Large Plastic Garbage Bag When it rains, this protects my board while I am carrying it back.

SEPTEMBER 4, 1996

To be able to interact with nature, with its sounds, with its smells, and with its various atmospheric moods, in this meditative state we call painting; to have someone else connect with this experience and feel some of what I felt; to change in some small way how this person perceives or sees this world—this is indeed incredible.

Plastic Quart Container I keep my painting water in this. If I am painting in an area with no water source, I fill it before I go; if there is a stream or lake nearby, I leave it empty and fill it once I get to my site.

Atomizer A small plastic atomizer is an important tool in dry climates to keep watermedia paint moist.

Small Metal Container and Binder Clip I clip the container to the edge of my palette. This is where I put my water while painting.

Masking Tape I prefer the thicker (1½-inch) masking tape. It helps attach the paper to the painting board. I like to use 300-lb. paper so I can cut it to any format, tape it down, and the paper doesn't buckle. Masking tape can be used for other purposes as well.

Bungee Cord I use this to hold my palette to the tray of the easel.

Sketchbook and Drawing Materials I take along a hardcover sketchbook and drawing material such as a wide-lined gel pen or litho crayon.

Paper Towels I like Viva's Job Squad. These are very heavy paper towels, so when my towel is saturated with paint and water, I place it unfolded on a bush or branch and let it dry while using another towel. When the second towel is soaked, I can then go back to the first towel and reuse it.

Pocketknife A small pocketknife is essential. Most often I use it to cut my watercolor paper down to the desired format, but it also comes in handy when I need to tighten a screw on an easel or slice an apple for lunch.

Wind Gust, Cathedral Woods, 33 x 20 inches (83.8 x 50.8 cm), watercolor and casein on 300-lb. rough Richeson Premium watercolor paper, Private Collection

I have a favorite sanctuary that I return to most autumns. Each time I push my paintings further—from more literal interpretations to paintings that are beyond the obvious.

Setting Up and Working On-location

Each winter I eagerly look forward to the spring, when I can begin a season of painting outside. This normally starts in late April and lasts to mid-October. As the season gets closer I visualize the locations where I want to work and the subjects I want to paint. This could be a favorite aspen stand, spring run-off in the high country, or a beaver pond that I had painted the year before. This gives me a bit of structure and a plan. Always, however, once the season starts, new inspirations take over—as new things happen each year. It may be a late spring snow in the mountains, a special sheep drive that comes through my area, or a waterfall that I discover on a hike. The season then reveals itself to me and I am open to it.

When I get to my site, whether driving or hiking, I will take out my sketchbook and do a quick line drawing of the subject. This helps me determine the format of the paper that I will use for the painting. While I sketch, I am determining how I will develop the painting, asking myself some questions, such as: How will I start? Will I wet the full paper, part of the paper, or will I start dry? What area will I develop first? Am I going to use some opaque paints, such as casein, in the painting? All of these questions have preliminary answers, which become apparent as I am sketching, meditating, and visualizing the process. These answers may change as the painting develops.

When I arrange my easel, if possible, I try to face the paper away from the sun to keep the glare off the paper. The paint will dry a bit slower and it is less harsh on the eyes. After I set up my easel and painting materials, I take a short time to meditate and commune with the subject and visualize the painting process. I see the painting path but also keep open to any changes or opportunities that may occur along the journey. This simply means that I do not lock myself in to only one way but remain open to the moment.

When a subject inspires me, I listen to it. I let it tell me how best to paint it, even directing me toward whether I should use watercolor, gouache, acrylic, casein, or a combination of these media to capture the experience. I work throughout the day, lost in my painting process. The challenges in working this long are that the light changes, shadows move, clouds come and go, and contrasts shift. It is important to keep the original inspiration and not change with the evolving day. Preliminary sketches and notes from the beginning of the day are very helpful in this regard.

I tend to work on a single large watercolor painting each time I go out. If you are just starting to work en plein air, I highly recommend that that you start small and do two or three paintings each time you go out. As you have success and begin to feel comfortable working on-location, then you can start to work larger.

Sometimes the elements of nature creep into a painting. In most cases this is great. It may be cold and your hands may be numb, making it

JULY 18, 1992

If one works and listens and looks long enough on-location, nature will reveal herself. Stay out in the weather and elements sketching or painting. Allow the smells, sounds, light, color, wind, and bugs to come into your painting. Get at the truth. It is internal, not external.

Emerging Spring, 36 x 26 inches (91.4 x 66 cm), watercolor and casein on 300-lb rough Richeson Premium watercolor paper, Collection of Mr. and Mrs. Robert Koets

I drove to this site along the Rio Grande and spent three days working on this painting. At one point a gust of wind blew over my painting board, overturning my palette and splashing water everywhere. I patched the painting but left a few interesting marks that happened during the event.

hard to hold a brush and robbing your marks of the sophistication that they would have in the warmth and quiet of your studio. In a good wind the painting board and paper may be constantly shaking. In addition, the arm and body may be braced and not relaxed. Thus the painting strokes might have variables that make them appear less than delicate. A few drops of rain might land on a damp area of the composition, creating some unexpected patterns. *Leave them!* They can add to the painting and let the viewer know that this was done on–site. The finished painting may not have the polished technique of a studio painting, but it will have an energy and feeling that you could never get in the studio. A certain integrity and honesty pervades work that is done from life; this energy is felt by the viewer.

When painting outside, I always stop before the work is complete. I find that at a certain point I am too influenced by the subject and it is hard to listen to the painting itself, so I bring it back to the studio for completion. Many times things are happening in the painting that cannot be recognized while looking at the actual subject. In the studio, I see with fresh eyes, and the painting has a new life. I then proceed with the direction the painting needs to go. I am reminded of the words of the great Canadian painter Robert Genn: "It is better to stop 5 percent too soon rather than go 1 percent too far." When the painting is taken too far it shows indecision and overworking. Viewers can feel this even if they do not have trained eyes.

Cabin, Yosemite, 26 x 18 inches (66 x 45.7 cm), watercolor and casein on 300-lb. rough Richeson Premium watercolor paper, Collection of Ginny and Jim Neece

I did this painting in a meadow in Yosemite National Park. I was inspired by the color and the texture of the foliage, the tucked-away cabin, and the brilliant blue sky that popped through the trees.

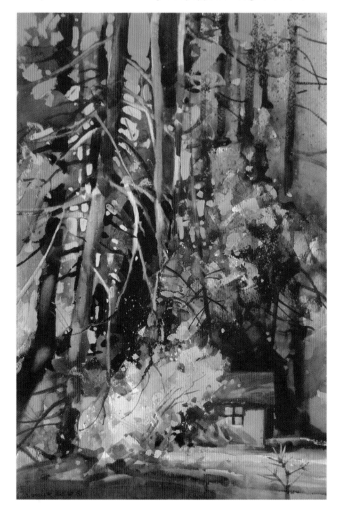

En Plein Air Studies

Find an area that inspires you, such as a city park or a country setting. Place your twelve-color or expanded palette of watercolor paints on the tray of a French easel. If you're working in other watermedia, arrange the corresponding colors plus white on some freezer paper on an easel. Use very small sheets of externally sized watercolor paper for this exercise; four sheets of 7½ x 11–inch paper will work well. Tape the paper down and work only with a 1-inch flat and a #10 round brush. Select a scene, work out the composition, and paint it quickly, trying not to capture every detail but rather to capture the main essence. Match the colors that you see with the colors on the palette. Do four studies in one session and do not spend too much time on any one study; thirty to forty-five minutes is ample time for each one. Stay at the same location but find different compositions by shifting your easel slightly to the left or right.

When I arrive at the painting site, I first try to find a fairly flat piece of ground where I can arrange my easel and paint. If I am working in watercolor, I simply set up my French easel, place my Standard Quiller Palette on the open tray, secure the palette with a bungee cord, attach my water container, and begin. If I am painting in acrylic, gouache, or casein on-location and I can drive close to the site, I like to use the French-style easel with the tray extended. I then place a French Companion palette on the tray. This portable palette comes in a hardwood oak box that opens to lay flat on the easel tray with the palette area in the center and an open container on either side.

When the French Companion is open I line the central palette area with a sheet of freezer paper. I then squeeze my paint around the edges of the paper. The freezer paper has a waxy surface, allowing paint to be mixed on it easily and facilitating quick cleanup. (At the end of the painting session I simply fold the paper with the leftover paint and dispose of it when back in the studio.) The two winged trays hold my water container, brushes, and tubes of paint.

If I am hiking and cannot carry the French Companion, I simply put some freezer paper in my backpack. Then, once I'm at my location, I tape the freezer paper directly on the easel tray (or to the lid of my watercolor palette, if it is already secured to the tray). I always have an atomizer handy to mist the paint. This way I can work back and forth from transparent watercolor with either gouache or casein, even when I am in the backcountry.

Although I use all of the watermedia extensively in the studio, I seldom work outside with gouache, acrylic, or casein in dry climates, such as the mountains of Colorado, because it is difficult to keep the paint moist and the brushes clean. However, if I am in a humid climate, such as Hawaii, the Mediterranean, or any coastal region, I can set up the paint on the palette and work for a long time, just occasionally spraying the paint. It is a dream to work outside under these conditions.

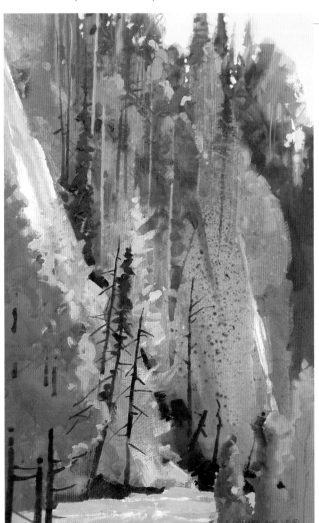

Canyon on the Little Susitna River, Alaska, 24 x 14½ inches (61 x 36.8 cm), acrylic on #5114 Crescent watercolor board, Collection of Gordon Green

I found this narrow canyon about forty miles north and east of Anchorage. Autumn was blazing and the mountain was filled with color, making acrylic the medium of choice for this painting.

Photo by Todd Katke

Here I am painting *Canyon on the Little Susitna River, Alaska.* There was plenty of humidity in the shadows of the canyon and it was easy to work for a few hours on-site with acrylic.

Traveling to Foreign Countries

I have lived in the mountains of Colorado most of my life and have found that my best paintings come from my experiences there. From time to time, however, it is important to travel and see different cultures and terrain. Confronting new situations helps us grow—both as artists and as people. Then when I come home, I see the landscape with fresh eyes and paint with a new energy and focus.

Whether I am in the United States, Canada, Europe, or Mexico, the challenge is the same: to get down on paper the smells and sounds, the color and light, as well as my thoughts and experiences of the area. When I travel to paint en plein air, time is limited and the weather may be less than ideal, but I want to go home with a good body of work. Some of my travels can be two to four months, so I need to plan ahead, and pack well to take advantage of this special time.

I like to remain in one spot for at least two weeks. I've found out the hard way that if I'm at a location for only a day or two, I'm just getting

Researching Masters and Mentors

I enjoy researching and seeking out some of the favorite places where my mentors and masters have painted. I have been to Cullercoats, England, and Prouts Neck, Maine, where Winslow Homer lived, worked, and had studios. I have been to the Boboli Gardens in Florence and many sites in Venice to paint subjects that my heroes John Singer Sargent and James William Mallard Turner once painted. I have painted in Claude Monet's garden; I have painted the Spanish Peaks in southern Colorado and the rim of the Grand Canyon where Thomas Moran worked. I have painted subjects in Arles and St. Remy where Vincent van Gogh lived and twice have painted Mont Sainte Victoire, the subject made famous by Paul Cézanne. The list goes on and on.

My idea is not to re-create something that these masters did. The light is different, the architecture and dress have more likely than not changed, and the time of year is probably not the same. However, to stand in the same spot, sketch or paint, and pay homage to a master who has inspired and influenced my life is as good as it gets. This is a great way to start an excursion. After painting in a place with a master's aura I find new subjects to work on and can easily spend a week or more inspired by this place.

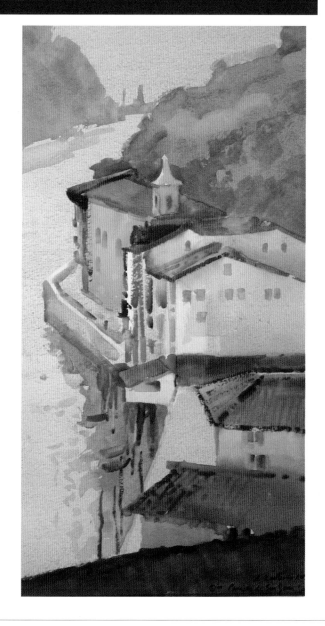

View of Port de Passage, 19 x 10 inches (48.3 x 25.4 cm), watercolor on 300-lb. rough Saunders Waterford watercolor paper, Collection of the Artist

This small village, located on the Atlantic Ocean in northern Spain, was Scottish painter Arthur Melville's favorite spot to paint during the last ten years of his life.

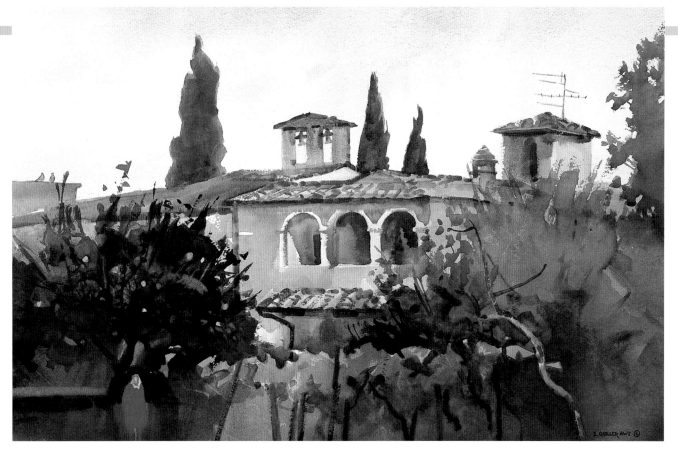

Chiesa de Quintole, 19 x 29 inches (48.3 x 73.7 cm), watercolor on 300-lb. rough Richeson Premium watercolor paper, Collection of Phil and Teresa Lack

A ninety-year-old priest tended his garden and persimmon tree while I worked on this painting. I can still see the man, sense the smells, feel the heat, and hear the sounds of that day. They are permanently ingrained in my being.

to know the area and unpacking when I have to repack again. I want to be able to think about and experience the idea or subject before I paint it. This gives me time to digest it, and the resulting images usually come out stronger. If I can spend a day communing with a place, I will take that experience with me the rest of my life.

To achieve these goals, I typically rent a small house where I can unpack, prepare meals, and store the foods that I'll take with me for lunch each day. I like to catch the weather on television the night before and then make a plan for painting. Also, I always rent a car so I can reach any site I choose.

When I first get to an area, I spend a day exploring and getting an overview. I look for things that inspire me, do quick sketches, and take notes. I prioritize the subjects that most interest me and start with them. As the days unfold I discover

other subjects, so whenever I spend two weeks or a month in one spot I always find a wealth of material—more than I can ever complete.

I take my sketchbook with me everywhere. I like to call it my brain. I write down my thoughts and do working sketches in it. I jot down notes as to the time of day, the textures, the smells, and anything that is particular to the area. It is indispensable to me, as I do not use photographic images for reference material. However, I do carry a small digital camera with me and take a photo of each subject that I paint. Later, when the painting is framed, I apply the photo to the back of the work along with a short story about where the painting was painted, what inspired me, and what was unique about the day.

The painting *Chiesa de Quintole* is a good example of this process. My family and I had rented

a small villa five miles from Florence, Italy, for the fall season. On our way to a market one day we took a small winding road to the tiny community of Quintole. I immediately planted myself in the shade of an olive tree in the area surrounding this church and did some sketches. During my stay I painted in this one place at least six days.

Although it is cumbersome, I carry all my watermedia—watercolor, gouache, acrylic, and casein—when I take a major painting trip. Then I let the subject tell me which medium will best help me capture the spirit I feel. At a monastery run by Dominican nuns close to Carcassonne in the south of France, the entrance lane was lined with trees in full autumn color, and there was a haziness to the atmosphere that made me think of using a combination of watercolor and casein. I worked in this location for three days, starting first with transparent watercolor. I then switched to casein because the velvety-matte visual quality captured the soft haze of the air and the solidity of the monastery and tree forms. The opaque casein also set off the transparent backlight of the leaves. The Dominican sisters would walk by

Making the Most of Inclement Weather

I want to make the best use of my time while I am traveling, so I have learned to make the most of less-than-optimal weather. Even when a day starts out pleasant, heavy winds, rain, or mistrals can change things quickly, so when I suspect this possibility I look for painting locations that have a covering and are out of the wind. When a day is rainy I often take an umbrella and work under it. Or I paint inside or under a covered patio on something like a floral still life that I have arranged from regional flowers or a painting from a previous day's sketches.

On a rainy day in the Languedoc region in the south of France I pulled out a sketch done a few days earlier in the village of Minerve. I had my wife and daughter model with umbrellas while I did a few line drawings. I then combined the drawings into this finished composition. I worked the entire day on this painting, and the next (beautiful, sunny) day I took it back to the actual site to touch up the architecture and finish the composition. While I was finishing the work people strolled by, observed the painting, looked up in the sky, and smiled.

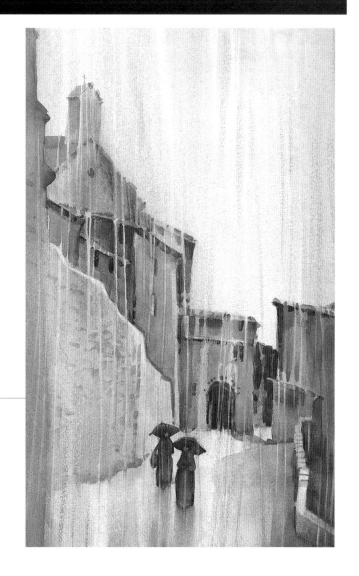

Pluie, Minerve, 29 x 21 inches (73.7 x 53.3 cm), watercolor on 300-lb. rough Richeson Premium watercolor paper, Collection of Tedd and Christine Benson

I wanted to capture the feeling of a rainy day in the south of France in this painting. To help me achieve this I applied an initial wash of cool granulating colors and then lifted vertical lines.

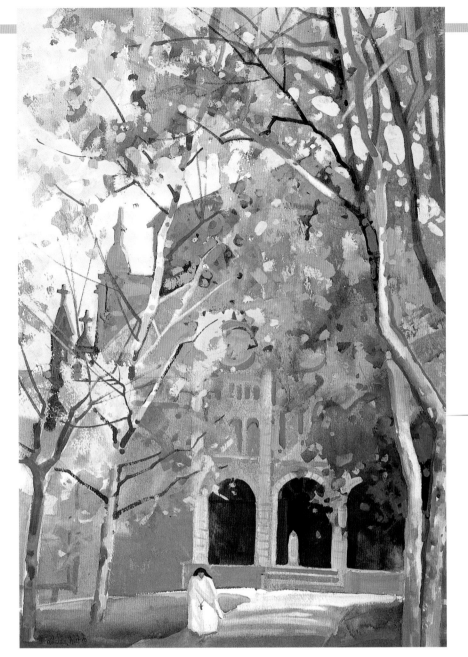

When I travel, it is very hard to part with the paintings. I want to bring them home, look at them, and feel their energy, light, and expression. They are like children with whom I have spent an intense and wondrous time, watching them develop, change, and grow.

Dominican Monastery, Prouilhe, 28 x 20 inches (71.1 x 50.8 cm), watercolor and casein on 300-lb. rough Richeson Premium watercolor paper, Collection of Steve and Peggy Willman

This is a good example of a subject that told me the medium I should use. I started with transparent watercolor, then switched to casein to articulate the opaque sky and monastery shape and to set off the transparent leaves.

periodically and comment on the progress of the painting. I took the opportunity to do some quick line drawings and then included them as a part of the composition in *Dominican Monastery, Prouilhe.*

On a typical excursion I may stay for as long as four months and do as many as sixty or more paintings. Some works are smaller, but most paintings are around 22 x 30 inches. I never know when the good (or hopefully even great) paintings will emerge, so I have found that it is important to just keep at it and strive to get to the core of what

I have to say. There is certainly no better way to spend time.

In general, I complete about 85 percent of each painting while on location. Then I ship them back to my studio in Colorado, where I finish them. I feel that it is important to complete the painting away from the original site to better take it in the direction it needs to go. Besides, it is a great experience to look out of my studio on a gray January day, watch a gentle mountain snow, and work on a painting experience from a foreign locale.

Working Large in Watermedia

There is nothing better than holing up in the studio during the cold winter months and working on a large watermedia painting—using big brushes, keeping various watermedia flowing, and listening to music. I savor this time of year, and the days fly by.

My friend and painter Robert Genn suggested that he only has so many large paintings in him each year. And, although everyone has a different pace and rhythm, I feel that I am much the same in terms of doing large works. I need to build up to a large painting, and once it is completed, I am drained by the process. I then go to smaller works and studies or prints before embarking on another large painting.

While working large can be satisfying, there are problems inherent in creating large-scale watermedia paintings. Archival materials—such as papers, stretching elements, and varnishes—must be chosen carefully. The actual process of framing a large work on paper under glass or Plexiglas is a challenge; and both materials have drawbacks—glass is very heavy and Plexiglas both scratches easily and attracts dust. And finally, shipping something large, heavy, and especially with glass can be prohibitively expensive.

I have found three different ways of working large in watermedia—supporting watercolor paper on heavy-duty stretcher bars, dry-mounting watercolor paper to hardboard, and painting on Aquabord. I have used all of these methods in my painting process and will describe each in detail. All of these methods use archival materials and can be displayed with or without glass.

Supporting Watercolor Paper on Heavy-duty Stretcher Bars

I love to work large and have found an approach that works well for me. In short, it involves creating a wooden frame and then stretching soaked paper onto the frame. When the paper dries it shrinks and the resulting surface is tight as a drum and a joy to paint on. I use any of the watermedia on this support. Here is my method:

First, I assemble a large frame according to the format of your image, up to 38 x 58 inches, using heavy-duty stretcher bars made by Best Easel. (A 38 x 58 inch frame accommodates a 40 x 60 inch sheet of watercolor paper, with 1 inch of overlap on all four sides.) I place the four corners of the stretcher bars together firmly. Once they are in place I measure the rectangle diagonally from corner to corner both ways to make sure that it is perfect. If the corners are not lined up precisely, framing will be a nightmare. When the stretcher bars are securely in place I brush on an acrylic varnish to cover the wood and then let it dry thoroughly; this coating will isolate the paper from the wood so that acids from the wood will not eventually come in contact with the paper.

I built a sink in my studio that holds a 40 x 60 inch sheet of watercolor paper. Richeson Premium Watercolor Paper is made in this oversized sheet, and I purchase it in packs of ten. When working this large it is important to use 300-lb. paper. When I'm ready to frame the watercolor paper, I submerge a single sheet in the sink and let it soak for forty-five to sixty minutes in cold water. When I take the paper out of the water I hold it vertically and let the water drip until most is removed. I am careful to place the paper evenly on the stretcher bars, without bumping or scarring the surface. Then, using a staple gun, I staple the paper onto the frame, starting in the center of each of the four edges and moving outward, placing a few staples at a time on each side. Finally, I finish the four corners. This involves cutting one edge of the paper at a 45-degree angle and stapling it, then folding the other corner over, cutting another 45-degree edge to conform to the first one, and stapling it.

It takes a day for the paper to dry. At that point I check to make sure none of the staples are

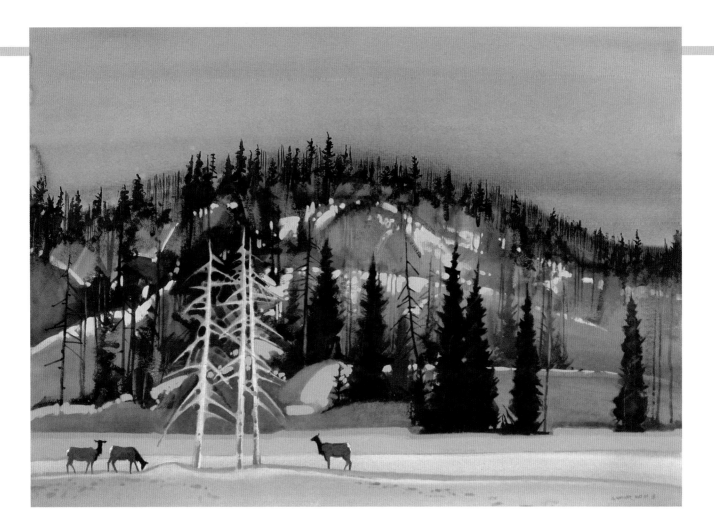

sticking out. If there are any protrusions, I take a hammer and gently tap the staples to flatten them. Although this is the method I use the most, it does have some limitations. First, soaking the paper removes some of the surface sizing. Thus if I am working in watercolor, the paint will not lift as easily. If I am using acrylic or casein, it will not be a concern because I do not use the lifting process with these media. It is also important to clean the sink bed thoroughly before soaking the paper so that any existing residue will not contaminate the paper.

The second consideration with this method is that molding choices for framing are limited to deep cap moldings, which will hide the heavy-duty stretcher bars. Generally I will use a 2- to 3-inch wooden liner, wrapped in off-white linen, next to the painting and then a deep cap molding around the liner. If the painting is large enough, however, it may not require a mat or liner, and a standard frame and deep cap molding will be sufficient.

Ghost Trees, 32 x 44 inches (81.3 x 111.8 cm), watercolor and casein on 300-lb. rough Richeson Premium watercolor paper, Collection of Lynn and Randy Burrous

At twilight one early April evening, I saw this subject off Miner's Creek Road and knew I must paint it. I did a drawing on-site and a color study before starting this large painting, which is on heavy-weight paper that I stretched over heavy-duty stretcher bars.

OCTOBER 3, 1993

A friend loaned me a book on the cave paintings in Lascaux, France. These early humans were painters, close to the earth, and connected to animals. As we have evolved and pursued intellect and technology, we have slowly beaten out the spirit that was inherent to us from an earlier time. It is now difficult to find.

Dry-mounting Watercolor Paper to Hardboard

While I was instructing a seminar in North Carolina, artist Judith Fields and her husband, Bob, told me about this approach to creating a permanent watercolor painting support. The basic concept is dry-mounting a 140-lb. piece of watercolor paper to a hardboard surface. Although you can use this method to make a support as large as 40 x 60 inches, it can work on a smaller scale as well.

There are a number of advantages to this method: Finished watercolors can be mounted, so you can decide whether to mount an image after if has been created. The external sizing of the paper is not removed. The finished board is about ¼-inch thick, so any molding can be used for framing. Because the paper is mounted on a hard support, the artist can work very wet without fear of having the paper buckle. When the work is complete, it can be framed with glass or varnished and framed without glass. This process is archival.

The major disadvantage to this procedure is that the press is very expensive and also takes up space. If you live in a region with a good frame shop, they might have a press. If so, you can take the paper in and let them know the size you need and how to do this process.

Here is the method Judith and Bob use:

Select a sheet of ¼-inch untempered hardboard (Masonite) and cut it to your desired size. (I personally have used this method for supports up to 36 x 60 inches, but the press can accommodate a width of up to 52 inches and an unlimited length.) It is recommended to gesso any hardboard supports to isolate the paper from the acids in the wood. It may be necessary to apply two to three coats of acrylic gesso to both sides of the panel. Let the last coat dry overnight.

Cut a sheet of dry-mount adhesive film slightly larger than the hardboard. Bienfang Fusion 4000 comes in 40½ x 90–foot rolls and works well. Then cut a sheet of watercolor paper the ex-

act same size as the hardboard support. Lighter (140-lb.) paper works better than heavier (300-lb.) paper. Once the paper is mounted it will not buckle. You can dry-mount finished watercolor paintings or you can dry-mount blank sheets of watercolor paper.

Place the watercolor paper on your work surface. Position the adhesive film on top of the watercolor paper and then place a piece of release paper on top of the film. Using a tacking iron, tack the corners of the adhesive film to the back of the watercolor paper. You only need to fuse it enough to keep the film in place; it does not need to be completely attached to the paper.

Turn the watercolor paper over, so that the adhesive film is now on the bottom, and place it on a cutting surface. Using a metal straightedge and a razor blade, trim the film to the precise size of the paper.

Now place the watercolor paper, film-side down, on the gessoed hardboard. Put a piece of release paper on either side of this "sandwich." It is ready to be "grilled" in the dry-mount press. Seal mechanical presses can be quite an investment, depending on the size of paper you want to mount. For most painters a Commercial 210M press will work. Paper can be mounted up to 36 inches wide. The platen (flat metal plate of the press) is 18½ x 23 inches. Thus a full sheet of watercolor paper (which is 22 x 30 inches) can be mounted with two passes. The Masterpiece 500T press will accommodate paper up to 52 inches wide. The platen size is 26 x 34 inches.

Open the 180-degree pre-heated dry-mount press and insert the assembled paper, hardboard, and release sheets. Ensure that the paper and the hardboard are properly aligned, and close the press. Apply pressure to the dry-mount machine for five to six minutes for 140-lb. watercolor paper and for ten to twelve minutes for 300-lb. paper. Remove the paper/hardboard from the press, wearing cotton gloves to protect your hands from

the heat. Put the release paper aside, as it can be reused. Put the paper/hardboard (paper side up) under a sheet of ¼-inch-thick glass on a flat table until it has completely cooled. This reduces the chances that an edge of the paper will curl before the adhesive is fully solidified.

Painting on Aquabord

Aquabord is an ideal watermedia support for working large. Smaller sizes (up to 30 x 40 inches) can be readily mail-ordered from any art supply company. However, larger sizes (up to 46 x 90 inches) can be special-ordered directly from the manufacturer of the product, Ampersand. A skill saw or table saw can then be used to trim the support to any desired format.

As I mentioned on page 82, this product is made especially for transparent watercolor. The surface accepts washes well and also lifts extremely well. I personally use the board mainly for acrylic and casein. It is a dream to paint on.

Large Studies

Set up a large frame using heavy-duty stretcher bars and mount a piece of watercolor paper, as described on pages 116–117. Let the paper dry overnight. Select a subject that will be fun to work with in a wet, splashy application. Choose either watercolor or acrylic for the initial wet transparent washes. When you are satisfied with the underwashes, let the paint dry completely. Now set up a palette of acrylic, casein, or gouache and begin overpainting translucent and opaque. Use only large brushes and dive into the painting. Leave much of the transparent painting exposed and just explore all three visual qualities in one painting.

Retreating Shadows, View from My Studio #1, 30 x 48 inches (76.2 x 121.9 cm), acrylic on Aquabord, Collection of Ginny and Lee Peterson

My studio sits at the edge of the Rio Grande and I see this view from the loft of my space. I actually set my studio easel by this window to paint the scene in late February. Aquabord provided the ideal support for this acrylic application.

Varnishing Watermedia Paintings

Many art collectors, as well as curators at galleries and museums, prefer to display watermedia paintings without glass or Plexiglas so that there is nothing between the viewer and the work of art. We have a gallery in the remote mountain region of Colorado and must ship most of the work that we sell. Although I like the look of watermedia matted and under glass and still show most of my smaller work this way in the gallery, I am now showing almost all of my larger paintings without glass. Not being concerned with the breakage of glass means that the work is easier to ship and hang. However, watermedia paintings—especially watercolor and gouache paintings—need to be protected from the elements. With proper varnishing, the painting will not only be protected, but it can actually be cleaned with a damp cloth when this is needed.

I use Golden Archival Varnish, which comes in an aerosol can and is available in three finishes: gloss, satin, and matte. I like the satin finish because the paint retains its original visual quality. The gloss finish gives a very shiny surface, and the matte finish, after a few coats, deadens the paint. This varnish can be removed for conservation purposes. The varnish solution contains UV light filters to help protect against light damage.

Watercolor paper surfaces tend to absorb the light spray coat, and thus six coats are required. Hold the can 9 to 12 inches from the painting and evenly coat the surface of the painting. Let it stand for fifteen to twenty minutes, turn the painting in another direction, and repeat. When the final coat is applied the painting should stand for a week before it is handled. It is a good idea to practice this on an old, discarded watercolor first. Let it stand overnight and then take water and a brush and work over the surface vigorously to make sure that no color lifts.

Painter Judith Fields offers a similar approach to varnishing using an airbrush-type gun. She uses a Critter Spray Products 118SG/22032 siphon gun, but any spray gun that will spray varnish should work. For the varnish, she uses Golden Polymer Varnish with UVLS (gloss, satin, or matte) mixed 50 percent with the Golden Airbrush Transparent Extender for spraying. This clear varnish is self-leveling, contains ultraviolet light stabilizers, does not yellow, and protects the watercolor painting, allowing you to frame without glass.

Spray six to eight coats of the varnish. Let each coat dry for at least half an hour and rotate the painting 90 degrees between each coat. Do not rush the process, as drying time is dependent on temperature and humidity. Let the final coat of varnish dry overnight before placing the watercolor painting in a frame.

Always wear a chemical spray mask while varnishing your work and use an exhaust fan if you do it inside. Breathing acrylic dust is hazardous to your health.

Autumn in Blue and Gold, 44 x 30 inches (111.8 x 76.2 cm), watercolor and casein on 300-lb. rough Richeson Premium watercolor paper, Collection of Jack and Linda Richeson

I created this painting on heavyweight paper that I stretched over heavy-duty stretcher bars. I then sealed the image with acrylic varnish so it could be displayed without glass.

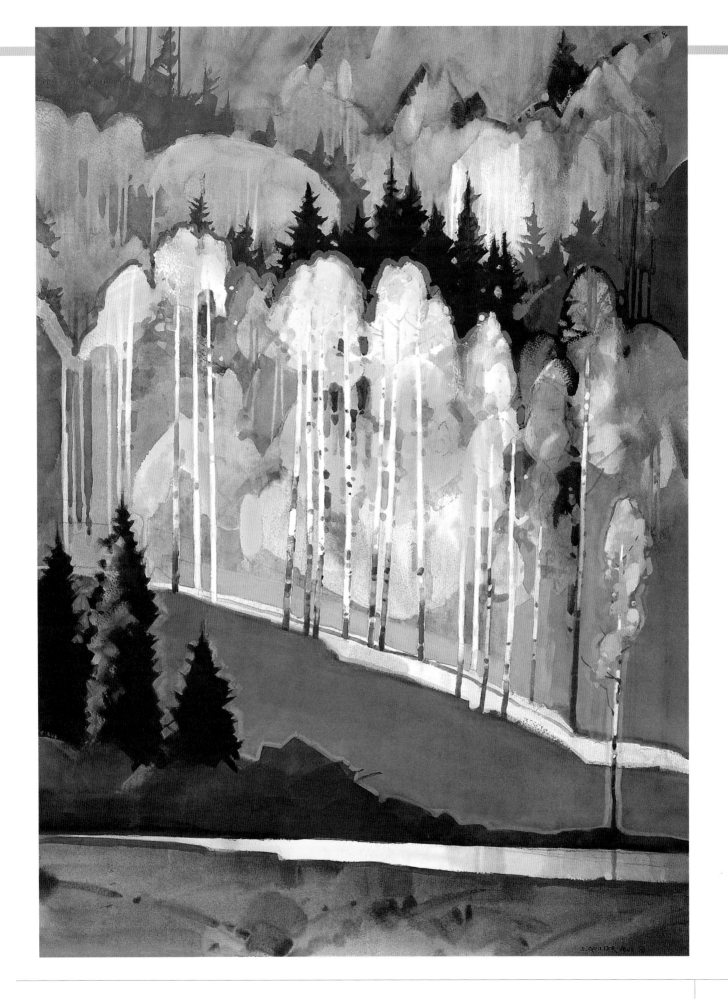

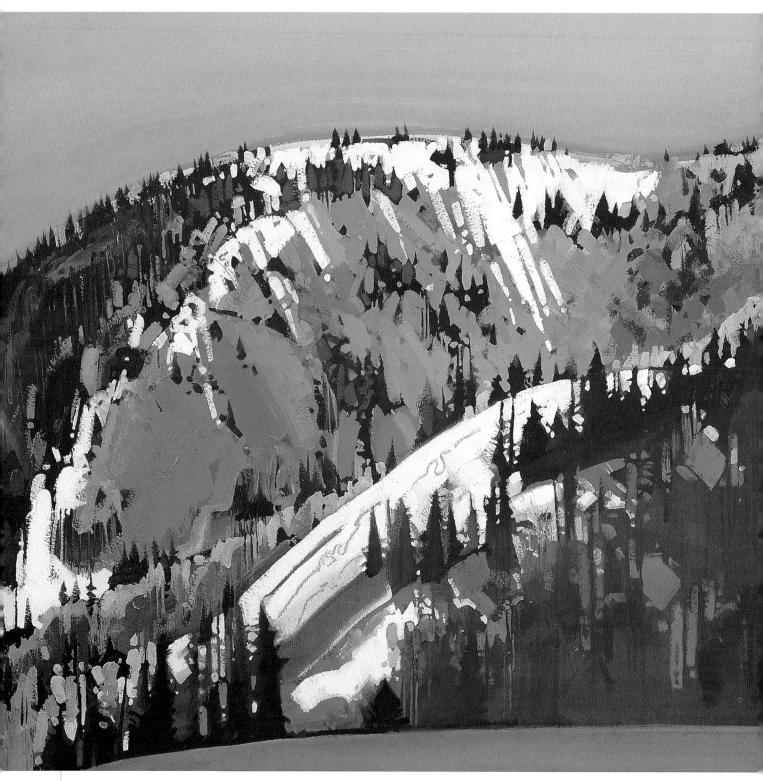

An Autumn Snow, 28 x 38 inches (71.1 x 96.5 cm), acrylic on 300-lb. rough Richeson Premium watercolor paper, Collection of David Benson

I have painted this mountain, which I view daily when I walk to and from my studio, more than any other subject during the last fifteen years. I observe its many moods—from dawn to night, in various atmospheric conditions, and throughout the seasons. In this painting, which employs a curvilinear motif, I focused on a small part of the mountain and emphasized the rhythm and patterns created by the contrasts between the strong light and shadow areas and the warm and cool colors. Linear beat and repetition are key to this painting.

Composition

COMPOSITION IS AN ALL–ENCOMPASSING TERM that means the structure of the painting. Most representational painters tend to think in literal terms: *This is a figure. This is a house. This is a tree.* And so forth. In other words, we think about the objects rather than the arrangement of the shapes. We forget about the abstract relationships that really are of utmost importance to the success of a composition. If an image is designed well, it will attract the viewer's eye. In fact, a strong abstract composition will hold together even a poorly painted work. However, an incredibly well-painted subject that has a mediocre composition will at best be a ho-hummer.

We sometimes hear advice, such as "design a center of interest," "create an entry point for the composition," or "do not put the subject directly in the center." This advice might be valid for a particular work, but every rule has exceptions. A good friend once told me, "Stay away from people who have all of the answers and seek out people who ask a lot of questions." Each painting has its own best composition. Thus it is important to know as much as possible about composition and to be able to listen to the painting and seek what is best for it.

This chapter covers two main themes. The first is simply defining the elements to look for in a composition. There are many elements and things to consider, but not all of them apply to every painting. The second is training the eye to see abstractly. This is truly the key to composition, but it is the hardest thing to teach. I introduce some exercises that will help you develop a new way of seeing. Even though I speak in universal, abstract terms while dealing with composition, the thoughts apply to painters working with any kind of subject matter— from landscape to still life, figurative to abstract.

Recognizing the Elements That Make a Composition Great

Each painting can best be stated with its own unique composition. And each composition depends on the type of inspiration that is to be painted. Is the image a noisy, night-lit city scene or a serene winter mountain at twilight? Both subjects will require completely different elements to best present the composition. Let's start by looking at some basic considerations in composition and then build to more complex concepts. I truly hope that working with the information and studying the examples in this section will help your work grow deeper and more meaningful.

Format

Simply put, the format is the shape and size of the support you choose to work on. Most watermedia painters think of the format as simply a full sheet (22 x 30 inch), half sheet (15 x 22 inch), or quarter sheet (11 x 15 inch) of watercolor paper. In other words, many artists work with standard-size formats. The main reason for this is that it is economical. No paper is wasted, and mats and frames can be exchanged from one work to another. However, the choice of format is critical, as all of the other compositional elements will be contained within this space, so before you begin a painting you'll want to carefully consider what the best format will be for that particular work.

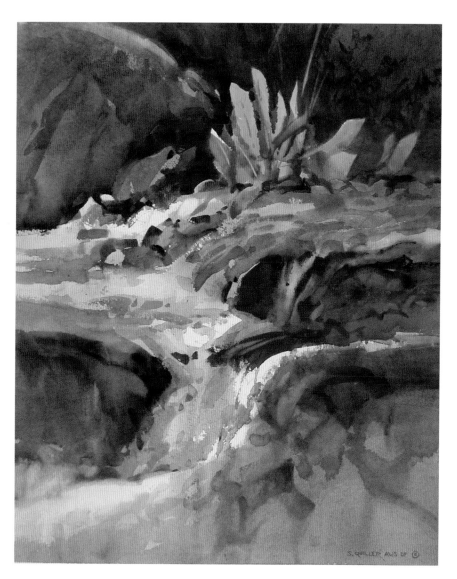

Skunk Cabbage on West Willow Creek, 25 x 19 inches (63.5 x 48.3 cm), acrylic on 300-lb. rough Richeson Premium watercolor paper, Collection of Lucy Nowak

I made the bank of this creek dark so it would set off the yellow-green leaves of the skunk cabbage. The white of the water is the paper.

This compositional diagram for *Skunk Cabbage on West Willow Creek* shows the essential curvilinear elements that govern the work.

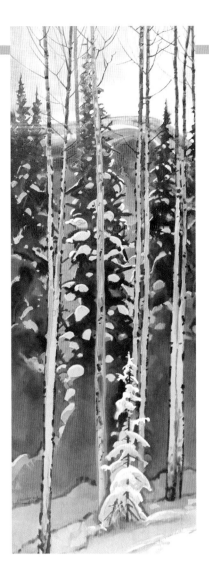

Alpenglow off the Old Logging Road Trail, 56 x 20 inches (142.2 x 50.8 cm), acrylic on 300-lb. rough Richeson Premium watercolor paper, Courtesy of Quiller Gallery

I chose an untraditional format for this large painting to emphasize the tree shapes and the piece of orange alpenglow that counters the long shadow area. The aspen tree forms are at a slight diagonal, positioned to give a syncopated beat to the composition.

This thumbnail compositional study for *Alpenglow off the Old Logging Road Trail* helped me determine that an elongated vertical format would best suit this image.

Unusual Format Studies

Choose any subject that inspires you. Take your sketchbook and do a series of thumbnail sketches. Look for ways that you can present your subject with unusual formats, such as an extended horizontal, an elongated vertical, or a square. Then find subjects that best fit these formats, such as a stand of tall pine trees or an attenuated, serene coastal vista. This can easily be accomplished with figurative, still life, or abstract subject matters as well. Select a thumbnail sketch that particularly inspires you and do a painting using the same format.

Each subject can best be presented with a certain format. It could be horizontal, vertical, or a square. For instance, the painting *Skunk Cabbage on West Willow Creek* is 25 x 19 inches. While a full sheet of watercolor paper is 30 x 22 inches, this work needed to be vertical but have a format a bit closer to a square. How did I determine that that format would be the best? Simply by doing a thumbnail drawing of the subject in my sketchbook and then drawing a rectangle around it to define the picture plane.

Alpenglow off the Old Logging Road Trail is another good example of a painting that was best presented with a nontraditional format. I was cross-country skiing in early January on one of my favorite trails in the high country seven miles from my home. It was late in the afternoon and I

was on the shadowed side of the mountain. As I moved down the trail I felt a flash of orange above the aspen-and-spruce-lined trail. It was the late-light alpenglow on La Garita Mountain Range.

As this strip of orange on the mountain danced on a couple of aspen and played against the predominant cool blues of the mountainscape, I was inspired. I quickly pulled out my sketchbook and captured the essence of the scene with a few quick strokes of a bold-lined gel pen. I jotted down a few notes concerning my inspiration and decided that an elongated vertical composition would best express my sensations. I did a thumbnail sketch of the subject to give me the format. Then, back in the studio, I stretched my paper on heavy-duty stretcher bars built to this format and got to work.

Expression of Line

The direction of the dominant lines in a composition can have a profound effect on the overall expression and mood in a work of art. Here are a few types of lines, along with the emotions they can evoke.

Horizontal Line

Horizontal lines can convey solitary, relaxed, still, serene, and restful moods. One needs only to think of the horizon line that joins sky and land in a flat, expansive landscape. Even if the subject is not a landscape per se, a series of horizontal lines can bestow this feeling. Furthermore, enhancing the horizontality of the format of the picture plane will enhance this effect.

Trace of Dawn, November 16, 2005, shown on pages 76–77, is a good example. This painting depicts early dawn light on the distant mountain with the valley floor in shadow, and so I wanted to create a feeling of solitude and serenity. To do this, first I extended the picture plane to create an elongated horizontal format. Then I emphasized the horizontal lines in the mountain range and distant valley shelves.

The composition for *Trace of Dawn, November 16, 2005,* which appears on pages 76–77, is governed by predominantly horizontal lines.

Vertical Line

Vertical lines convey feelings of stability, strength, and power. One needs only to think of redwood trees or skyscrapers. Both have meaningful lines with substance and vigor. In my compositions I am careful to not get too rigid with vertical lines, as they can become static when they are too

Santa Croce Church, Christmas Market, which appears on page 39, features many vertical lines.

straight. Look at Monet's paintings of the Tower of London. The tower is actually at a slight angle, which is more pleasing to the eye.

To increase this kind of expression the verticality of the format can be expanded. *Alpenglow off the Old Logging Road Trail* on the previous page is an example of this. In addition, vertical lines feature prominently in *Santa Croce Church, Christmas Market, Florence* on page 39. The façade of Santa Croce Church protrudes into the sky when viewed from the open market square. It gave me an awe-inspiring and magnificent feeling of endurance, authority, and towering might. The vertical line was evident in the architecture of the church and the figures toward the bottom of the composition. The moist pavement of the market square gave me the opportunity to pull the vertical line into the reflection of the figures as well.

Diagonal Line

Diagonal lines connote movement and action. Place one end of a pencil on a table, hold the other end up and at an angle, and then let go. What happens? It falls, of course. Thus any angular line will stir this feeling of restlessness and activity. In nature, diagonal lines occur more dramatically when the composition is seen from a bird's-eye view. Historically, European compositions have tended to emphasize horizontal and vertical ele-

ments. By contrast, diagonal forms feature prominently in Chinese sumi-e brush paintings and Japanese woodblock prints.

Autumn in Blue and Gold #2, shown on page 101, celebrates the diagonal line, which is in abundance throughout the mountainous forms in the part of the country where I live. To achieve a slight bird's eye view for this image, and thus bestow some movement to the water, I set up on a bank above the river. The mountain and tree lines both have a pronounced diagonal energy; this is reiterated in the dark spruce shapes. The diagonal line in this composition emphasizes the active quality I was expressing.

Diagonal lines set the mood for *Autumn in Blue and Gold #2,* which appears on page 101.

Curvilinear Line

Curvilinear lines in a composition oftentimes summon a carefree and lighthearted feeling. Examples include cumulus clouds or water patterns at the base of a waterfall. However, this same line can create a feeling of intense anxiety. One needs only to think of Edvard Munch's *The Scream.*

Truth, Monumento al Conte Nicola Demidoff, shown here, emphasizes curvilinear movement. The female subject of this composition (called "Truth") was part of a large monument located in a park along the Arno River in Florence, Italy. It was a warm, sunlit, late autumn day. The soft, sensuous marble figure elicited a lighthearted and carefree feeling in me, and I selected a curvilinear line to help evoke this expression. I repeated the curvilinear line of the figure in the dark foliage, branch patterns, and open pockets of light.

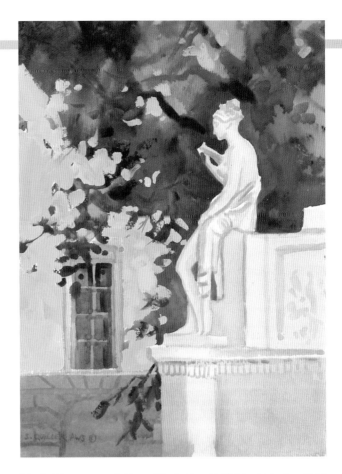

Truth, Monumento al Conte Nicola Demidoff, 15 x 11 inches (38.1 x 28 cm), watercolor and casein on 300-lb. rough Richeson Premium watercolor paper, Collection of Ray and Ellen Deaver

I painted the opaque yellow casein in a negative way around and through the trunk and foliage to provide contrast for the translucent and soft violet of the curvilinear forms of the statue.

The composition for *Truth, Monumento al Conte Nicola Demidoff,* shown above, is held together by a series of interlocking curvilinear lines.

Geometric Motifs

The geometric motif of a composition is simply the form that is most basic to the image. Three kinds of shapes are typically used for this purpose: rectangles, triangles, and curvilinear forms. Just as works of art often have many kinds of lines, paintings can (and frequently do) feature many different shapes. However, successful compositions tend to allow one of these shapes to dominate, while featuring variety—of size, of proportions, and so forth—with the dominant geometric motif.

Rectangular Motifs

A rectangular geometric motif can evoke a sense of stability and even generate a calm, timeless quality. The horizontal and vertical structure and lack of movement in the composition of *City Square, Cassis* help capture a serene "still life" of this French village in morning light. Johannes Vermeer, Charles Sheeler, Paul Cézanne, Piet Mondrian, and Andrew Wyeth all frequently worked with rectangular motifs.

I did *City Square, Cassis* on-site in late November at a French fishing village at the edge of the Mediterranean Sea. It was market day and the downtown square was teeming with life. I set up off the square by a small city park and, while there was activity on my other side, this park was serene, with people sitting on the bench, reading newspapers, and quietly walking to the market. Notice that the large vertical rectangular shapes are followed by medium and smaller rectangles, which are oriented both horizontally and vertically. The small rectangles form interesting pockets that create a nice beat in the painting.

Triangular Motifs

The triangular motif creates a feeling of flux, vivacity, and even turmoil and is a natural motif to employ when you want to break up the space in a freeform and asymmetric manner. With landscape and still life subjects a triangular composition

City Square, Cassis employs a rectangular motif, which gives this image a sense of stability.

City Square, Cassis, 26 x 18 inches (66 x 45.7 cm), acrylic on 300-lb. rough Richeson Premium watercolor paper, Collection of John and Dana Goss

I did this on-site painting in mid-November. It is about the life in a small town in the south of France.

often calls for a bird's-eye or aerial vantage point. Edgar Degas was a master of this approach, as was Mary Cassatt.

Edge of the Pond is a good example of a triangular motif. I was set up above the pond, looking down at the beaver dam. While on-site I created a number of sketches and a watercolor painting. Back in the studio I was free to focus on the color I could achieve using acrylic and casein in combination as well as to create a stronger, more dramatic design than the one I observed in reality. The

Geometric Motif Studies

Find a subject that incorporates rectangular shapes. Do a series of thumbnail sketches and create a composition that features a rectangular geometric motif, a square format, and symmetrical balance. Develop these ideas into a finished painting.

Edge of the Pond, 32 x 24 inches (81.3 x 61 cm), acrylic and casein on #5114 Crescent watercolor board, Collection of the Artist, Recipient of the Louis Kaep Award from the American Watercolor Society

It is rare for me to work in the studio during the summer. I did a study for this painting at the edge of a beaver pond and then returned to the studio to work this up into a larger painting.

Triangular forms set an active tone in *Edge of the Pond.*

whole painting is based on a series of triangles—from very large to very small—that dance throughout the composition and give the work a feeling of unity. Variety is key to the success of this image.

Curvilinear Motifs

The curvilinear motif can depict a carefree, lighthearted, or fantastical mood, but it can also suggest haunting or wild expressions. Paul Gauguin, Vincent van Gogh, Edvard Munch, and William Blake are a few great painters who frequently used this form of composition.

After a fresh snow in the high country, curvilinear shapes are everywhere. If the snow is wet and there is an overnight freeze, these shapes will hang on for a good while. I painted *Fresh Snow, the Blue Hour* after one such snowstorm. Notice how the snow-covered branches in the foreground are all rounded, giving a rhythmic unity to each expression. This painting also features parallel soft-diagonal rhythmic snow field planes that run from upper middle ground to the lower foreground. All of these flowing shapes are counterbalanced by the gentle diagonal lines of the trees.

Fresh Snow, the Blue Hour is filled with curvilinear forms. This helps convey the lighthearted mood that I had when I discovered this scene.

Fresh Snow, the Blue Hour, 24 x 33 inches (61 x 83.8 cm), watercolor and casein on 300-lb. rough Richeson Premium watercolor paper, Collection of the Artist, Recipient of the Hal P. Moore Award from the American Watercolor Society

Many of my paintings focus on vistas and distant landscape forms, but sometimes I like to home in on foreground subjects such as the patterns created by a fresh snowfall.

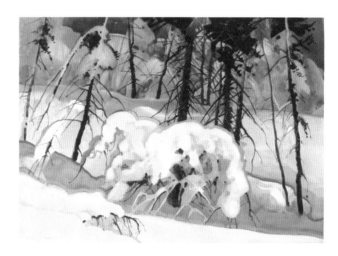

Positive and Negative Shapes

Positive and negative shapes are vital ingredients in all compositions. While the basic idea may seem familiar, artists who take the time to enhance their understanding of this concept often find that they are able to conceive of their works in new and different ways, as it affects their thinking about composition in fundamental ways. In Chinese philosophy, the positive, bright, masculine principle is referred to as yang, while the negative, dark, feminine principle is called yin. The interaction of these two principles influences the destinies of all living creatures. Likewise, the interaction of positive and negative space influences the destiny of a work of art.

In a painting, the positive space is frequently the object of the image. Positive space is "active" and generally contains the greatest contrast, texture, color, and detail. Negative space is usually the area surrounding the object. It may be characterized as "passive," as quiet and restful, for it generally lacks detail, offers less contrast and texture, and makes use of analogous value and more neutralized color.

As much thought, or even more, should be given to the negative areas of the painting. This space is what allows the eye to see the positive shapes. In other words, the quiet, neutralized, less textured shapes are places where the eye can rest and then enjoy the more active, colorful, textured areas. When a painting is filled with active, color-ful, and textured shapes, it is impossible to enjoy viewing the work. Thus it is critical to develop the eye—not only to see the negative space but to learn how to make it interesting. If the negative space is beautifully designed, the positive space will be interesting. However, if the negative space is uninteresting, no matter how well the positive space is painted, it will not be interesting.

Let's examine two wash drawings of crows. In the first drawing no thought has been given to either the positive or negative space. The positive space (the crow) is just a lumpy, ill-defined shape. The head and much of the body disappear into the dark, central form. It is hard to define the subject. The negative space is equally weighted on all sides of the central shape. Paintings like this, where the subject is just put in the middle of the painting surrounded by even space, are often called "vignettes."

Notice how the interaction of the positive and negative space is much more interesting in the second drawing. The elongated horizontal format accentuates the shapes in this composition. And the outlines of the birds are well defined. The figures extend beyond the bottom of the picture plane, breaking up the format and isolating some of the negative shapes rather than having one even shape encircle the subject. Further, having the crow's feet extend beyond the picture plane involves the viewer and lets him or her know that not everything is said or confined inside the space.

This crow is depicted in such a way that the positive and negative shapes are totally uninteresting.

By contrast, overlapping the figures, not placing the objects symmetrically in the picture, and carrying elements to the edge of the image all contribute to making the positive and negative space around these crows visually engaging.

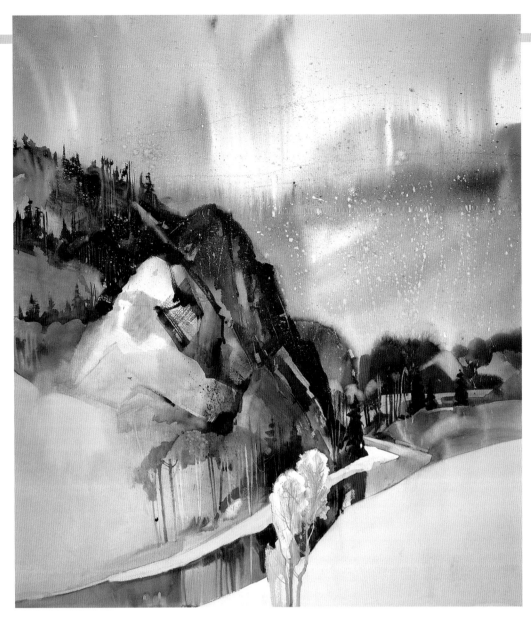

The Gap, Late November, 27 x 21 inches (68.6 x 53.3 cm), watercolor and casein on 300-lb. rough Lanaquarelle watercolor paper, Collection of William and Nikki Hayden

Wagon Wheel Gap is a well-known landmark in our region. The Rio Grande winds through the gap and the main highway runs beside it.

OCTOBER 14, 2005

A thread of water laces through many of my works. I think it is the influence of the Rio Grande, which I am near most of the time. It weaves through my life. It has become a compositional element, a way to repeat color in a painting, but emotionally it is much, much more.

Squint your eyes and study the white space that is around and between the two animals. Notice that the negative space at the lower left corner squeezes the shape of the bird and then opens as the white space moves upward. Look at the white space around them and how that space cuts into their feathers, heads, and legs. This interesting interaction of the positive and negative space holds the viewer's attention. Finally, notice that the areas to the left and right of the birds are not equally weighted. All of these elements combine to make an interesting use of space. Even though I am using birds in this example, these principles could be applied to any subject—from buildings to flowers to abstract shapes.

Spatial Relationships

The expression "spatial relationships" is an all-encompassing term that includes everything that has been discussed so far. It is simply how the lines, shapes, and positive and negative space relate on the picture plane. Let's take a close look at *Chiesa di San Giusto* to see how I incorporated the elements we've examined so far—not only to see how they were assembled to create interesting spatial relationships but how they were used to express what I was after in my painting.

I created *Chiesa di San Giusto* on-site. This small Catholic church about five miles from Florence, Italy, was first built in the thirteenth century and houses some beautiful late Renaissance paintings. The church was only open from 5 to 6 pm during the week so I could work unbothered during most of the day.

The first diagram simply shows the format and what will be the picture plane of this composition. The dimensions are 25½ x 18 inches. Obviously this is neither a full or a half sheet of watercolor paper. It was simply the size best suited for this particular painting.

The dominant line in this composition is vertical, as captured in the second diagram. This is shown most forcefully in the tower, which protrudes beyond the picture plane, but it also echoes in other features of the architecture as well as the figure. In this example, the vertical line denotes strength, power, stability, and a sense of age.

This painting has a rectangular geometric motif. Notice in the third diagram that I utilized large, medium, and small rectangles to break up the design in an interesting way. Even the two large sky shapes can be seen as rectangles. The main structure does feature curvilinear forms (in the arches, tiles, and tops of some windows), which provide a delicate counterpoint. However, the rectangles give unity to the composition.

In this painting the building constitutes the positive space and the sky constitutes the negative space. To develop interesting negative shapes, I decided to take the tower through the picture plane. This breaks up the negative area into two dominant shapes. Each of the negative shapes has a beauty about it because of the positive elements—the architecture, roofline, and cross—that cut into the shape.

When all of these elements are put together in an interesting manner, spatial relationships are created. Doing this successfully is akin to putting together a complex puzzle, where all of the elements have been equally considered and each

These five images depict some of the compositional decisions that I made before painting *Chiesa di San Giusto*. First, I decided that this image was best expressed with a vertical format.

Second, I established that vertical lines would dominate the image, setting a tone of stability and security.

I reinforced the feelings of calmness and strength by emphasizing a rectangular geometric motif in the image. Notice how I varied the size of these rectangles.

Next, I ensured that I had positioned the church on the page so as to maximize the positive and negative shapes. Notice how the cross is set off to the right and how the tower breaks through the top edge of the picture plane.

The combined effect of these four decisions is a series of spatial relationships that are both harmonious and effective.

component plays off and unifies the others. In the fifth diagram the black line denotes the format as well as the dominant vertical line. The deep yellow line shows the overall rectangular geometric motif. The pale blue mass is painted to illustrate the negative space. And finally the intricate red marks show the smaller, repeated pattern that gives life to the composition. Ultimately the key to creating successful spatial relationships is developing your eye so you can determine if the lines, shapes, and spaces are interesting and balanced and if they relate to the overall composition.

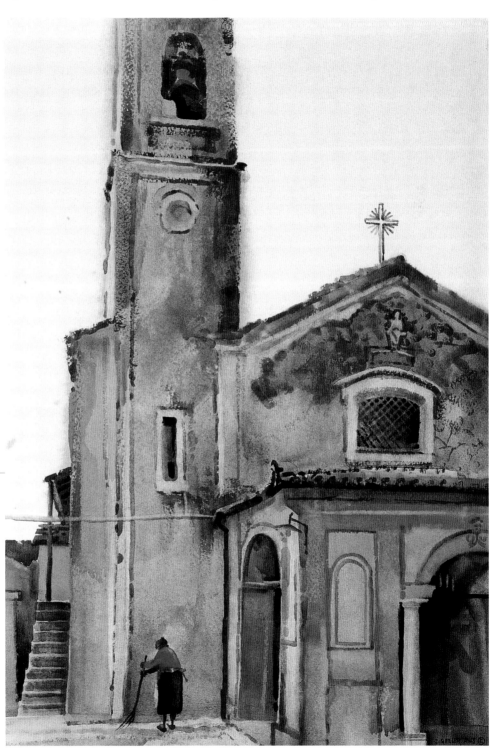

Chiesa di San Giusto, 25½ x 18 inches (64.8 x 45.7 cm), watercolor on 300-lb. rough Richeson Premium watercolor paper, Collection of Chuck and Kay Harbert

My wife discovered this out-of-the-way church while on a walk in the Tuscan hills. I decided to focus in on the building—both to show its texture and age and to emphasize the rectangular motif.

Additional Compositional Elements to Consider

In addition to the essential abstract elements that have been mentioned thus far, many other abstract elements need to be considered in creating a successful composition. Certainly not every element is necessary for every painting, as each work will have its own unique problems and require different solutions in terms of breaking up the space. I discuss each element and show how I used it in one of my works. You might pull out some sketches that you are working on (or paintings that you have been struggling with for one reason or another) and decide if any of these compositional elements may be helpful in bringing the work to a more successful completion.

Division of Space

The division of space is the way the large, abstract shapes relate to each other on the picture plane. Placement of these shapes requires a lot of thought. Imagine a horizontally oriented rectangle that is divided with the horizon line located precisely at the halfway mark. This composition would be static because there would not be any tension between the two areas. This composition would be more visually pleasing if the line were moved further up or down the picture plane. Take a long brush, hold it horizontally, and move it up and down the rectangle. Intuitively you will find a position where the proportion will be beautiful.

It needs to be an intuitive decision made by both the eye and the heart. One needs simply to listen to the painting. The proportions of the division of space can be vertical or diagonal as well. It all depends on the subject and shapes that are used in the painting.

This diagram illustrates my thoughts about the spatial divisions for *Crows in Flight near Nikolaevsk*. (The final painting is shown on page 59.) The most important division of space in this image is the one that creates the two main rectangles in the composition. The larger rectangle encompasses the sky area, and the smaller, elongated horizontal rectangle represents the white light that bounces off the sea and the lower landform. I found the relationship between these two rectangles pleasing to the eye, and this locked in their eventual placement. The secondary division of space that governs this work is the placement of the three slightly diagonal rhythmic landforms that break up the lower rectangle. Likewise, their positions just feel right to me. Many of my paintings can be broken down abstractly in a similar way.

Overlapping and Interlocking Forms

An important method of unifying a composition is to overlap and interlock the various forms. This can be thought of as weaving together the shapes on the picture plane. If the shapes or forms in the composition are isolated, they will appear flat and two-dimensional. Occasionally, this is what the artist is after (as in the case of Hans Hofmann's

This illustration depicts the division of space for *Flight near Nikolaevsk,* shown on page 59. Notice how much of the composition is dedicated to the sky.

The overlapping and interlocking forms in *Aspen Patterns and La Garitas, August,* which appears on page 96, hold this composition together.

work, where rectangles seemingly float on the surface of the canvas). However, more often than not we want to tie these shapes together. A simple way to achieve this is to place a shape in front of but connected to another shape. This will accomplish two things. First, it will link the two shapes and integrate and unify the area. Second, it will create depth in the painting, as the shape in front will automatically appear closer than the second shape behind.

Certainly there are many examples of overlapping and interlocking forms throughout the book, but *Aspen Patterns and La Garitas, August* (shown on page 96) is one good example. The foreground aspen and spruce shapes protrude vertically in front of the rhythmic horizontal mountain and sky forms. The vertical trees interlock with the horizontal land and sky shapes, weaving the two linear elements together. In addition, the thin, horizontal orange shape (in the lower left to center of the composition) repeats the movement of the upper horizontal shapes and weaves in and out of the lower aspen trunks.

OCTOBER 27, 1995

Pattern, texture, and rhythm are of utmost importance to me. It is important to recognize our differences and strengths as artists and focus on them instead of trying to paint as others do. It is important to connect to our intuition and know that these callings are inevitably true.

Color of Winter, La Garitas and Aspens, 28 x 58 inches (71.1 x 147.3 cm), watercolor and casein on 300-lb. rough Richeson Premium watercolor paper, Collection of Jim and Ginny Neece

I did a quick line sketch from the crest of a hill overlooking the tree patterns and the white rhythmic line of the mountain range before returning to the studio to paint this image. This is a very large painting. Using the method described on page 118, I mounted the watercolor paper on Gator Board, varnished the work, and now it is shown without glass.

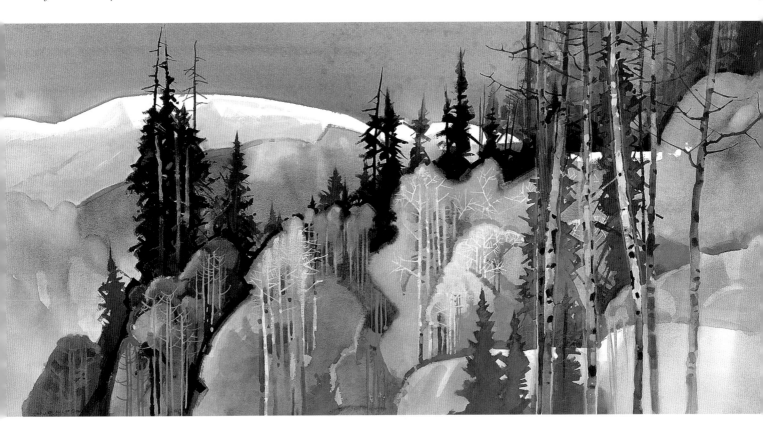

Banding

Banding is a compositional device that most painters have used, whether they are conscious of it or not. It is a unifying thread that links the various elements of the composition. I first became aware of this method when studying Winslow Homer's paintings in the early 1970s. His seascapes and river scenes use water as a horizontal thread to which all other forms—including the sky, vegetation, and figures—are tied.

I painted *Isola, San Giorgio Maggiore, Venice* on-location on a cold and drizzly early December day. I found the only overhang on the main walkway by San Marco Piazza that faced this view. The gondolas were covered with blue rain tarps and people walked by with umbrellas. The main band in this painting is the distant light water that connects the buildings in the distance with the boats and the figures in the foreground. In the diagram I have simplified the composition and made this band dark. It acts as a thread that the architecture sits on and that the pilings overlap.

A banding thread does not necessarily need to be horizontal; it can be diagonal, vertical, or even curvilinear, as is the case with *Orange Band, Winter Rhythm* on pages 40–41. Here the orange band meanders through the landscape, allowing all of the foreground and background forms to play off it.

Surface Tension

I was made aware of the concept of surface tension while reading about and studying Hans Hofmann's work. He was an important teacher in the mid-1900s; his paintings opened the way for the first generation of post–World War II American painters to develop Abstract Expressionism. Many of his paintings feature simple, flat rectangles that are placed on a very active painting surface. Hoffman positioned these rectangles in such a way that the space between them creates a tension that stimulates the eye. He called this important compositional device "surface tension." Although Hoffman employed rectangles, this concept can be used with any kind of subject matter, including flowers, figures, barns, and trees.

The first diagram below shows two rectangles. Study the space around and especially between the rectangles. It is static and uninteresting. The

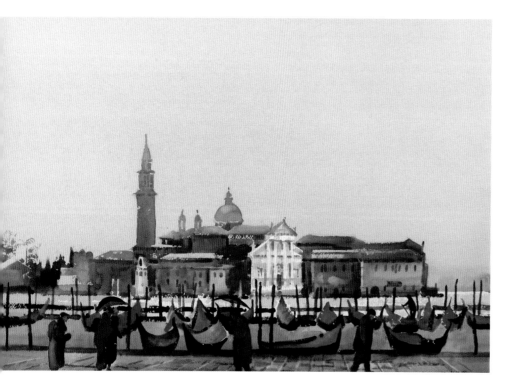

Banding worked well to unify foreground and background elements in *Isola, San Giorgio Maggiore, Venice.*

Isola, San Giorgio Maggiore, Venice, 21 x 29 inches (53.3 x 73.7 cm), watercolor on 300-lb. rough Richeson Premium watercolor paper, Courtesy of Mission Gallery

The blue tarps that covered the gondolas created a nice pattern. The neutral sky is a transparent watercolor mix of permanent orange and ultramarine blue deep.

arrows moving between the two rectangles represent an energy that flows evenly between the shapes. Keep in mind that these rectangles can represent any realistic object.

The second diagram also contains two rectangles. However, they are different sizes and weights and they are positioned differently. Study the space between the rectangles. Notice the arrows that move into the space between the shapes and observe how the space narrows and squeezes the energy as the arrows move up. The energy pulls in very tight before being released when it opens.

This squeeze and movement is surface tension. I incorporate this element when I position the tree trunks in my aspens compositions.

I did *Cathedral Woods* in a remote location in early October. I was in a meadow pocket surrounded by an old stand of aspens. During a heavy week of painting I completed four large paintings and did not see one soul. I was keenly aware of the spacing and the beats between the various aspens and focused on the surface tension when positioning the trunks. The diagram below shows the interesting tension between pairs of the aspen.

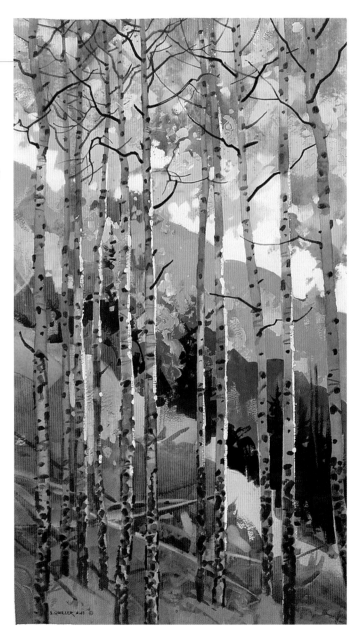

Cathedral Woods, 33 x 19 inches (83.8 x 48.3 cm), watercolor and casein on 300-lb. rough Richeson Premium watercolor paper, Private Collection

One autum, I did four works from this very spot. This was the first one. Each painting delved further beneath the surface. *Wind Gust, Cathedral Woods,* which appears on page 107, is one of the later works. It took this first painting to get to that later one.

These three images represent the concept of surface tension. When two similar shapes are positioned parallel to one another, the surface tension is not very interesting. However, when the shapes are different (both in terms of weight and size) and they are positioned at an angle, the energy flow is squeezed, creating tension. The variable spacing between the trunks of the aspen trees in *Cathedral Woods* creates surface tension throughout the painting to the right.

Balance

Balance in a composition refers to the spatial relationships among the various shapes in an image and their respective weights in the picture plane. The weight of a shape depends on its size, value, color, texture, and the amount of detail it is given. An extreme example would be if all of the shapes on the picture plane were on one side of the composition while the opposite side was a void. The painting would be obviously lopsided. To have harmony in a composition there needs to be counterweight of some fashion on the other side of the work; this counterweight provides balance. Painters use two kinds of balance—symmetrical balance and asymmetrical balance.

Symmetrical Balance

Symmetrical balance simply means that equal weight is given to both sides of the painting. A portrait of a face that is centered in the composition and facing the viewer is one example. Many times a painting using this compositional approach will have a formal and universal appearance. It can be elegant and sometimes even dreamlike or surreal. Georgia O'Keeffe was an American painter who frequently used symmetrical compositions. As a result, her images, which feature such mundane natural objects as cow skulls and flowers, have a cosmic, spiritual quality.

I painted *Pagoda and Koi* at a nature center in Maui, Hawaii, utilizing a symmetrically bal-

anced composition. I was inspired by the pagoda, which reflected in a small pool teeming with koi. I wanted the painting to have a meditative Eastern quality and to capture feelings of both intimacy and reverence. Therefore I decided to place the pagoda and its reflection in the center of the composition and to give equal weight to the sides.

Asymmetrical Balance

By contrast, asymmetrical balance is an uneven balance of objects in a composition. Most often powerful scenes in nature are asymmetrically balanced. There are infinite ways to balance an asymmetrical composition. Imagine a large, light-gray rectangle placed on one side of a picture plane, opposed by a small, bright orange rectangle on the other side. The large rectangle has a lot of volume, but its weak color holds little attention. While the second rectangle is small, its strong, bright color

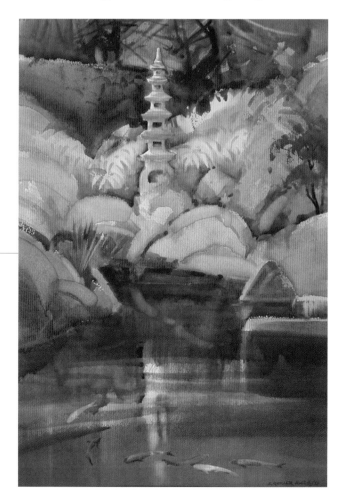

To create a meditative quality evocative of Eastern art, I employed symmetrical balance for *Pagoda and Koi*.

Pagoda and Koi, 26 x 17½ inches (66 x 44.5 cm), watercolor on 300-lb. rough Lanaquarelle watercolor paper, Collection of the Artist

I created this image entirely with transparent watercolor, lifting and glazing to achieve the rhythmic painterly quality.

grabs the viewer's attention. These two rectangles provide equal weight and therefore create asymmetrical balance.

Retreating Shadows #2 is based on the view that I see when I look out from the study in my studio. I was inspired by the color of the spruce cones and snow as well as the patterns of the open water and shadows. I used weight and counterweight to arrange the elements and provide a cohesive, asymmetrically balanced composition.

I placed a lot of emphasis on the strong contrast of the snow and shadows and water on the right, which I counterbalanced with the color of the spruce cones and the shape of the spruce on the left side of the painting. The clumps of snow on the tree and the strong highlights of bright light at the sunlit edge of snow where it meets the water provide even more emphasis.

I have countered this weight by enhancing the contrast between the shadows and lighted areas. In particular, I enlarged the pool of sunlit water, so this part of the image would have more emphasis, and I even added a rounded clump of snow to bring attention to this spot. Although this is a good example, the key to creating asymmetrically balanced compositions is to train the eye—because each painting requires its own unique arrangement of space and balance.

Asymmetrical Composition Studies

Select a subject that can be shown with diagonal line, a triangular geometric motif, and an asymmetrical composition. Create a series of thumbnail sketches in order to work out the composition, maximizing the expressive movement in the work. Choose the medium or the combination of watermedia that will best relay this motif and develop it into a finished painting.

These three images assess the asymmetrical balance of *Retreating Shadows #2*. Even though the orange rectangle is smaller than the gray one, its color gives it equal weight.

The contrast between the white snow clumps and the blue-green water and spruce gives strong emphasis to the left side of the composition.

The white in the upper-right area is counterbalanced by the large dark shape of the pool.

Retreating Shadows #2, 26 x 34 inches (66 x 86.4 cm), acrylic on Aquabord, Private Collection

The color and rhythmic curvilinear patterns of this view provided enough inspiration to do this painting.

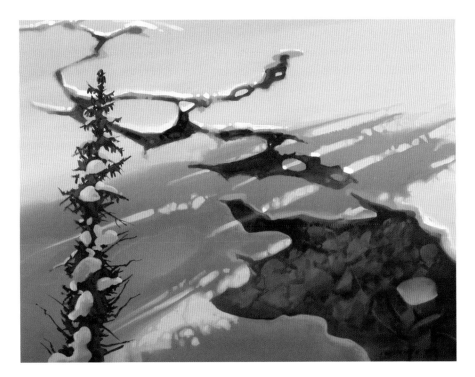

Pattern, Rhythm, and Transition

Although they are, in fact, three separate concepts, I think of pattern, rhythm, and transition together, as they act jointly to create a unifying presence in a piece of art. These techniques are instrumental in producing dynamic and pleasing compositions and are essential to my way of painting.

Pattern

The concept of pattern can be linked to the concepts of geometric motifs and spatial relationships, discussed earlier. If a composition contains similar shapes that are arranged well, it will be pleasing to the eye. However, if all of these shapes are the same size, they become monotonous. Thus there should be variety in the unity of the shapes.

Let's return to *Retreating Shadows #2* on page 139. Notice the curvilinear forms that permeate the work. They vary in size and in complexity—from large and sweeping to small and intricate. However, the basic shape is consistent and therefore the overall effect is pleasing to the eye. In this diagram, I have outlined the large forms in yellow, the medium shapes in orange, and the smaller patterns in blue. Notice the variation in the size of the shapes and yet how the forms consistently move throughout the composition.

The curvilinear forms that touch and interlock throughout *Retreating Shadows #2* give this painting a carefree quality.

Rhythm

I think of the rhythm as the beat of the composition. This beat can be even or syncopated, depending on how the elements are placed in the painting. Normally an even beat will be monotonous and boring. Here is an even beat:

BING......BING......BING......BING.
The BING can be telephone poles, flowers, trees, figures, or any other repeated element in the work of art. The more interesting beat is the syncopated beat, which can go like this:

*BING......BING, bing, bing...bing... ...BING.........**BING!***

Let's go back to *Cathedral Woods,* which appears on page 137, and imagine the aspen trunks that run through the painting as soft diagonal bars that have a beat. This diagram clarifies how I was envisioning the rhythm or beat of the aspen trunks as they dance through the painting. The orange trunks strike the major beats, the violet trunks thump less emphasized (but still solid) beats, while the gray trunks tap soft beats in the painting. Together the rhythm goes like this:

BING... bing.bing..bing... ...**BING**... **BING**... bing.**BING** ... BING ... **BING**BING. This melodic, syncopated rhythm is the beat of this painting.

This diagram of *Cathedral Woods* (which appears on 137) illustrates how I used rhythm with this image.

Transition

The term "transition" is used to describe how the viewer's eye moves from one element or area of a painting to the next. Sometimes a painting will contain a crescendo, or an area of emphasis. This area may feature hard edges, a strong contrasting value, intense color, and possibly more detail—all of which can create weight and provide emphasis. However, most elements and areas of a composition will be secondary, and therefore the eye needs to flow freely from shape to shape, from one area or passage to another. Let's examine how

I worked with transition and crescendo in *Sheep Drive, A Soft Day.* Along the right edge of the mountain in the middleground, notice how the sky, clouds, and distant mountain are vague and amorphous. In the central ridge, the trees become a bit sharper overall. However, I have left some edges on the ridge soft and open, which allows the eye to move freely from the distant landscape and sky to the objects in the lower left area. These trees and landforms are sharper, have richer color, and feature more dark and light contrast—all of which attracts the eye.

The bottom third of the painting also demonstrates how the eye moves from secondary passages to the primary crescendo. At the far right notice how the distant mountain and trees are soft; the colors are not too strong and the values are close.

As the eye moves to the left the shapes are sharper, have brighter color, and are lighter against the contrasting dark forms. All together, this brings attention to the area. The distant sheep link together and move the eye to the foreground sheep, which have even more color and detail. Throughout this area hard and soft edges encourage the eye to stay for a while and then continue on.

Syncopated Beat Studies

Choose an elongated sheet of watercolor paper and orient it vertically. Create a painting that has no focal point. Rather, develop the whole painting in a patchwork pattern, emphasizing a syncopated beat and rhythm. Create transitions and movement from one area of the painting to the next.

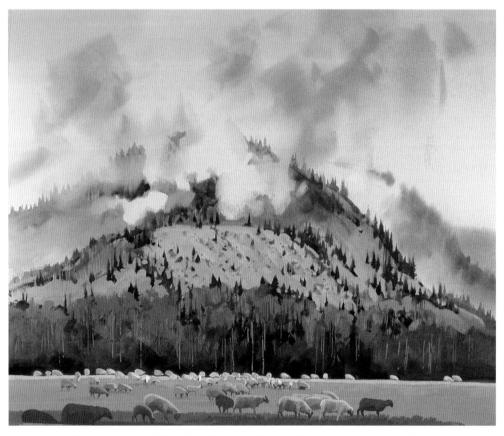

Sheep Drive, a Soft Day, 28 x 38 inches (71.1 x 96.5 cm), watercolor, acrylic, and casein on 300-lb. rough Richeson Premium watercolor paper, Courtesy of Quiller Gallery

The dampness of this soft day in early July brought out the magenta undertones in the shadows and underlying vegetation of the hill. This color provided the base note off which all the various greens could play.

Developing the Art
of Seeing Abstractly

In the first part of this chapter I discussed format, expression of line, geometric motifs, positive and negative shapes, spatial relationships, the division of space, overlapping and interlocking forms, banding, surface tension, balance, pattern, rhythm, and transition. These aspects of composition are essential to know if you want to create unique and high-quality artistic expressions. However, to really understand and use these compositional devices it is most important to develop your eye to see abstractly.

Most of us are conditioned to see representational objects and to think literally. For instance, we see a building or a mountain, a tree or a waterfall, a flower or a bottle. We give more thought to painting the object well than to where it should be placed on the picture plane. To develop strong compositions, however, it is important to first think of these elements abstractly and consider where each shape should be placed and then worry about depicting the objects.

I have found in my seminars that the hardest thing to teach someone to do is to see abstractly. However, I have developed a series of exercises that, if rigorously followed for a period of time, will help lead to a new way of seeing. There are no shortcuts. However, when students embark on this process earnestly and with focus, their eye becomes more developed and ultimately their compositions become much stronger. This next section features these exercises. It also gives tips about how to train your eye by studying the work of master artists. And finally, it helps you to evaluate the abstract characteristics in your own paintings while they are in progress.

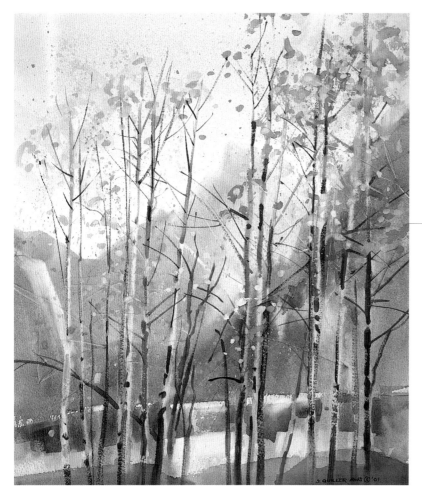

Half Dome, Yosemite, November, 26 x 21 inches (66 x 53.3 cm), watercolor and casein on 300-lb. rough Lanaquarelle watercolor paper, Collection of Edward Robran and Marty Siemion

Most painters who go to Yosemite want to paint the landmark Half Dome. The problem is that when it is painted from an open meadow, it looks like a thumb sticking out of the earth. I found this stand of birch along the Merced River. A bit of autumn was holding on and the colors and forms of the trees created the perfect counterpoint for this composition.

We are trained to see positive shapes. If, however, you can train your eye to see the space between the shapes, you will see less literally and your mind and eye will see spatial relationships, which is ultimately the key to developing strong abstract compositions. When I teach composition I ask my students to do a series of exercises, all of which focus on negative shapes. After a few days they tell me how differently they are seeing. Suddenly they see pockets of light emanating through tree forms and beautiful relationships between positive and negative space. Far and away this is the most important thing you can do to train your eye to see abstractly. Here is a series of exercises that can guide you along this path. To engage in this process properly, these exercises will require a two-month-long commitment, at the minimum.

Focusing on Negative Shapes

Choose a room or an area that appeals to you and that is filled with interesting objects. It could be a kitchen, garden, or any other space. Do not do any preliminary sketches. Identify one object. On a large sheet of watercolor paper and using a 1½-inch brush and watercolor paint, define that object by painting the negative space that surrounds it. Be free with the brush and paint and do not be too concerned with accuracy or technique. When you are finished, move on to another object. Fill your paper with negative-shape paintings.

To the right is a sheet of negative-shape studies I made on an 11 x 15–inch sheet of paper using 1-inch and 1½-inch flat brushes. I randomly chose a chair, teapot, and candlestick holder. The idea is to visualize the object and paint around and through the shape. In other words, instead of painting the object, I painted the space between around the object.

Many things can be gained from this exercise. First, since you're painting the space, your eye focuses on the negative space and becomes much more conscious of the relationship between the positive and negative space. Second, by using fairly large brushes to create the painting, you will learn a lot about brush control—when to use the flat side, corner, tip, and edge of the brush, when to push down for emphasis, when to lighten up, and so forth.

I suggest doing this exercise with simple objects around the house for at least half an hour a day for two weeks. Your eye will mature greatly with this effort.

Painting *around* an object or objects, such as the chair, teapot, and candlestick holder shown here, is a fabulous way to focus on its negative shapes.

Building Negative Shapes with a Plant

This study shows the progression of a negative-shape painting of a geranium plant in our sunroom. For the first step, I used two flat brushes (1½-inch and 1-inch) and worked freely, focusing only on the space around and above the flower and plant. I didn't do any sketching. Instead, I visualized the shape and painted the negative space, using a mix of phthalo turquoise and cadmium red medium.

For the second step, I used the same mix of watercolor to paint the lower negative space around the flower. Then I shifted to a ¾-inch flat brush and focused on the more intricate spaces between the leaves and stems. My eye was aware of the small, pocket-like patterns (what I call "sky holes" in landscape painting) that occur when the leaves and stems overlap one another.

Finally, I took magenta and painted a second plant behind the first, using a 1-inch flat brush. This required more complex visualization, because while painting the second plant my eye and brush had to be aware of the white shape of the first plant. I focused on the intricate patterning of the second plant, particularly where it repeated the patterns of the first one.

It will take some time and skill to develop this exercise. I suggest doing at least one study a day for two weeks with just plant forms. Use transparent watercolor for this exercise. The same plant could be used each day for the first week. Then move outside and do the same exercise with trees or architectural shapes. Then go to a park and do a series of negative-shape studies of figures on benches, pigeons that gather on the ground, or whatever else inspires you.

Rendering a plant by painting its negative space is a good way to train one's eye to see abstractly. Here I first concentrated on the negative shapes surrounding this pot of geraniums.

Next, I painted the negative space created by the overlapping flowers and leaves as well as the negative space surrounding the lower area of the geraniums.

And finally, I introduced a second geranium plant, being careful not to interrupt the negative space defined in the first two stages.

Incorporating Negative Shapes with a Painterly Approach

I began this exercise by wetting an 11 x 15–inch sheet of cold press watercolor paper and then charging it with various mixes of cadmium orange, cadmium red orange, ultramarine blue deep, and ultramarine violet watercolor paint. While the paint was wet I lifted back to the white paper (to suggest tree trunks). Then I loosely painted some dark negative shapes behind the lifted trunk forms.

At the second stage, I mixed ultramarine blue deep and violet and painted negatively—both behind the trunks and through the foliage. I placed a few darker trunks in the foreground to form a base and extended a few of the trunks into the front.

For the final stage, I used casein so I could paint opaque over transparent. I started with a mixture of cerulean blue and titanium white and painted around the upper edge of the painting to form the tree foliage shape. I then took the same color and painted sky holes and pockets through the tree and trunk forms. I wanted a soft diagonal flow to form a dark hill shape so I mixed ultramarine blue deep and a bit of titanium white casein and painted the opaque blue-violet wedge and rhythmic shape, which counters the sweep of the dark hill.

Try this exercise yourself, using tree forms at first and eventually any subject, for at least one hour a day for two weeks. This approach continues the process of learning to see abstractly. However, with this exercise you can now use juicy, exciting paint to give an in-and-out quality to the painting and utilize a painterly approach.

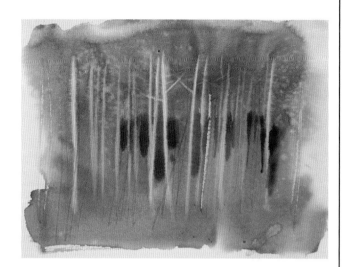

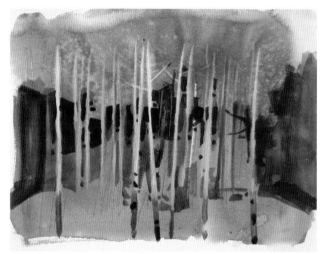

Negative shapes can also be created using a painterly approach. Here, I used ultramarine blue deep to begin to define the space behind these tree trunks.

Next, I used ultramarine blue deep and violet to enhance the trunks as well as to define the upper foliage areas, again focusing on negative space.

And finally, I added an opaque layer of light blue casein to define the outlines of the foliage.

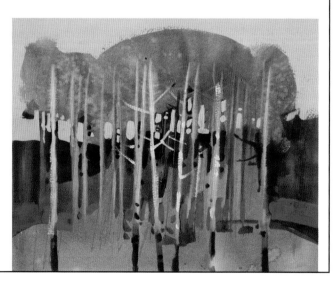

Working from Dark to Light with Negative Shapes

I have been observing red-winged blackbirds daily these past few years. In the late winter, spring, and summer they live in the willows by the river close to my home and studio. I thought it would be fun to use them as an inspiration for this study of working with negative shapes from dark to light.

In the first step, I wet an 11 x 15–inch sheet of 140-lb. watercolor paper and charged it with phthalo green, phthalo blue, Quiller violet, and quinacridone violet acrylic. While the paint was wet I used charcoal and drew into the paint. The charcoal melted into the paper, leaving rich, black, velvety marks. While the paint was damp, I scraped some linear movement into the dark paint to suggest wings and activity.

When the paint was dry I articulated the area around the dark bird shapes with a translucent mix of phthalo blue and white acrylic, as is visible in the second step. I let the brush strokes evoke the movement of flight.

In the final stage, I pushed the paint even further, layering warm light opaque yellow and orange acrylic paint and creating a negative-shape painting around the two red-winged blackbirds. Then I glazed rich ultramarine blue and phthalo blue (green shade) into the foreground. As a final touch I placed some marks of crimson pastel into the bird wings and blue foreground.

If you're not inspired by birds, you can make similar dark-to-light exercises with any of the subjects previously mentioned, including plants and flowers. I suggest working an hour a day for two weeks to get a good feel for this approach. Actually, when you think about it, this process is similar to starting with a white sheet of paper and working down. It is simply the reverse; you begin with a dark sheet and build back to the light.

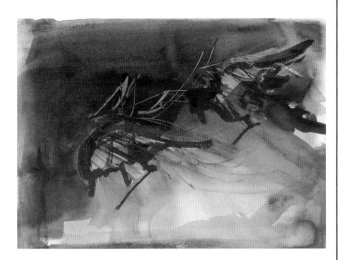

Negative shapes can also be defined by starting with a dark underlayer and building up with lighter colors. I started this study of red-winged blackbirds in flight by working with charcoal and blue, green, and violet tones of acrylic.

Next, I defined the two bird forms by working around them with light blue acrylic paint.

And finally, I created an entirely new environment for the birds, continuing to work around them in a negative fashion.

Training the Eye to See Abstractly by Studying the Masters

Another extremely important way to develop the eye to see abstractly is to study and look at great art. I strongly recommend that you go to art museums often and closely study works that you admire and to which you respond. I take a small sketchbook, and when one work especially hits me I do a quick line drawing of the composition and take a few notes. I jot down something important about the work that may specifically deal with the composition, color, or way the brush strokes were put down.

While this process helps me learn from the work, I do this for another reason as well. I like to pay homage—both to the artist and to the work of art. When I take the time to look deeply at a work, jot down some notes, and do a compositional drawing, I feel a positive exchange of energy between myself and the painting. While studying these paintings, take note of the compositional elements mentioned earlier in this chapter that the artist used. While you take all of this in, the most important thing is to stand back and feel the power of the expression of the work.

When I do a compositional line drawing of a painting, I intentionally keep it very simple, with no detail. In fact, I emphasize the geometry of the work, such as the banding or whatever is relevant to the composition. I use a gel pen that has a bold, 1-millimeter line. When I teach composition in my workshops I start each morning by asking my students to create rapid-fire compositional line sketches. I flash a slide of a master painting on the screen and give everyone three minutes to get the essential elements of the composition. I then move to the next painting. We do this for thirty minutes to help my students develop the eye to see abstractly.

I have a great library of art books at my home and studio, and I peruse them constantly. I purchase books by artists that I admire and read about

The love, joy, and excitement that are put into a painting do not depart once a painter has finished the work. They are always there. If one looks at a good Wyeth, a good Homer, a good O'Keeffe, a good Degas, a good Vermeer, and so forth, the energy is there.

their lives as well as studying their art. I have been doing this since the late 1960s and now have these books organized alphabetically according to artist or art period. I suggest studying and reading about great artists—both past and present—that you really like. Take your sketchbook and do some compositional line drawings of some works in the book that stand out. By involving yourself in this process, the work will become imbedded in your mind. I have found going to museums and galleries and reading about and studying great works useful in my own painting. Occasionally, when I come across a problem while I am painting, something in a work I studied twenty years earlier can help me solve the problem.

Following are four artists who I admire greatly: Johannes Vermeer, Winslow Homer, Arthur Melville, and Charles Burchfield. Except for Vermeer's work, the paintings I have selected are in watermedia. I have done one compositional drawing of a single painting by each artist and list some of the compositional elements I notice in their work. I also give the some details about a particularly noteworthy book on each artist, in case you want to delve further. While I have chosen these four painters, many other artists can be studied as well. I encourage you to identify a couple of artists you like and spend an afternoon doing compositional sketches and taking notes. In the process of this interaction your eye will see much more deeply. One of the most important things in life is to be a student. I wish you well on this never-ending journey.

Johannes Vermeer, *Woman with a Lute,*
early 1660s, 20¼ x 18 inches (51.4 x 45.7 cm),
oil on canvas, Metropolitan Museum of Art,
Bequest of Collis P. Huntington, 1900

Credit: Art Resource, New York, NY

Vermeer employed strong horizontal and
vertical forms to give this work a feeling of
calm strength.

Johannes Vermeer: *Woman with a Lute*

Johannes Vermeer (1632–1675) was a Dutch painter of interior scenes and city views. The interior setting in this painting has a timeless feeling of quiet solitude. Notice that he uses a slightly vertical but almost square format. The strong horizontal and vertical lines suggest feelings of restfulness and stability. His beautiful use of the abstract rectangular geometric motif and wonderful arrangement of spatial relationships and asymmetric balance add to this feeling. Overlapping and interlocking forms tie the composition together. For further information, you might consult Leonard J. Slatkes's *Vermeer: The Complete Works*.

Winslow Homer: *Three Boys on the Seashore*

Winslow Homer (1836–1910) was an American painter whose images of the American land scape and marine subjects are especially powerful and expressive. He gave a light hearted, carefree feeling of a midsummer day in this painting. To achieve this effect he used an elongated horizontal format and employed a slightly curvilinear line and motif in the clouds, figures, boats, and fore-ground rock. This image has a beautiful division of space as well as an interesting rhythm, beat, and pattern between the figures and boats. The quiet horizontal banding line of the sea in the background and the overlapping and interlocking shapes unite this composition. Turn to Miles Unger's *Watercolors of Winslow Homer* to study his work further.

Winslow Homer, *Three Boys on the Seashore,* 1873, 8⅝ x 13⅝ inches (21.9 x 34.6 cm), gouache and watercolor on paper mounted on board, Daniel J. Terra Collection, Terra Foundation for American Art, Chicago

Credit: Art Resource, New York, NY

The curvilinear lines, particularly noticeable in the clouds and figures, help depict a carefree feeling, appropriate for a summer day at the shore.

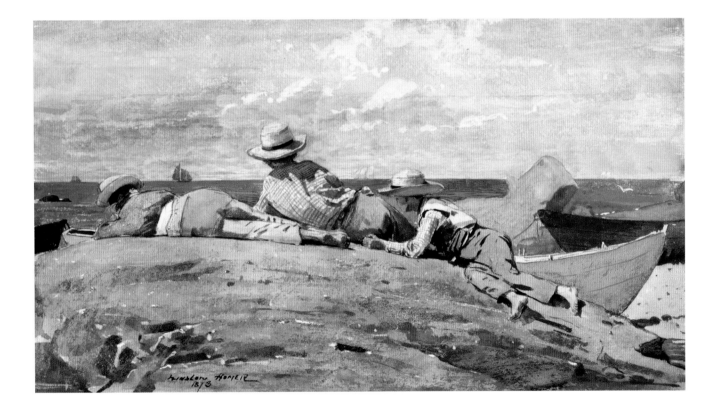

Arthur Melville: *Mediterranean Port, 1892*

Arthur Melville (1855–1904) was a Scottish painter who spent a great deal of time painting in the Middle East, Spain, and his native land. He is particularly well known for his Middle Eastern markets, cityscapes, and ports. He created his own sizing by saturating his wet watercolor paper evenly with Chinese white watercolor paint and letting his support dry overnight. He then would proceed to work transparently in watercolor but could lift color as needed because of this underlayer of paint.

In *Mediterranean Port, 1892* Melville incorporated a strong rectangular geometric motif with a variety of sizes of rectangular shapes that create beautiful patterning. The simplicity of the water provides a quiet but incredibly well-designed negative shape. The stunning placement of the vertical pilings and candle shapes on the boat bestow a syncopated beat to this composition. The overlapping shapes—from the boat to the buildings—provide depth to the work. For more information about his life and work, look for Iain Gale's *Arthur Melville*.

Notice how the overlapping shapes create a tremendous sense of depth in Melville's powerful image.

Arthur Melville, *Mediterranean Port,* 1892, watercolor on Whatman watercolor board, 20 x 31 inches (50.8 x 78.7 cm), Culture and Sport Glasgow (Museums)

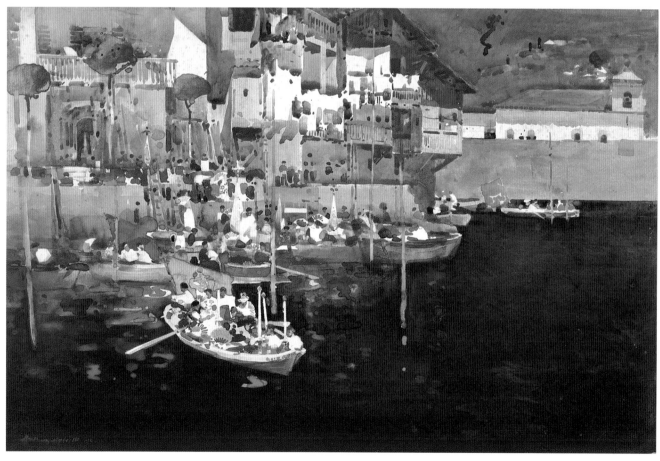

Charles Burchfield: *Orion in December*

Charles Burchfield (1893–1967) was a regionalist painter who did most of his work near his homes in Salem, Ohio, and Buffalo, New York. This image has a magical, fanciful, mystical, and spiritual feeling that is created and emphasized by his use of a curvilinear line and a curvilinear motif. However, he also incorporated soft triangular forms to connote movement and energy. The variation among the variously sized sentinel-like tree forms creates a wonderful rhythm and syncopated beat. He also positioned these forms in such a way as to create marvelous surface tension in the painting. For more about Burchfield, you can consult Nannette V. Maceijunes and Michael D. Hall's *The Paintings of Charles Burchfield, North by Northwest* or go to the Burchfield Center on the Buffalo State College campus in Buffalo, New York.

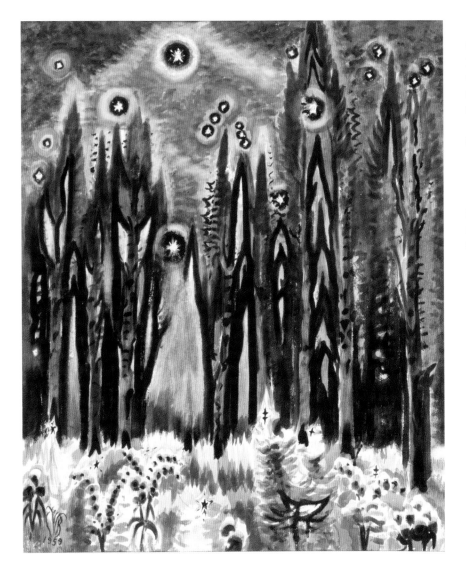

Charles Burchfield, *Orion in December,* 1959, 39⅞ x 32⅞ inches (101.2 x 83.4 cm), watercolor and pencil on paper, Smithsonian American Art Museum, Washington, D.C.

Credit: Art Resource, New York, NY

Burchfield positioned these tree forms masterfully, creating not only rhythm but also surface tension in the image.

Seeing the Painting Abstractly While It Is in Process

If you've done the exercises that I provided earlier in this chapter and spent time studying the work of master artists, then no doubt you've come a long way in terms of training your eye. But the real test is how it all comes together when you're actually in front of the paper or canvas, creating a work of art. Sure, you want that figure to look just like that figure or that barn to look just like that barn. However, you also need to give a lot of thought to the placement of the objects on the picture plane if you really want it all to come together masterfully; so, now, perhaps even more than ever, it is important to be able to see abstractly. Luckily, there are a number of things that you can do to really *see* a painting that is in progress and to focus on its abstracted composition. Following are four possibilities to help you concentrate specifically on the abstract composition of the painting.

Turning the Painting Upside Down

The best and most common way to see your painting abstractly is to simply turn it upside down and to stand back and study it in good light. In doing so, you remove the reality of the subject, can assess the success of the abstracted composition, and can make decisions more clearly. While the painting is upside down, ask yourself:
Does it have proper balance?
Is there an interesting relationship between the positive and negative shapes?
Is there a consistent geometric motif?
Does the paint application communicate what I want to express?
Is there an interesting rhythm, beat, and pattern in the painting?
Does the color work?
Is this the ideal format?

While studying the painting, try to look with "soft eyes." (This simply means to let the paint-ing—its shapes, colors, balance, and so forth—come to you and enter without too much thinking; by contrast using "hard eyes" would be seeing with a very analytical vision—dissecting everything but missing the essence.) Try not to think too much about each question, but let thoughts and choices emerge or come to you. Your gut will know what needs to be finessed. Listen and react.

Using a Mirror

Another great way to disassociate your painting from its representational subject matter is to look at it in a mirror. I teach a lot of painting workshops where I demonstrate this, making a painting that the audience views in progress with the help of an overhead mirror. Partway through the demo I go out in the audience and study the painting in the mirror. I see the painting in reverse (which is the way they see it while I'm making it). When I finish the presentation, workshop participants come around to my side of the table and witness what appears to them to be the "reverse"of the image.

In your home or studio you can hold a painting to a mirror and study the abstract composition. If you want to see it *very* differently, turn the painting upside down as well.

JUNE 11, 1996

The difference between a beginning painter and an advanced painter is that the former is afraid to make a mistake while the latter welcomes the opportunity. There is really no such thing as a mistake, but instead an unexpected moment that can create an opportunity for an interesting change or a new direction. This will occur if the artist is listening to the painting and participating in the process rather than trying to be in control.

Squinting the Eyes

One of the things I do most frequently while painting is stand back and squint my eyes. By squinting I obliterate the detail, recognizable shapes, and subject matter in the painting and see the work more abstractly. I have done this for so long that I have developed pronounced crow's-feet on the corners of my eyes. If you are very nearsighted, you can accomplish the same effect by simply removing your glasses.

Using a Viewfinder

When painting on location, artists are many times overwhelmed by the subject matter. They're thinking, *With all of this out here, how can I best focus and choose what I'm going to paint?* The View Catcher, produced by the Color Wheel Company, can help you to home in. Created by nationally known artist Patti Andre, the tool is a viewfinder that you look through. It can be turned so that it frames the image horizontally or vertically, plus a flat slider can be adjusted to help you find the ideal format for the composition, including an extreme vertical or horizontal or a square. It is a neutral mid-gray, which also lets you see the true color of the subject. In short, the View Catcher crops outlying material so that you see only the beautiful, abstract shapes in nature. This tool can also be used when painting the figure or the still life.

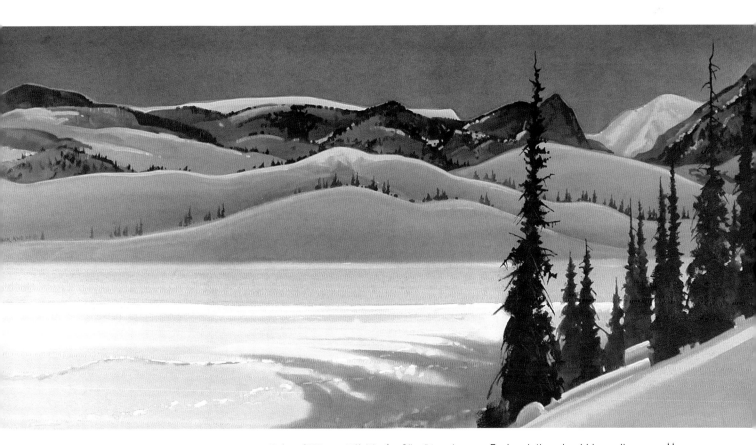

Color of Winter, Elk Tracks, 28 x 56 inches (71.1 x 142.2 cm), acrylic on Aquabord, Colletion of Robin and Bob Brobst

Each painting should have discovery. Here I found that a void, or an area without much physical subject matter, can provide a counterweight to a heavily developed area.

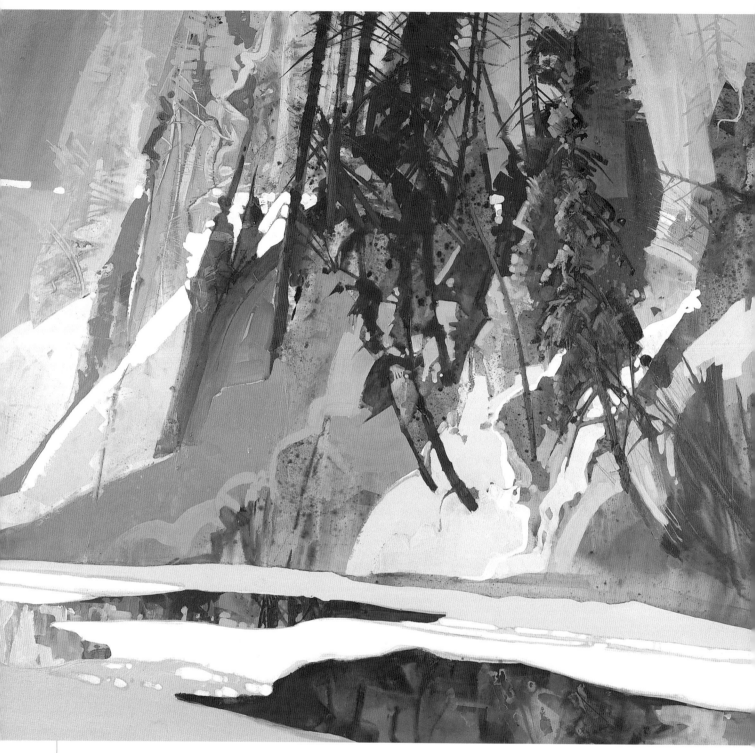

Early Spring Light, San Juan Mountains,
26 x 36 inches (66 x 91.4 cm), acrylic on
#5114 Crescent watercolor board, Collec-
tion of the Artist

Late February through mid-March are my
favorite times for painting. Most people in
this area take their vacations at this time
because of the mud, wind, rain, and snow.
Indeed, these things can be problematic,

but on the good days *life is emerging.* Ice
and snow are starting to melt, revealing
fresh earth. The strong light and shadow
on these elements accentuates the color,
rhythm, and pattern.

S QUILLER AWS ©MM

<div style="border: 1px solid black; padding: 10px;">

CHAPTER SEVEN

</div>

Solid Working Methods

IN OUR SOCIETY, WE DO NOT PLACE A LOT of value on drawings and sketches. We tend to want to get on to the "great, finished painting." But to truly get "there," we can't take any shortcuts. We must know how to develop our inspiration and prepare and build to the finished painting. I love studying J. M. W. Turner's sketchbooks and reading Charles Burchfield's journals. These show their working process, what they were thinking—in short, what was going on in their brains. I look at the etchings Pablo Picasso did when he was in his 90s; the line in these prints is as effortless and facile as the drawings he did in his early years.

I am not proposing that working drawings must be great, finished works. Far from that. Drawings should help you develop your composition and home in on your inspiration. They should help you to make decisions about how to eliminate superfluous information and detail so that the final painting can be all that it can be. Sometime take a look at *Wyeth at Kuerners,* a coffee-table book on the drawings and preparatory studies for subjects Andrew Wyeth did near his home in Chadds Ford, Pennsylvania. Often Wyeth made many, many studies before doing the final work.

Each artist works differently and has his or her own process. One important thing to remember is that the working sketches should inspire, but not limit, the creation of the painting. I have seen artists' sketchbooks that are filled with framable work. Each study is so finished and beautiful that it is complete. Larger work sometimes ends up being a reproduction of a smaller study, and, as such, it is inevitably not as strong. A good working sketch should help you home in on your inspiration but allow you the freedom to go deeper and still enjoy the discovery in the process of making the finished painting. This process helps the artist to develop his or her own personal mark.

Robert Henri, *Advance and Retreat,* **1906,** *7½* x *7½* inches (19.1 x 19.1 cm), graphite on paper, Collection of Stephen Quiller

This drawing not only helped Henri to grow as an artist but it now inspires me daily when I go to my studio.

Drawing is the key to developing a signature or style. *Advance and Retreat* is a small drawing by American master Robert Henri. Henri was a highly respected painter and instructor who lived in New York City from the latter part of the nineteenth century through the first part of the twentieth. He was a leader of a group that they called "The Eight" (but that was commonly referred to as "The Ash Can School"). His book, *The Art Spirit,* still in print today, has inspired a multitude of artists. He drew constantly. I acquired this work in the late 1970s and am inspired by it to this day. I view a few works from artists I admire each morning. These pieces get my juices going and motivate me as I go to my studio to work.

In this chapter I begin with a discussion about the importance of working from sketches. This is the process of taking your initial ideas and inspiration and working them through on paper, which is critical to making your paintings much more personal and in finding your individual mark as an artist. Then I examine in detail the working process of three contemporary master painters, all of whom work with watermedia. Next, I give some solid advice about how to put together everything that you have learned in this book, to help take your watermedia painting to that next level. And finally, I give some critical advice about knowing when to stop and call a painting "finished." I hope that you have enjoyed our journey together—and that it has strengthened and inspired you for the many exciting journeys that are still to come.

Working from Sketches

When I give indoor painting workshops throughout the United States and abroad, I ask participants to bring reference materials to work from while painting. Inevitably 90 percent of the students bring photographs while 10 percent bring sketchbooks and some notes. While the purpose of the class is to introduce color, watermedia, and composition (and not to end up with finished paintings worthy of framing), it does my heart good when artists take the time to sketch their inspiration, to put on paper what they respond to and what is in their hearts. Their resulting paintings are always much more personal and meaningful and have the individual artist's mark and signature. These painters have taken the time to interact, meditate (if you will), with the subject, and it becomes a part of their souls.

Many times I have seen students go through a stack of photos that they brought to class to find something to paint. Sometimes they select an image but then can't remember where or when they took the shot. Nevertheless, they proceed to paint from it, using the same colors and composition. The resulting work is occasionally quite competent, but it never has the spirit that is unique to that individual.

I can look at a sketch I did in 1969 and remember the atmosphere, the day, the trip, and

the companion with whom I was traveling. The sketch might be crude and there may be a smudge or rain-spattered texture on the paper. That is fine. The sketch and notes are for me, for my reference, and not to be shown to the public. I have many times said that it would be terrible if I lost a number of my paintings in our gallery, but it would be devastating to lose my sketchbooks because these are my diaries and my brain, my thinking process that makes my paintings happen.

I want to encourage you to draw, to put marks on paper—no matter how crude. Through the process of observing, interpreting, and drawing, the subject will become ingrained in your soul. We all have something unique to say within us. The more you hone the process of putting down notes and sketches and using them to create finished painting, the closer you will come to finessing your personal style and mark.

I can walk into a museum, look at a painting, and immediately know if Winslow Homer, Edgar Degas, Georgia O'Keeffe, Robert Henri, or Jo-hannes Vermeer created it. Why is that? I believe it is because they spent a lifetime of sketching, taking notes, and studying; in short, living their art. As they matured, their marks became more distinct. There came a point when they mastered the craft of painting and let this mastery serve their power of expression. Yet they kept probing deeper inside, taking risks, and finding uniquely what they had to say. They all got to the point where their knowledge of the craft, their study of other masterworks and periods, served so they could most fully express their vision. In short, they got to the point where they could let their subconscious and spirit take over.

Coastal Village, Bandon Jetty, 8 x 11 inches (20.3 x 28 cm), soluble felt-tip pen on sketchbook paper, Collection of the Artist

I did this sketch on a drizzily green-gray day. I used a water-soluble marker for the drawing, washed over the image with some water, and let rain do the rest to capture this jetty by the village of Bandon, Oregon.

Sketching Materials

Every artist has particular materials that he or she favors for one reason or another. Lots of different drawing materials are available today. Here are some of the materials I use for my working sketches—and some examples of the sketches that I have made with them.

Gel Pen

I find that gel pens make a mark that is fast and direct, which helps me to think simply and abstractly. I make line drawings or compositional studies with gel pens most of the time when I'm traveling, working in the backcountry, or cross-country skiing. As you can see from this line drawing for *Crows in Flight near Nikolaevsk*, I feel free to write notes that are important to my inspiration directly on the sketch itself. (The finished painting appears on page 59.) Presently I am using a uni-ball Gel Impact Bold Black Pen that gives me a 1-mm-thick line.

Study for *Crows in Flight near Nikolaevsk,* 10 x 19½ inches (25.4 x 49.5 cm), gel pen on sketchbook paper, Collection of the Artist

Notice the additional studies of the crows along the right side of the main image.

Studies of Red-winged Blackbirds, 18 x 28 inches (45.7 x 71.1 cm), crayon on Somerset drawing paper, Collection of the Artist

I love observing red-winged blackbirds in flight and in their various feeding positions and especially enjoy listening to their song.

Black Crayon

I find that a black crayon is a great choice for sketching in my sketchbook or for creating a finished drawing. A good wax crayon will not smudge easily, so drawings hold well. You can get a bold mark and obtain a great range of value—from black to light gray. And sketches can be done quickly. I used black crayon to create these two drawings, *Retreating Shadows #2* and the study of the red-winged blackbirds. (The finished painting for the former image appears on page 139.)

Study for *Retreating Shadows #2,* 9 x 12 inches (22.9 x 30.5 cm) black crayon on sketchbook paper, Collection of the Artist

Many times I note the date on my sketches. This comes in handy if I want to do a work a year or two later that has similar light or other environmental conditions.

Study for Ghost Trees, 18 x 28 inches (45.7 x 71.1 cm), charcoal and white pastel on Somerset drawing paper, Collection of the Artist

I did this on-site drawing on a gray-toned drawing paper, working first with a charcoal stick and then white pastel.

Charcoal Stick

I love the velvety-black visual quality of charcoal. What works best for me is a compressed charcoal. The stick holds together well and is not as "dusty" as a vine charcoal. I smudge the black marks with my thumb or with a paper towel to soften edges and create transitions. The charcoal melts nicely on wet paper to fluid black stokes; conversely, dry charcoal marks can be wet with a soft brush to gradate an area. I created this study for *Ghost Trees* with charcoal. (The finished painting appears on page 117.) The only thing to note when working with charcoal is that a light coat of acrylic fixative should be applied to the finished drawing so it doesn't smudge.

Intimate Studies

Find a subject that is close to your heart: a special tree, your cat on the couch, your spouse in the garden. Do some sketches and line drawings of the subject. Do not use a photograph for reference. Take notes in your sketchbook of any thoughts that are pertinent to this idea. Next, work out this idea in a color study and build to a final painting. Think of the format, color, medium, and paint application that will best express this idea.

Lithography Crayon

I have come to use litho crayons for the majority of my value drawings and sketches. It has a velvety-black mark and can be placed on edge to obtain a very wide, even-value shape. This tool comes in a range—from #0 (which is extra soft) to #4 (which is very hard). I use a #2 made by W. M. Korn. It is hard enough that the marks do not smudge easily but soft enough to get a very deep black mark, if desired. I have stacks of drawings done with litho crayon in my files, including *Golden Light by the Cross-country Trail,* shown here. (The finished painting appears on page 87.) When I do a more finished drawing, I use a quality pH-neutral drawing paper that is at least 70-lb. I want these drawings to last. I feel that by using quality materials, I will take my work seriously.

Study for Golden Light by the Cross-country Trail, 22 x 30 inches (55.9 x 76.2 cm), litho crayon on Somerset drawing paper

I used this drawing as reference for the large acrylic painting that appears on page 87. Many times I use a #2 litho crayon because I can turn it on edge to create large, broad shapes and also make any value I need, including rich blacks. I can complete a compositional study in a short time with this tool.

Studying the Working Process of Three Master Painters

When we look at the work of a great master painter, the marks we see are a culmination of years of working—right up to the moment that that particular painting was done. On these next few pages I show three painters whom I admire and allow them to divulge how they develop their expressions. Each of these artists has spent a lifetime developing the craft and the art of his or her work. Notice that each painter has his or her own style and mark, own subject matter and methods, and own path of working from sketches to finished painting.

Carla O'Connor

With my figurative works I continue to be inspired to create a collection of paintings that I call *Beach Walkers*. Whether it is a single figure or a group of many, I present these people walking or standing in ordinary poses and then abstract, stylize, and flatten the shapes. Many of the shapes are echoed or repeated and find their way into all my work, regardless of the subject matter. Although I often rely on photos for my source material, the original *Beach Walkers* came from a fleeting glimpse of people as I walked the shore myself and has stayed in my memory for years.

I take great liberties with the human form and place emphasis on the non-objective aspects of the painting. I move the viewer's eye around the painting by using strong, contrasting light and dark areas, a balance of color, and small, broken, patterned or textured shapes to create a pathway through the painting. As a figure painter, I have the advantage of knowing that the viewer will always begin the journey with the face, no matter how abstracted it is. It's human nature, after all. I use both transparent watercolor and opaque gouache, side by side, one always a little more dominant than the other.

Carla O'Connor, *Beach Walkers,* 4¾ x 7 inches (12.1 x 17.8 cm), ink on smooth drawing paper, Collection of the Artist

This is the first sketch—from my memory and imagination—of the beach strollers. These stylized figures turned out to be the reference material for many paintings.

When working on a new painting, I can save time and avoid frustration by checking my sketch. I try to divide the four edges of my rectangle differently—in an interesting and surprising fashion. This has helped me recognize bad habits—like always putting the figure in the middle—and hopefully correct them. It is a lot easier to make corrections at this point than to wait until a full-sheet watercolor paper is nearly finished. From the sketch to the paper, I block in large shapes and areas of color, using a brush, never a pencil, and stay light and simple as long as possible. From this point on, I layer paint and then scrub it off, adding too many shapes, then simplifying and so forth until I am satisfied with the result. I save tiny details until the very end.

Carla O'Connor, *Travelers #1,* approximately 5 x 5 inches (12.7 x 12.7 cm), ink on smooth drawing paper, Collection of the Artist

A square format is generally more difficult to compose than a rectangle because the artist starts with four equal sides. On the other hand, it is an exciting new challenge.

Carla O'Connor, *Beach Walkers,* 34 x 34 inches (86.4 x 86.4 cm), watercolor and gouache on 270-lb. hot press Arches watercolor paper, Collection of the Artist

The unusual palette of so many different greens was as much a challenge as the curved wave, which was like a flow of energy, superimposed over the flat geometric shapes. This finished painting is a long way from that first glimpse of figures strolling the beach looking for shells that I saw so many years ago.

Carla O'Connor is a signature member of the American Watercolor Society, the National Watercolor Society, and the Northwest Watercolor Society and is an American Watercolor Society Dolphin Fellow. She is the recipient of many awards, including the American Watercolor Society Silver Medal, and is a frequent contributor to such publications as *The Artist Magazine* and *International Artist Magazine.* O'Connor teaches watermedia workshops across the United States and internationally, most recently in Prague, the Czech Republic. Her jury experience includes working with the American Watercolor Society, Northwest Watercolor Society, Rocky Mountain International, and (forthcoming in 2010) Western Federation of Watercolor Society.

Frank Francese

I'm always on the lookout for wonderful areas to paint. When one of my workshop students showed me photographs from northern England, I was immediately taken by the subject matter. I knew this area would be my destination that year, but I will never forget my travel agent's response to this desire: "Frank, no one goes to the North Sea during Christmas!"

Upon arriving in Whitby, England on Boxing Day I was convinced I had made the right decision, however. Sometimes while I was looking at a certain scene my skin would start "crawling." Those are wonderful moments—moments that scream for paper and paint.

Creating *Whitby, England, Low Tide* was one of those moments. I wanted to capture the buildings, fishing vessels, and docks with people sitting on them, preparing their ships for the sea. I was wet and cold; the wind was constant. While this made it difficult to sketch, I knew I had a winner.

While in Whitby, I was able to sketch for about six hours each day before it turned dark and was too cold to work. I spent all of my time outside, sketching and digitally photographing each site to give me information that I used later in my studio to create the paintings. On-site I did a lot of contour sketches, creating big, interlock-

Frank Francese, *Church Street Harbor,* 5 x 7⅞ inches (12.7 x 20 cm), Sharpie Twin Tip Permanent Marker on 90-lb. white bond paper

This is the value study I used for the finished painting *Whitby, England, Low Tide.* I focused on the value arrangements, leaving the central building white and arranging strong darks for contrast.

Frank Francese, *River Esk,* 5 x 7⅞ inches (12.7 x 20 cm), Sharpie Twin Tip Permanent Marker on 90-lb. white bond paper

This is another value study I did while in Whitby. It focuses more on the harbor, boats, and working life of the village. The diagonal movement became important to the composition.

ing shapes and leaving out most of the confusing details. Each of my drawings took only about five minutes. I sometimes stood in the rain, smelling the area, feeling the wind, and studying the local people. Back in my hotel room I finished the sketches, putting in the light, middle, and dark values. I relied on memory to complete this process, making it into something fun and from my heart, not my brain.

Drawing and sketching is the most valuable tool any artist has. The more one understands the process of using line, shape, and form to establish a well-designed composition, the easier it will be to apply these elements to create strong paintings. It seems as if everyone knows how to start a painting, but few painters know how to finish the work. When an artist takes the time to plan out the composition before starting the painting process, not only does it make the entire process more fun, but the artist gains confidence in his or her creative abilities.

When painting an image, I enjoy working on a very wet surface, letting the pure color mix itself on the paper. My shapes tend to be large and loose, and I disregard fine detail. I often incorporate abrupt color changes of the same value, playing off the white of the watercolor paper to bring my paintings to life.

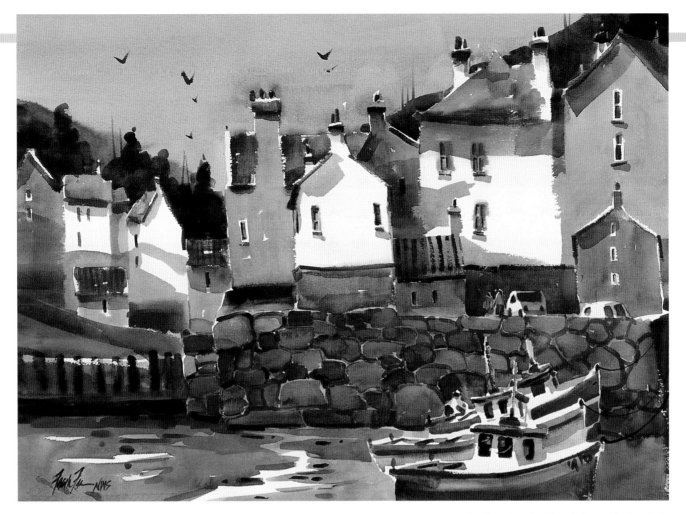

Frank Francese, *Whitby, England, Low Tide,* 22 x 30 inches (53.3 x 76.2 cm), watercolor on 140-lb. rough Winsor & Newton watercolor paper, Collection of the Artist, Recipient of the Award of Excellence at the Western Federation 31st Annual Exhibition, 2006

I referred to the *Church Street Harbor* study of Whitby while making this final painting. I worked quickly and directly on the paper, placing my bold color intuitively. Studying my sketches helps me to focus on the broad abstract patterns of the composition and to eliminate unnecessary detail—both of which are essential to the painting.

Frank Francese was born in 1951 in Arizona but has lived most of his life in Colorado. He has been a professional artist since 1976 and is a member of the National Watercolor Society, Transparent Watercolor Society of America (master status), Watercolor West, Western Federation Watercolor Society, San Diego Watercolor Society, Taos Society of Watercolorists, and the Colorado Watercolor Society. Watercolors came to the forefront of Francese's attention in 1983. His liquid style is uniquely distinctive. He has received a number of awards for his work, including the Western Federation of Watercolor Societies 31st Annual Exhibition Award of Excellence (2006); the Colorado Watercolor Society's 13th Annual Exhibition Best of Show (2004); Watercolor West's 34th National Exhibition First Place Award (2002); and the Second Place Award in Landscape Division, Artist's Magazine Competition (2001). Frank's paintings and articles have been published in *The Artist's Magazine, Watercolor Magic, Splash 5,* and *Best of Watercolor Series,* 1997.

George James

I begin with the motivation to paint, as I derive great satisfaction in just moving paint around. My concept of composing is based on two ideas: the dynamics of the picture plane and the point of view. First, I am concerned with the shape of the paper and the location of the dynamic center of this working area. As for point of view, where do I see the idea? From there I draw on my recent or current thoughts. I look at shapes, design, and placement. I focus on what is important. Next, I make sketches, more complete drawings, and/or small painting studies of the ideas I may use in the final painting. Here I use a fine-tip marking pen, which allows me to work more rapidly.

Mostly, these studies are anecdotal, as I begin to focus on the serious elements of the work. Producing a small study of the idea, I attempt to gain a sense of the dark and light patterns I intend to use. Although some artists make a complete value study at this point, I prefer to plan the dark and light patterns utilizing the concept of "exchange."

George James, *Dark and Light Patterns Study,* 8½ x 11 inches (21.6 x 28 cm), fine-tip marking pen and watercolor on sketchpad paper, Collection of the Artist

In this image I worked in monochromatic watercolor to build the design, pattern, and value. This study helped me establish the basic abstract design of the painting.

George James, *Arthritic Hands,* 8½ x 11 inches (21.6 x 28 cm), fine-tip marking pen on sketchpad paper, Collection of the Artist

This gestural contour study is a close-up of arthritic hands, which I used for the finished painting. Using a fine-tip marking pen allows me to work rapidly.

Exchange is the method of using the dark patterns to visually explain the light patterns. This process allows me the freedom to apply the concept of chiaroscuro, as I find using "light logic" in my dark and light patterns too limiting.

Eventually, I begin the final painting using a Derwent watercolor pencil to construct a complete drawing on Yupo paper. These pencil marks can be corrected or removed by washing away the undesired marks from this paper. At this point, I use a light, neutral wash to indicate the planned dark and light patterns. Next, I refer back to my original concept and continue painting. That original concept, however, influences all of my decisions of color, design, and paint. Painting transparent watercolor on Yupo paper, therefore, provides me the freedom to redirect the final painting at any time.

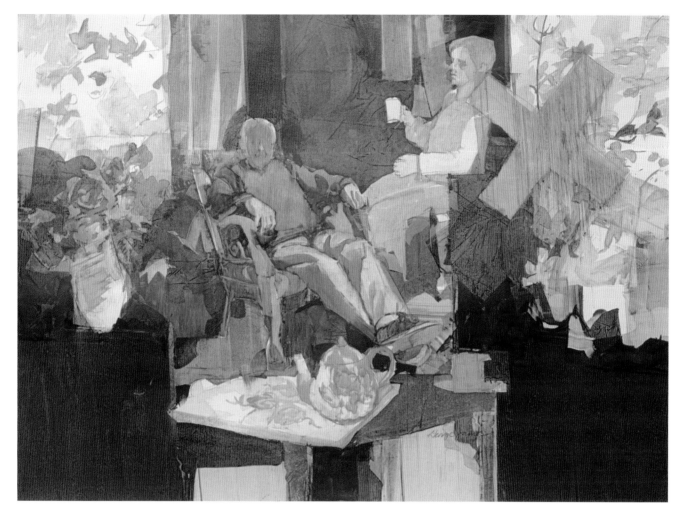

George James, *Nanny's Chair,* 26 x 34 inches (66 x 86.4 cm), watercolor on Yupo paper, Private Collection

This chair belonged to my grandmother. It had been in storage for many years. After retrieving it, my brother sat in the chair and we began reminiscing about our grandmother. This emotional experience became the start of this painting.

George James is a Dolphin Fellow of the American Watercolor Society, a member of the National Watercolor Society, and a Professor Emeritus of Art at California State University–Fullerton. Working with synthetic paper and traditional watermedia, he has elevated the watercolor experience to a new level. He has received a number of awards for his paintings, including the American Watercolor Society High Winds Award (2007, 2003), the National Watercolor Society Silver Star Medal (2001), the American Watercolor Society Gold Medal (1999), and the American Watercolor Society Bronze Medal (2001, 1998). James's paintings and articles have also been reproduced/published in *The Artist's Magazine, Watercolor Magic, Southwest Art,* and *International Artist.* Two authors, Gordon T. McClelland and Jay T. Last, document his watercolors in the following books: *The California Style: California Watercolor Artists 1925–1955* and *California Watercolors: 1850–1970.*

On a trip to southern France I enjoyed watching the late afternoon games of *pétanque*. Men gather every afternoon for conversation and this particular sport. I filled a few pages with line drawings of the men in different positions using my black, bold-lined gel pen. I then did a compositional line sketch, with the park and sycamore trees as a backdrop. In the October light under the trees, with the figures in backlight, the setting was spectacular.

A few days later I did the painting *Pétanque Players, Lemioux* on the terrace of the small villa we had rented in Cassis, France. I referred to the line drawings and then just reacted to the southern Mediterranean light that was present in the gardens. I wanted to capture the interaction of the figures—the camaraderie of the players and the nonchalant, easygoing manner of the crowd. I looked for a syncopated rhythm and beat between the figures and let the banding element of the wall connect the men. I wanted to get the feeling of the golden light, the texture of the bark of the sycamore, and the linear energy of the gnarly, twist of the branches.

Study for *Pétanque Players, Lemioux,* 10 x 8 inches (25.4 x 20.3 cm), gel pen on sketchbook paper

Each line drawing of the figure took me ten to twenty seconds. Most of the time my eye was on the figure and not on the paper.

Study for *Pétanque Players, Lemioux,* 10 x 8 inches (25.4 x 20.3 cm), gel pen on sketchbook paper

I looked for the positioning and movement of the figure before putting down the line.

Study for *Pétanque Players, Lemioux,* 10 x 8 inches (25.4 x 20.3 cm), gel pen on sketchbook paper

In this sketch I was interested in capturing the tree patterns and the contrast between the dark background and the sunlit figures.

Pétanque Players, Lemioux, 27 x 19 inches (68.6 x 48.3 cm), acrylic on 300-lb. rough Richeson Premium watercolor paper, Collection of Christine and Tedd Benson

The men of small villages throughout the south of France gather each afternoon to play the game of pétanque, or boules as it is often called.

Putting It All Together

Throughout the twentieth century and now into the twenty-first, artists enjoy unprecedented freedom with their work. We are not held hostage by a monarchy or the pope. We are not dictated to concerning how, when, where, or why we do our work. This freedom is tremendously liberating. However, with this freedom comes responsibility.

Throughout this book I have discussed in-depth the characteristics of the various watermedia, provided techniques for using them, and described the compositional elements that can profoundly affect your painting. All of these are important considerations, and yet any of these can be discarded, as you, the artist, find other methods that may serve your works better. While experimentation is critical to the artistic process, it should have a foundation—and that is what this book is about. It is meant to give you a beginning, a place to start, a home base from which you can explore and then hopefully build the confidence to grow, set yourself free, and push on.

Every painting is different. Each requires that you make different choices, and each has different answers. That is the interesting thing about painting: No matter how successful your last painting was, the new one starts with a blank, white sheet of paper. That is the scary thing—and yet that is what keeps bringing us back. We may get close to what we are after, but at a certain point we raise our standards to grow as a painter. We finally realize that it is never ending. Rembrandt, one of the greatest painters ever, said on his deathbed, "I am ready to begin."

In summary, here are five major steps that are covered in this book and that lead to the creation of a painting. Each category has a few corresponding questions. Remember, earlier in the book I told you about a friend who suggested that I seek out people who ask questions. Questions are the key to growth. Ask yourself these questions—both as you develop your composition and during the painting process. Think of your own questions. All of these questions will help you in putting your work together.

Inspiration What strikes you about this subject? What drew you to it?

Composition Is there a good relationship between the positive and negative space? What is the best geometric motif for this work? Do you have an interesting division of space? Is there an expressive pattern, rhythm, and transition between the shapes? Does the composition have a sense of balance? Are there overlapping forms and a sense of unity?

Color What mood do you wish to convey? What color will you choose to emphasize this feeling? Are certain colors repeated throughout the composition? Are the values arranged well? Is the strongest contrast of lights and darks and the strongest notes of color in the areas that you want to emphasize?

Media Which medium or media will best express this inspiration? Does it need to be a delicate, transparent watercolor; a bold, expressive, and colorful, hard-edged acrylic; a juicy, velvety-matte opaque casein; or a combination of the above?

Paint Application Which method of paint application will best convey the mood of the painting? Should it be a wet-on-wet transparent piece or an impasto opaque? What kind of brushes and strokes will be most expressive to this work?

MARCH 1, 2005

Simply living my passion and attempting to present this to the world is an expression of love in the highest sense—that of simple gratitude. The resulting paintings can help shift existing energy and consciousness. Quite frankly, I feel that as a way of life nothing is more important.

March, View from My Studio, 26 x 17 inches (66 x 43.2 cm), watercolor on 300-lb. rough Richeson Premium watercolor paper, Collection of David Toole

I created this painting in the early spring, using a limited color selection of cadmium orange and red-orange and the complementary color, ultramarine blue deep.

Knowing When a Painting Is Complete

If an artist-author could write a convincing book on how to finish a painting, he or she would sell a lot of books and make a lot of artists happy. I have been invited to many painters' studios only to find stacks and stacks of unfinished paintings. Painters tell me that the first part of the painting process is so much fun but the last part is hard work. Many painters will simply not finish the paintings they start. Instead, they just begin another piece.

Unfortunately, there are no formulas for finishing a painting. There are no answers. However, the only way to grow as an artist is to push through and finish each painting. You must make some decisions to finish the work. Sometimes these decisions will be right, but many times they will be wrong. If you end up not being happy with the result of your decisions, you will at least have learned a lesson. This way, when you come across a similar challenge in a future work, you will not do the same thing.

Learning how to finish a painting comes the hard way—through the passion and efforts of pushing through to the end with hundreds and hundreds of paintings. Throughout this process you will build your sensitivity for knowing what the painting requires. At a certain point you can "listen to the painting" and it will tell you what it needs. While this skill only comes after years and years of experience, there are two things that I think are helpful to know as you travel along your own path.

First, it is better to complete a painting 5 percent too soon than to go 1 percent too far. If a painting is overworked, not only does the artist know it, but all viewers in the future will feel it as well. Ultimately, it is best to get to the point where you know precisely when to stop, but there is no finish line. Only your intuitive sense can make that call.

Second, and this may sound contrary to the last statement, it is important to take risks. At a certain point in the process of most paintings, I can stop and the painting will be safe and competent, but for me this is not good enough. For the work to realize what it can best be, I may need to do something daring. It may be an unexpected color, a shift to an opaque medium, or some jarring marks to stir the soul. I always take that risk. Occasionally it does not work; and from that experience, I learn. However, most of the time I make it a better expression, one that is closer to what I wanted.

JANUARY 31, 2006

I love blue, blue-violet, and violet. I have long considered these colors to be the base notes in my painting, but as I think about this color family more deeply, I am aware that there is another reason that I use these colors in my meditative works. Over the years I occasionally have observed an aura, or energy, of the soul. This aura permeates and radiates from a person's body. The color of the aura that comes from a peaceful, serene, meditative person is blue-violet to almost cyan. I feel this color present in nature.

Violet Sun, 28 x 44 inches (71.1 x 111.8 cm), acrylic on 300-lb. rough Richeson Premium watercolor paper, Collection of Russ and Bonnie Weathers

I see the mountain country in layers. Light can shift and the mountain farthest away may be the strongest color or value. I created the golden sky and violet sun with an acrylic interference wash.

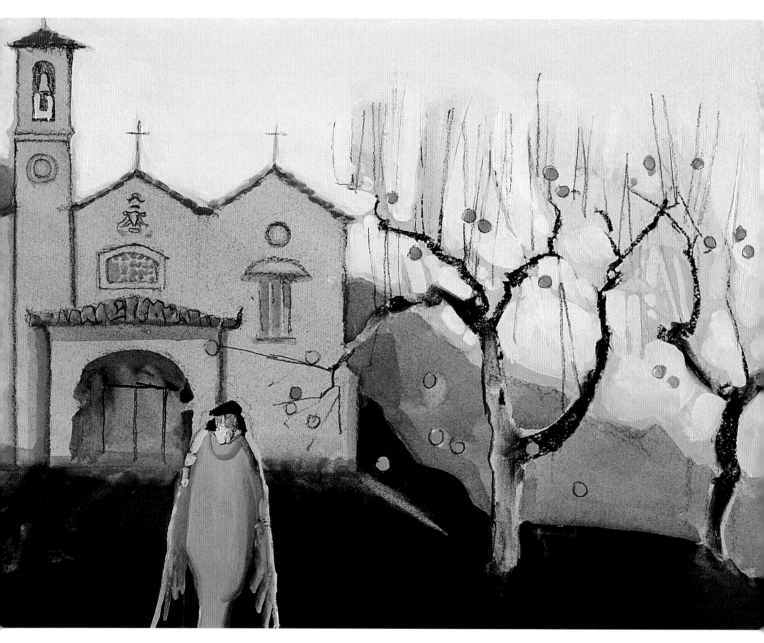

Persimmons and Chiesa di San Giusto,
12 x 16 inches (30.5 x 40.6 cm), charcoal,
acrylic, and casein on #5114 Crescent
watercolor board, Collection of the Artist

I did this painting on a soft, drizzly day in
mid-November in a small studio in Tus-
cany next to our rented villa. The orange
persimmons seem almost like ornaments
next to the angel-like figure.

Epilogue

This is the first part of a trilogy poem, called *Father, Brother, Lover,* written by my daughter.

I burst out of your head
and separated into hawks flying
formations around your meditations.

My father wanted me to bloom from
the current of the Rio Grande,
so I grew limbs and struggled to learn
how to crawl.

When I was small, he showed me
how colors are alive, how
grass is never green
and the sea never blue.
Pigment became me, and
I danced watercolor into my
blood.

My father taught me about the
color of water.
We drove to North Clear Creek Falls.
I stood near the top and
leaned over the railing into the canyon
so I could feel the spray,
imagine falling
onto the rocks. I thought waterfalls
were Poseidon's angry tears
and that if I fell in, the dead would drag me
into tangles of seaweed.
I though of kicking at their skeleton
bodies and breaking off their limbs,
and my father told me to look hard
so I could catch them in the perfect light.

He took me under the earth
and tried to explain the sky,
breathe on my fingers to show the wind
drops of water to simulate rain.

Nature is our church, he told me
when we stayed home Sunday mornings,
this river and this life is all we need
for proof that some God exists.

After my brother fainted
in the shower and flew to a hospital,
my father built a meditation room
in his studio. There were fires
in Colorado that year, and no one
was interested in buying art.
So my father built a meditation
room, and put in a picture window
facing the Rio Grande and the east.

At night, our paths often crossed
and we decided insomnia was hereditary.
We drank toasted milk and he told
me the things he regretted. I closed
my ears and refused to believe he
was capable.

The moon blushed
midnight Fourth of July. The
last of the fireworks wrapped their
arms around us.
My father bit his index knuckle.
And we waited. My father told
me it was easy to be stupid
when you are seventeen.
We could hear the rough cheers
and exploding beer bottles downtown.

I nest myself in wildflowers
while he paints. To me,
he is dancing around the
canvas. It is his lover and his enemy, his paint
a caress and a weapon.
He strokes his lover blue
and slices it red.
Watercolor is made with honey,
and today a bumblebee is
caught in cadmium red light.
His orange legs stick together,
he buzzes, he wades.

Allison Quiller, Interlochen Academy of the Arts, Spring 2006

Snow Shadows, 29 x 21 inches (73.7 x 53.3 cm), acrylic and casein on Fabriano watercolor board, Private Collection

This painting is typical of many of the compositions I did throughout the 1970s. This was the beginning of the *Snow Shadow* series, which I continue to this day.

Bibliography

Bennett, Cathy. *Exploring the Endless Possibilities of Casein.* (catalog) Kimberly, WI: Jack Richeson and Company, no date.

Cohn, Marjorie B. *Wash and Gouache.* Cambridge, MA: Harvard University Press, 1977.

Frood, Catherine. "Making the Grade." *The Artist's Magazine,* February 2004, page 61.

Gawain, Shakti. *Living in the Light.* Mill Valley, CA: Whatever Publishing, 1986.

Goodman, Cynthia. *Hans Hofmann.* Munich: Prestel-Verlag, 1990.

Henri, Robert. *The Art Spirit.* Philadelphia: J. B. Lippincott Company, 1930.

Mayer, Ralph. *The Artist's Handbook of Materials and Techniques.* New York: Viking, 1991.

Myers, Bernard S. *Encyclopedia of Painting.* New York: Crown, 1979.

O'Donohue, John. *Anam Cara: Spiritual Wisdom from the Celtic World.* London: Bantam, 1997.

Page, Hilary. *Guide to Watercolor Paints.* New York: Watson-Guptill Publications, 1996.

Quiller, Stephen. *Acrylic Painting Techniques.* New York: Watson-Guptill Publications, 1994.

Quiller, Stephen, and Barbara Whipple. *Water Media: Processes and Possibilities.* New York: Watson-Guptill Publications, 1986.

Quiller, Stephen, and Barbara Whipple. *Water Media Techniques.* New York: Watson-Guptill Publications, 1983.

Ruskin, John. *The Elements of Drawing.* New York: Dover Publications, 1971.

Steindl-Rast, David, and Sharon Lebell. *Music of Silence.* Berkeley, CA: Seastone, 1995.

Tauchid, Rheni. *The New Acrylics.* New York: Watson-Guptill Publications, 2005.

Tolle, Eckhart. *Stillness Speaks.* Vancouver, Canada: Namaste Publishing, 2003.

Wilcox, Michael. *The Wilcox Guide to the Best Watercolor Paints.* Perth, Australia: Artways, 1991.

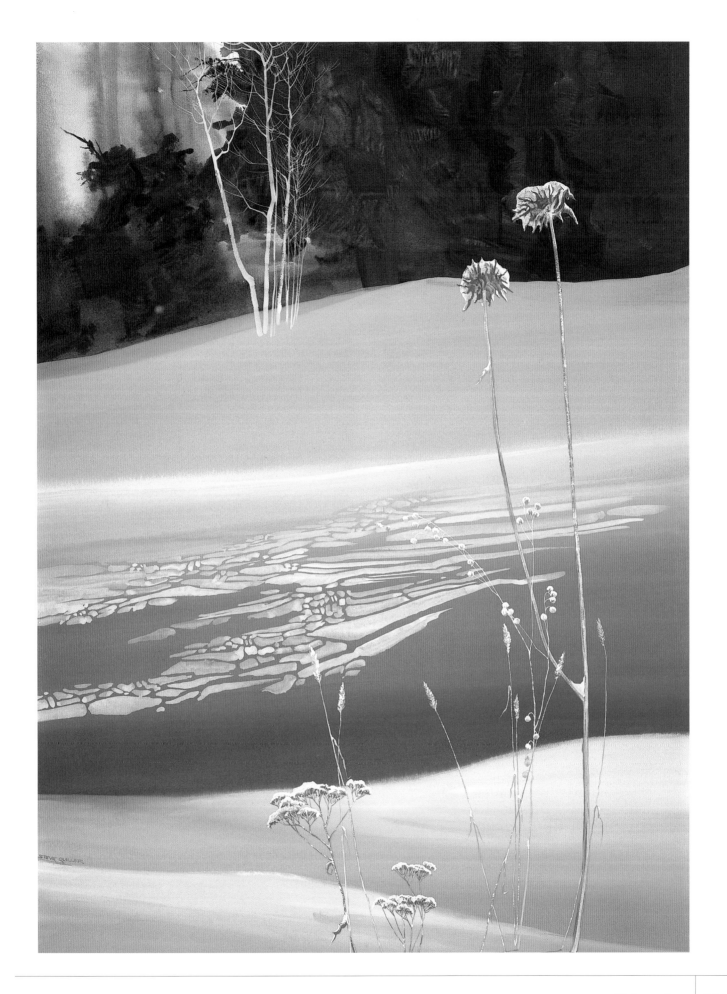

Index